MASTERING
CALLIGRAPHY

The Complete Guide to Hand Lettering

by GAYE GODFREY-NICHOLLS

CHRONICLE BOOKS

SAN FRANCISCO

First Published in the United States in 2013
by Chronicle Books LLC.

ISBN: 978-1-4521-0112-5
Manufactured in China.

Section Four written by Wendy Tweedie
Illumination tutorial calligraphy by Bailey Amon
Illumination tutorial photography by Robert Bredvad

Designed by Emily Portnoi and Andrew Milne Design
Cover design by Brooke Johnson
Front cover photograph by Robert Bredvad
(calligraphy by Bailey Amon)
Back cover photographs, clockwise from top left,
by Robert Bredvad (calligraphy by Bailey Amon),
Yanina Arabena, Robert Bredvad (calligraphy by Bailey
Amon), Gaye Godfrey-Nicholls
Cover illustrations © Bernard Maisner
Page 1 photograph by Yanina Arabena
Page 2 photograph by Robert Bredvad
(calligraphy by Bailey Amon)
Page 4, clockwise from top left, by Robert Bredvad
(calligraphy by Bailey Amon), Vitalina and Victoria
Lopukhina, Rachel Yallop, and Robert Bredvad
(calligraphy by Bailey Amon)

Published and distributed outside of
North America by RotoVision SA.
Route Suisse 9
Ch-1295 Mies
Switzerland

10 9 8 7 6 5 4 3 2 1enden

Chronicle Books LLC
680 Second Street
San Francisco, CA 94107
www.chroniclebooks.com

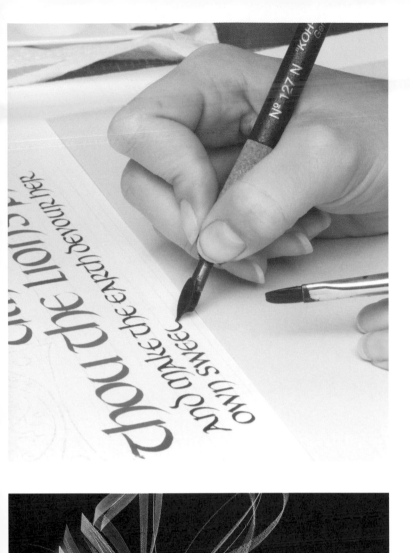

CONTENTS

THE BASICS

HANDS

DESIGN AND DECORATION

DIGITAL CALLIGRAPHY

INTRODUCTION

Calligraphy is often presumed to be the neat or fancy handwriting found on invitations or certificates. For most calligraphers, however, it is a serious study of historical letterforms and the personal development of those scripts. It is a craft that requires practice, patience, and perseverance.

As dry as that sounds, calligraphy is about discovering the sumptuousness of illuminated manuscripts, marveling at the low-tech ancient masterpieces produced in freezing, dingy scriptoria. It is opening the latest *Letter Arts Review* with anticipation and being overwhelmed by modern masterpieces that dance across the page; letters that find their genesis in archaic counterparts but that evolve and metamorphose into new and exciting forms.

Calligraphy is about delighting in the vast variety of letterforms: The friendly generosity of Uncial and its idiosyncratic but magnificent brother Insular Majuscule; the bombastic, Rubenesque voluptuousness of Lombardic Versal and its anorexic cousin, the supermodel-thin Modern Versal; the exquisite carved Trajan Roman and the darkly dense medieval majesty of Gothic. Calligraphers revel in the sensual, sinuous, and arch elegance of Italic and its baroque and extravagant descendant, Copperplate; the Zen-like utilitarian minimalism of Foundational and its revolutionary, empire-changing mother, Carolingian. These forms throb with their own life and stories, which they reach out to share with you.

Calligraphy is about discovering the pleasure of watching pigments in water meet, fall in love, and create new colors on paper. It is watching with anticipation the surface drying into a state of readiness for the kiss of the pen. It is not so much about losing yourself in the moment as finding yourself in a desirable state of flow, where the journey is as nourishing as the undoubtedly gratifying destination. Time stands still and you watch your own hand take over and create the forms for which you have striven for so long. This is what calligraphy is to me.

Calligraphy is a relaxing, enjoyable, and practical activity. It can become a full-time profession, a high-priority interest, a hobby, or just an opportunity to relax and focus on something apart from work or family.

Everyone develops their skill sets at different rates, and this is influenced by many factors. Previous drawing experience is an advantage, as is any activity requiring good hand-eye coordination. Calligraphy is essentially drawing with a pen, with a focus on letterforms.

Bearing this in mind, be patient with yourself. Many beginner calligraphers experience frustration and impatience when their first few efforts are not identical to that of their teacher. This may be due to the fact that we exist in a culture that demands instant results, promotes a competitive attitude, and encourages unrealistic expectations. With calligraphy—as with any activity that requires mastering new skills—the only way to achieve satisfactory results is to practice.

Most teachers have spent thousands of hours and (sadly) several forests' worth of paper improving their letterforms. Regardless of your level of experience or interest, a systematic and regular approach to calligraphy practice is necessary to make progress.

Some sources claim that to become a calligrapher, you must work at it for three years. Some say seven. An article about Turkish calligraphy suggested that it takes about 12 years studying under a master to get your diploma. For most people, such amounts of time are arbitrary; everyone who takes up calligraphy has their own motivations, expectations, and priorities. The important thing is to enjoy the process of learning and to celebrate your moments of success.

May the siren spell of ink and pen entrance you as it has me, and may your relationship with calligraphy be long, happy, and fruitful.

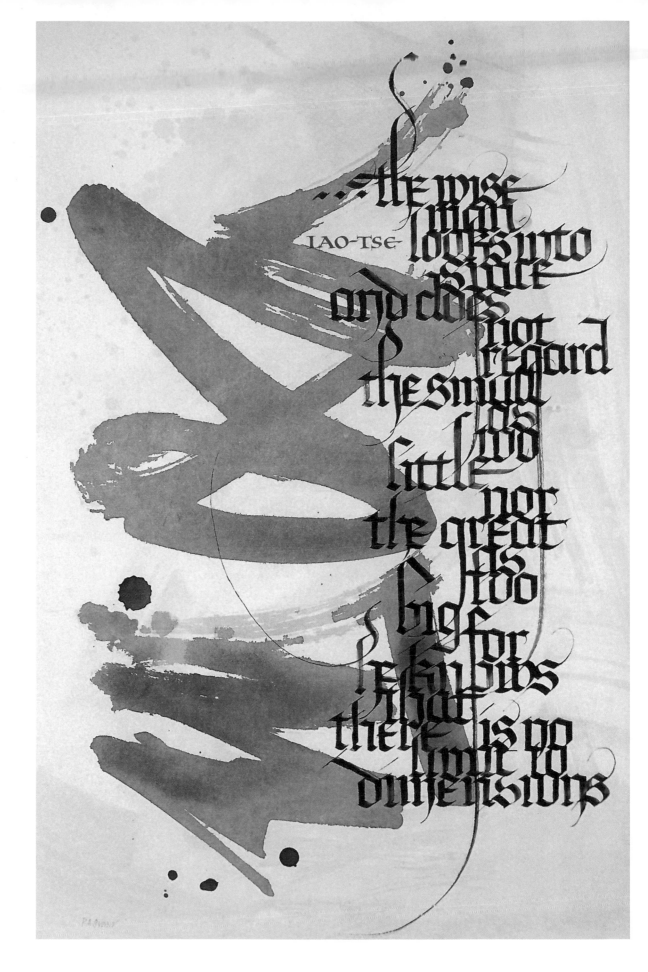

...the wise man looks into space and does not regard the small as too little, nor the great as too big, for he knows that there is no limit to dimensions

LAO-TSE

PETER EVANS
Watercolour on paper; large
pointed brush and metal nib;
19 x 26¾in (480 x 680mm)

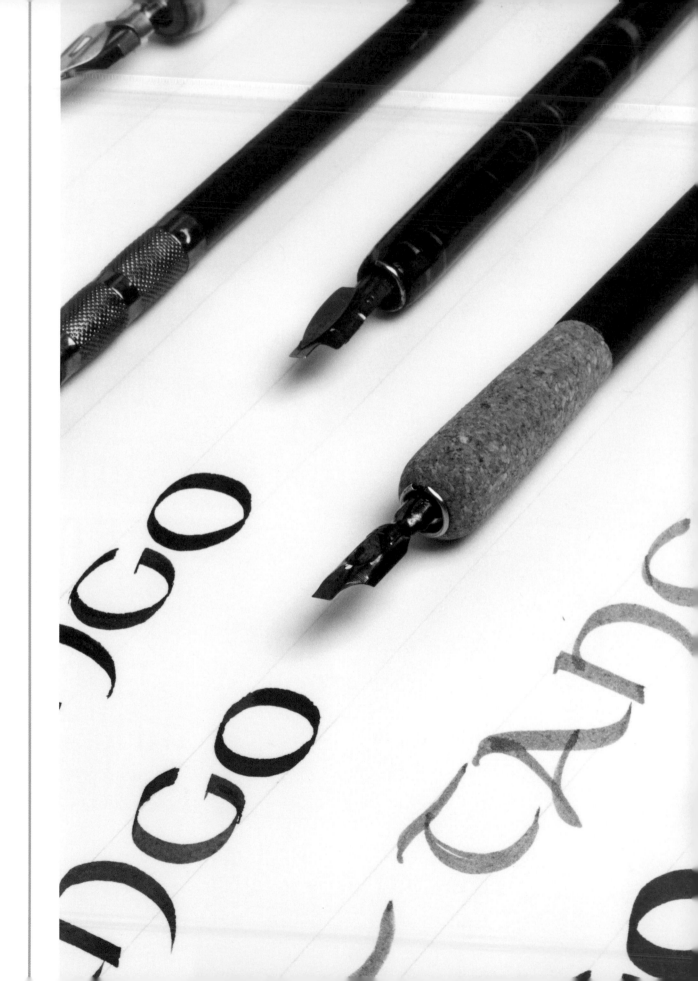

HISTORY AND EVOLUTION OF WESTERN CALLIGRAPHY

Here we review some of the most significant letterforms for contemporary calligraphers, most of which are examined in the Hands section of this book. Western or Latin alphabets evolved from the Phoenician alphabet in use around 1200 BCE. Greek, Etruscan, and Roman forms borrowed heavily from Phoenician, with Latin forms developing from Roman. Of the three main Roman scripts in use by the 1st century BCE, the basis for our modern alphabet was the Imperial Roman capital (the other two being Old Roman Cursive and Rustic capitals). Other notable scripts included the Square capital, Greek Uncial, and Latin Uncial. The fall of the Roman empire around the 5th century CE also saw the demise of the classical Roman scripts and the emergence of national and regional scripts, including Luxeuil, Beneventan, and Merovingian.

Latin Uncial gradually evolved into the Half-Uncial or Insular Majuscule script. From the 6th to the 8th century CE, this script was used to produce many outstanding illuminated books, including the renowned *Book of Kells* and the *Lindisfarne Gospels*. These scripts were produced using a square-cut or broad-edged quill on a substrate of vellum (calfskin) or parchment (sheepskin). The highly legible Carolingian script flourished in Europe around the 9th century. The 11th century saw increasing vertical compression and the development of transitional or proto-Gothic scripts, which evolved into the most compressed of all scripts: Gothic. This broad term encompasses many national variations, such as Textus Prescissus, Textus Quadratus, Rotunda, and Fraktur, which were in use from the 12th to the 15th centuries.

At the same time, less formal, faster scripts were needed for less prestigious work, so the "bastard" or hybrid scripts developed, named for their mixed parentage of Gothic and Cursive. In England, the memorably named "Bastard Secretary" rose to prominence, while in France Batarde dominated Books of Hours and chronicles from the 13th to the 16th centuries.

AFTER THE RENAISSANCE

The Renaissance heralded the emergence of the Humanistic Minuscule, a reinvigorated form of Carolingian. Over time, this script became compressed, and when written at speed gradually evolved into the Chancery Cursive—what we know today as Italic. This elegant script, first attributed to Niccolo Niccoli around 1420, was used extensively in the Papal chanceries until the 17th century.

Copperplate, so named for the copper plates engraved to make printed reproductions, developed from the use of the burin, a sharp engraving tool, to engrave the plates. Although the basic form was that of Italic, the burin used pressure to create thick and thin strokes that affected the form, making it increasingly slanted, with fewer pen lifts, and thus faster. The use of the burin was instrumental in the invention of the pointed metal nib, the principal tool of Copperplate.

By the 19th century, Copperplate became the standard hand taught in schools in Europe and the United States. Penmanship was disseminated through writing manuals such as George Bickham's *The Universal Penman*, and the style remained the basic copybook hand in many countries well into the 20th century.

The invention of the ballpoint pen by John Loud in 1888, and its subsequent improvement by the Hungarian Biro brothers in the mid-20th century, signified the end of the era of universal penmanship. The inflexible ballpoint pen has a limited capacity for calligraphic forms, as it is a monoline instrument, unable to create a contrast between thick and thin. Although skilled calligraphers can conjure calligraphic lines from virtually any instrument or found object, many people believe the widespread adoption of the ballpoint was instrumental in the degeneration of handwriting. For non-calligraphers, writing is purely utilitarian; there is even speculation that with the prevalent use of keyboards handwriting itself might eventually become obsolete.

JOKE BOUDENS

Detail from concertina book; ink, aquarelle, and gouache on Arches paper; original size 5½ x 29½in (140 x 750mm), folded into three

Joke successfully blends traditional hands and detailed illustrations with a consummate sense of design.

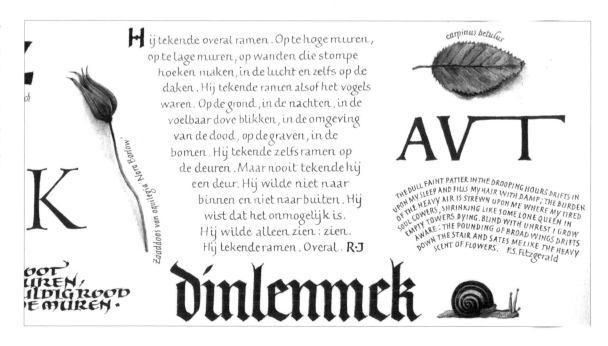

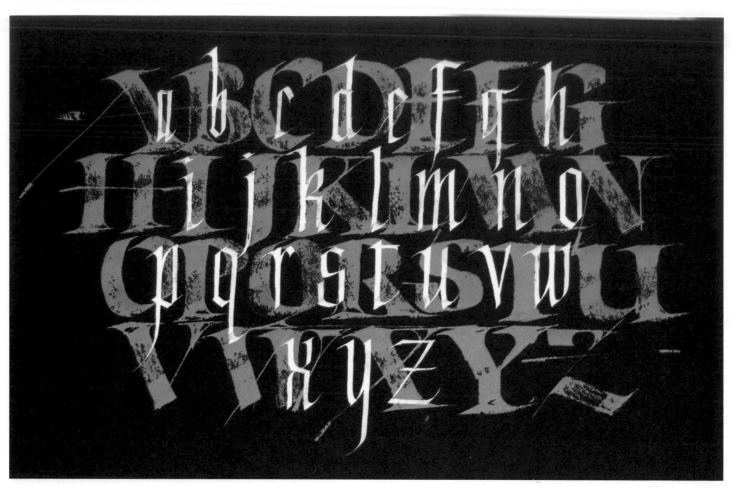

PETER EVANS
Gouache on black paper; homemade pen and metal nibs; Roman square caps and a Gothic Italic hybrid; 27½ x 20in (700 x 500mm)

Peter imparts a modern flavor to these traditional forms with bold color under an elongated, condensed hybrid hand.

DAVID McGRAIL
Watercolor; Sumi ink on Saunders HP watercolor paper; Brause nibs and sable brushes

THE REVIVAL

It is widely acknowledged that Edward Johnston (1872-1944) was responsible for starting the modern calligraphic revival. Johnston rediscovered the techniques for making and using reed pens and quills. This led to his breakthrough discovery of the use of broad-edged pens (Johnston referred to them as square-cut pens) in manuscripts. Previously it was thought that letterforms in manuscripts were produced using a pointed pen, as with Copperplate, and filled in. His book, *Writing, Illuminating and Lettering* (1906), is regarded as one of the most significant manuals on calligraphy. Another of Johnston's enduring legacies is his design of the London Underground Railway sans serif type, completed in 1916.

Many of Johnston's students became highly regarded teachers themselves, including Anna Simons, Eric Gill, Graily Hewitt, T.J. Cobden-Sanderson, Percy Smith, Dorothy Mahoney, and Irene Wellington. Johnston's students founded the Society of Scribes and Illuminators in London in 1921. Alfred Fairbank, another of Johnston's students, wrote two classic books on Italic: *A Handwriting Manual* in 1932, and *A Book of Scripts* in 1949. Fairbank, a founder member of the Society of Scribes and Illuminators, also founded the Society for Italic Handwriting following World War II, aiming to improve the handwriting of the British nation.

Another luminary of calligraphic rediscovery was Rudolf Koch. Born in 1876, Koch was a German calligrapher, artist, teacher, and type designer at the Gebr Klingspor foundry from 1906 until his death in 1934. Koch began teaching calligraphy in 1908. His courses evolved into the Offenbach Workshop, where students learned calligraphy and applied it to decorative items such as tapestries, metalwork, woodcuts, manuscript books, and church bells. The Offenbach became a highly regarded institution and was attended by students from around the world. Much of Koch's design work involved German Fraktur/broken-letter types; he was experimental and progressive in all of his artistic approaches, particularly in his use of tools.

Johnston and Koch revived the use of the broad-pen and infused incipient scribes of the early 20th century with a vigor and enthusiasm for calligraphy that continues today.

CRAFT OR ART?

Western calligraphy has often struggled for recognition, tending to be viewed as a craft rather than as art. I suggest that, as with any art practice that requires mastery of skills, study of its history, understanding of relevant abstract concepts, and personal development, calligraphy falls on the art side of the craft/art spectrum.

Other traditions of calligraphy, such as Chinese (which led to Japanese), Arabic, Hebrew, and Sanskrit/Devanagari, have an illustrious history, and calligraphic artists receive the highest recognition. Brody Neuenschwander makes an insightful observation in his essay "Can Handwriting Be Beautiful?" Looking at the two great calligraphic traditions, Chinese and Arabic, he notes that Chinese calligraphy "is an art of form, content and expression; and each character is a time capsule of Chinese history and culture," while Arabic calligraphy was created to "develop a script worthy to transcribe the divine voice." He notes that in these two traditions, calligraphy is the central art. Contrast and varieties of form, scale, and movement, integration of discrete elements—these characteristics are a feature of Chinese and Arabic characters.

By contrast, Latin and Greek developed from a merchant script—a simplified and reduced set of characters with a utilitarian purpose. The current movement of more abstract and gestural Western calligraphy leans toward the inherently beautiful and expressive forms of Chinese and Arabic.

TOOLS AND MATERIALS

For a self-confessed stationery and art materials addict, there are few things more pleasing than a well-organized, clean, and inviting studio. A plan chest stocked with crisp, pristine watercolor paper, a full spectrum of colored paper, odds and ends of rare and unusual papers—handmade fiber, papyrus, handmarbled sheets, watercolor washes, and paste paper, and an assortment of printers' offcuts—await transformation into finished calligraphic artworks. Add to that jars of color-coded pencils (all sharpened to a lethal point), size-coded pens, markers, fountain pens, inks, gouaches, watercolors, acrylics, glues, and varnishes. Small plastic containers filled with nibs of all different origins, handmade pens and quills, antique and vintage items scored from garage sales or donated from kindly friends or strangers. Fat brushes, skinny brushes, pointy brushes, and flat brushes. These are some of the items from my treasured hoard. Part of the joy of calligraphy is having permission to collect these items and having a ready justification for their presence in your studio!

Clearly, if you have a tendency to collect things, calligraphic items will readily accrue to fill your available space. However, one of the most encouraging aspects of calligraphy is that it needs only a few basic and inexpensive materials to make a start.

THE BASIC KIT

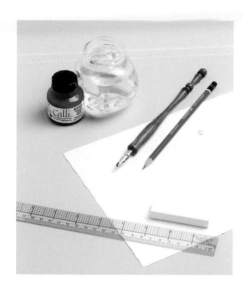

Keep your calligraphy materials in a sturdy container. A small fishing tackle box or craft box is ideal as they are solid and have a number of compartments suitable for storing nibs, which need protection during transportation.

Your basic toolkit will include:

- Nib and holder
- Ink or gouache
- Paper
- HB pencil
- Eraser

- Long plastic ruler
- Water jar
- Tissues or rags
- Exemplars to work from
- Guidelines

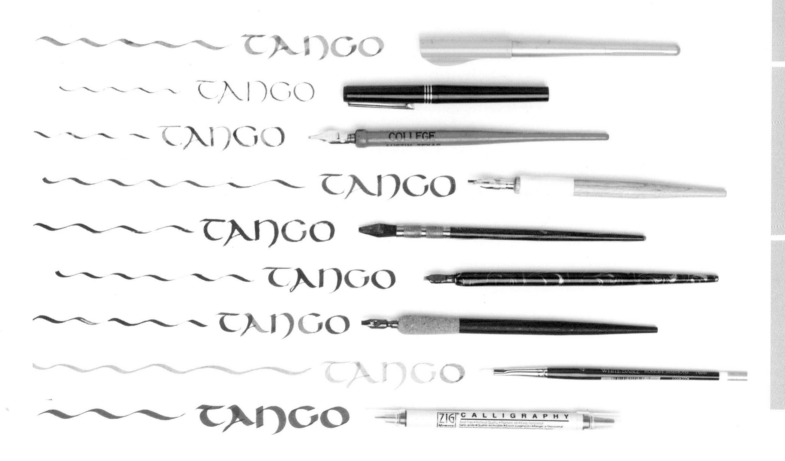

(Top to bottom): Parallel pen, Osmiroid, Speedball, Tachikawa, Automatic, Brause, Mitchell, flat brush, Zig marker. The same pens are used for all the major hands except Copperplate and Contemporary Pointed Pen, which use either a Mitchell elbow nib or a pointed pen with an oblique holder.

Nib and holder

A pen holder and dip pen are used in preference to fountain or felt-tip pens. The results are much crisper and your own choice of media can be used. The nib has two components: the writing edge and the reservoir, which holds the ink. There are three main brands of nib you might use:

- The Speedball nib has a top-mounted reservoir (the gold flat piece); the reservoir is attached, not removable.

- The Brause nib also has a top-mounted reservoir, but it is removable and adjustable.

- The Mitchell nib has a separate removable reservoir that is fitted underneath. The reservoir requires contact with the pen to work effectively. Too close to the edge of the pen and the media will run out quickly, too far back and it will not flow comfortably. Ensure that the nib is fitted firmly into the pen holder; sometimes the nib may be too loose and will require twisting into the holder until firm.

Inks

Non-waterproof inks usually provide a thinner hairline than waterproof inks. They are easier to remove from the nib (and anything else). Inks are usually dye-based. Waterproof ink is thicker and often contains shellac, which is very difficult to remove from the nib when dry. Many ink colors are available and are suitable for practice; however, black offers the best contrast and visibility.

Nib care

When using a nib for the first time, it can be scratchy and may not hold much ink, as nibs are coated in a protective lacquer in storage to prevent rust. Run the nib under hot water to remove the lacquer (some people light a flame under the nib for a few seconds). If the nib is still scratchy, it can be lightly sanded with fine-grade (1200 or above) wet-and-dry sandpaper to remove irregularities on the edge.

Wash the pen immediately after use to prevent ink buildup, even if you are only stopping for a coffee break. Drying the nib with a rag or tissue is essential, otherwise it may become rusty. If you have neglected your pen and it has a buildup, this can be removed by soaking in window cleaner for 20 minutes, gently scrubbing with an old toothbrush, rinsing thoroughly with clean water, and drying carefully. Avoid pulling the reservoir away from the nib, as it requires contact to work effectively. Treated with care, a Speedball, Brause, or Mitchell nib should last for a year or more of solid work. When your nib collection expands, you may wish to have a pen holder for each nib, instead of changing over each time.

Gouache

Gouache, or designers' color, is a form of watercolor made opaque by the addition of whites and fillers. It is pigment-based and an ideal medium for calligraphy; it can be diluted to flow smoothly through the pen, and an endless palette of colors can be mixed. It usually delivers a crisper letter than ink on a similar surface.

Paper

Layout paper or copy paper is suitable for practice, but a good-quality watercolor paper is the ideal surface for finished pieces. Many different types of paper are suitable for calligraphy, and testing them out with different media is recommended. For a wide variety of colors, Canson Mi Teintes is a reliable option. It has a textured side and a smoother side and each can be written upon. Keep paper samples with labels and notes for future reference. 16½ x 11¾in (420 x 297mm) is a good size for practice pages, especially if you are using a large nib.

Other items suggested for the basic kit are an HB pencil and long plastic ruler for ruling-up guidelines (see p. 27); a water jar to rinse out your nib when finished; and a rag or tissues to dry off your nib to prevent rust. Your exemplar may be one from this book or elsewhere and will show the instructions for constructing the letters of your chosen hand or script.

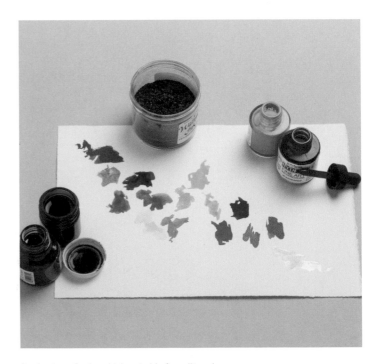

A selection of colored inks suitable for calligraphy.

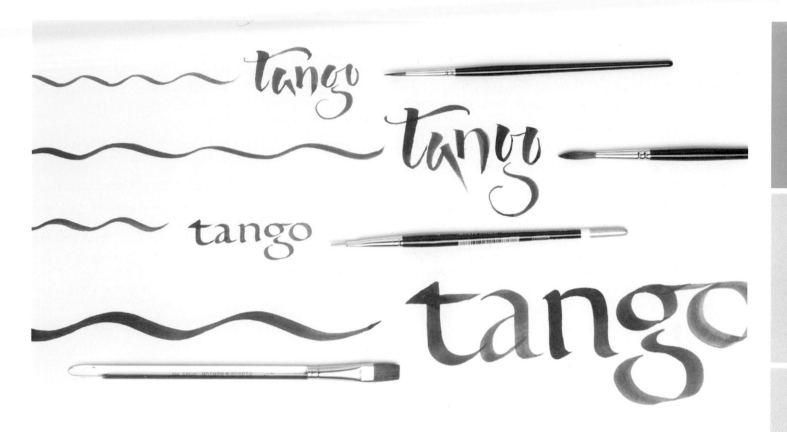

A selection of brushes illustrating the marks they make. The top three examples are pointed brush and the lower one flat or edged brush. All samples on this page by Bailey Amon.

A selection of colored Canson paper with a Copperplate exercise executed with a pointed pen.

Brush care

Good brush care will prolong the life of your brushes and help you achieve the best possible results. Poor brush care often results in the ferrule (the metal band that holds the hairs together) becoming clogged with paint and distorting the shape of the brush so it no longer has the desired point or sharp flat edge. When you have finished working, clean your brushes by first rinsing in clean cold water until most of the pigment is gone. Carefully scrub the brush over a bar of soap or brush cleaner and gently agitate it in your palm to get the soap all along the hairs. Rinse the soap off, squeeze out the excess water, and store with the bristles pointing up, or flat. A pin can be used to straighten the bristles if any are misaligned. Fabric or bamboo brush rolls are a convenient and portable storage system. It can be helpful to coat the brush with brush cleaner to hold a sharp point or edge during storage—simply rinse it off before you use it next time. Preparing the brush to write requires more attention than a metal nib. With pointed and flat brushes, each time the brush is loaded it needs to be reshaped prior to placing the stroke on the substrate. Test and shape the edge on scrap card.

EXPANDING ON THE BASIC KIT

Although your basic kit covers everything you need to learn calligraphy, there may come a time when you wish to expand and experiment, so I have included a list of other items that I have found useful in my practice.

Preparatory items

Compass: for circular calligraphy and arcs.

Craft knife or scalpel: for fine cutting—cardboard stencils, rubber stamps, and so on.

Eyedroppers or syringes: for measuring out water, gum arabic, and so on.

Kneadable eraser: does not leave residue behind and can be manipulated into tight corners.

Large ring-binder file and plastic pockets for presentation and protection of work.

Magic removable tape: for affixing paper to your board, and for pasteups.

Palette or small mixing containers: for mixing gouache or watercolors.

Protractor: for measuring pen and writing angles.

Sandpaper: wet and dry 1200-grade or finer for sharpening nibs.

Sloping board: transportable size for classes or fixed for use at home.

Small jars: one jar for clean water, one for dirty water.

Stanley trimmer: for more heavy-duty cutting tasks such as heavy cardboard folios, bookbinding, and cards.

Steel ruler: 16in (40cm) for cutting.

Tweezers: for removing nibs that have fallen into ink bottles!

Paper

Colored paper.

Practice paper: good-quality photocopy paper, bleedproof, bond, bank, bond layout pad.

Watercolor paper: hot-pressed is the best type for calligraphy.

Writing instruments

Brause nibs 5mm-0.5mm (removable top-mounted reservoir).

Brushes for lettering: nylon, pointed, riggers, and flat/chisel for washes, lettering.

Brushes for mixing: small chisel-ended bristles for mixing and loading.

Colored pencils: normal, watercolor.

Felt pens: variety of colors, sizes, and ends available.

Fountain pens: ink may be injected into used cartridges.

Graphite pencils: large range available.

Mapping and copperplate nibs.

Mitchell nibs 0-6 (a separate reservoir fits underneath).

Pen holders: large range available, handy to have one for each nib.

Pens: Automatic 6A-1, Coit 1-16.

Pilot Parallel pens: range of sizes, great for color mixing and very crisp lines.

Ruling pens.

Scroll, multiline, and music pens.

Speedball nibs C0-C6 (built in top-mounted reservoir).

Spoon burnisher: for embossing.

Witch pens.

Media

Gouache: selection of colors plus white.

Inks: waterproof and non-waterproof.

Masking fluid: for resist techniques.

Moonshadow mist or walnut ink spray: for an antique effect with metallic highlights.

Stamp pad/erasers: for making your own rubber stamps.

Stick ink and stone: many different grades and sizes available.

Watercolors: small palette of half-pans or tubes.

Additives and glues

Gloss varnish: for a final protective seal.

Gum arabic: for binding and intensifying colors.

Gum sandarac: for preparing surfaces that are difficult to write on.

Liquid paper: for correcting mistakes in artwork for reproduction (not on the original pieces).

PVA glue: for bookbinding, sizing, collage.

UHU stick.

Workable fixative: for sealing layers that could lift.

Gilding materials

Gilding base or size: gum ammoniacum for flat gilding, gesso for raised gilding, PVA or acrylic medium.

Glassine paper: goes between burnisher and leaf.

Gold leaf and Dutch metal leaf: for gilding.

Hematite burnisher: tool used for attaching leaf to base.

CALLIGRAPHY TERMS

Note that there is a full glossary on pp. 282–283, but below are some terms that may be unfamiliar to you. These terms will appear frequently in Section 2.

Arch is the curved stroke springing from the stem.

Ascender is the part of the letter that extends above the x-height, as in: b, d, f, h, k, l.

Baseline this is the horizontal line on which the letters sit.

Counterspace, also called white or negative space, is the space inside a letter.

Crossbar is the horizontal stroke on a letter.

Descender is the part of the letter that extends below the x-height, as in: g, j, p, q, y.

Ductus is the order of strokes to create a finished letter.

Hairline is the thinnest mark that a pen can make.

Interlinear space is the space between each baseline.

Majuscule is the capital or upper-case character.

Minuscule is the small or lower-case character.

Pen angle is the angle at which the blade or edge of the pen is held (not the pen holder), measured from the horizontal line. The thick and thin lines that characterize a calligraphic script are achieved by using and maintaining the correct pen angle; this determines the thickness or heaviness of the letter and the placement of the thick and thin strokes.

Pen width is the width of the mark made by the pen when held at 90° to the writing line (sideways). It is used to determine measurements for the x-height, ascenders, and descenders.

Provenance is the original source of the manuscript.

Rhythm is the pattern made by the stems.

Serifs are the starting and finishing strokes of a letter.

Stem is the main vertical stroke of a letter.

Substrate is the writing surface or material.

Writing angle is the angle at which the letters slope (not to be confused with the pen angle), measured from the vertical line.

x-height is the height of the body of the letter without extensions, as in: a c e m n o r s v w x z. The x-height is measured upward from the baseline.

Key points

Each script has its own unique set of characteristics that are based on modified historical models. The hands shown in this book have a key points box that shows you the major variables. These are:

- pen angle
- x-height
- ascender height
- descender height
- writing angle
- shape and origin of arch
- underlying rhythm

GOOD PRACTICE

EXEMPLARS

When we first begin studying calligraphy, we usually use an exemplar. This shows the letter shape, explains its key characteristics, and displays the ductus or stroke order. Many experienced calligraphers believe that exemplars are limiting and prefer to use a system of analysis that allows you to better understand the script. The theory is that in copying an exemplar you are copying the calligrapher's interpretation of that script and the strength and qualities of the original form are therefore diluted.

Research manuscripts to see these forms for yourself. There are many books with good reproductions of historical samples. Stan Knight's *Historical Scripts*, Stan Knight and John Woodcock's *A Book of Scripts,* Donald Anderson's *Calligraphy: The Art of Written Forms*, and Michelle P. Brown and Patricia Lovett's *The Historical Source Book for Scribes* are a good start. Devoted to a single manuscript, the *Book of Kells*, the *Lindisfarne Gospels,* the *Sforza Hours,* and Stephen Harvard's *The Cataneo Manuscript* are all full of useful material.

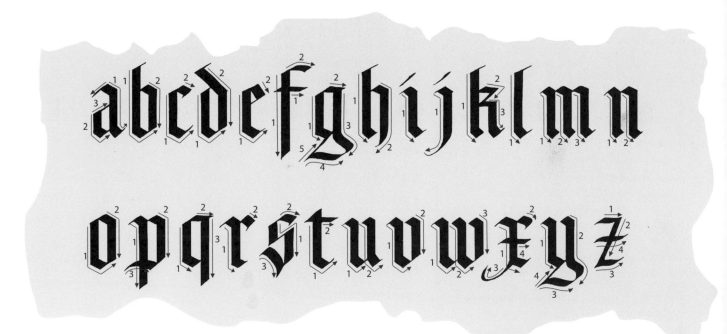

This exemplar format shows Gothic letters in alphabetical order with directional numbered arrows indicating the order of the strokes.
The hands explored in this book have this standardized exemplar style as well as stroke-by-stroke examples organized into letter groups.

ANALYZING SCRIPTS

Once you have progressed through a few basic hands, it is helpful to learn the method for analyzing a script. When you understand the principles of script analysis, you can then make your own interpretation of that script. Edward Johnston (see p. 15) developed this method through investigating how to create letterforms from old manuscripts. Calligraphers still use it when trying to achieve a modern version of a historical sample; it is essential for understanding the qualities that give each hand its essence.

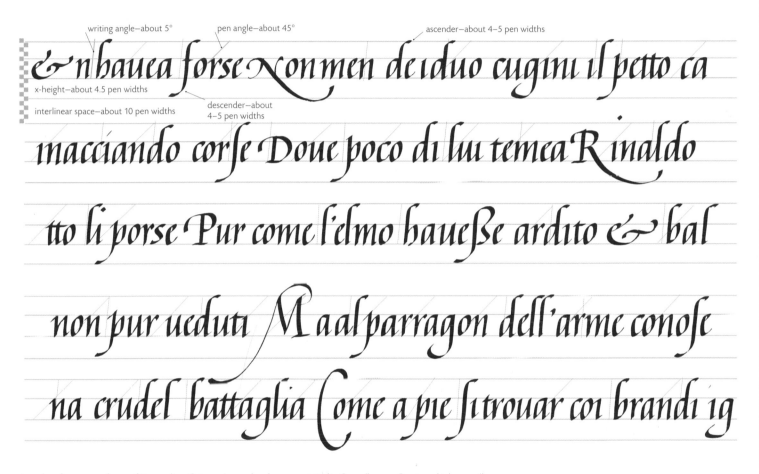

I made a free copy of one of Bernardino Cataneo's copybook pages using the Cancellaresca Corsiva, which we will use to examine the process of script analysis. I have treated it as an analogue for the original, which is under copyright.

Method

Select your historical script example and photocopy it. Enlarging is recommended. Rule along the starting points of the strokes, which indicate the pen angle and nib width. Find a nib that matches the sample size. Record the details of the following measurements in your notes.

Proportion

Using a contrasting monoline pen (the example uses gray), rule along the baseline of the passage, the top of the x-height, the ascender line, and the descender line.

Check the x-height, ascender, and descender heights using the nib to measure. In this example the heights range from four to five pen widths.

Writing angle

Rule along the strokes themselves (the writing angle). Measure the writing angle (slope not pen angle) with a protractor. Measure as many writing angles as possible—there is usually considerable variation within the sample. Note the variations and take an average angle as the dominant one. The common writing angle in the sample is about 5°.

Pen angle

Rule along the starting points of the strokes, which indicate the pen angle. Measure the pen angle with a protractor. Again, measure as many as possible, noting that some letters will be done at different angles. The Cataneo copy varies from about 35° to 50°. Italic has frequent pen angle changes, but the average angle is about 40°.

Letter shape

Look at the shape of the o and how it relates to the other letters. The example has a symmetrical, compressed, sloping oval o relating to most letters in terms of counter, volume, and arch shape.

Observe the shape of the arch in groups n, m, h, b, p, k, r, and a, q, g, d, u, y, c, e, and o. The example has asymmetrical arches, springing from the bottom of the letter but emerging and rejoining at the x-height at the midpoint to upper two-thirds. Check the consistency between a, q, g, d, u, y, c, e, o and inverse n, m, h, b, p, k, and r.

Check for archaic or unusual forms: as well as a normal s, the Cataneo has a long minuscule s form that looks like an f without a crossbar, an ss ligature of both forms, and an in-curving h. The starting serifs on the minuscule p are sharper and more angled than most of the similar letters. It also has an unusual majuscule N, which has a long descender but no ascender area, an odd elongated C, an M with a long descender, and an R with a long sweeping descender. The sample commences with an ampersand that clearly shows the origin of the abbreviation—the minuscule letters e and t ligatured to form a compound symbol. Dots for i are placed high above the x-height.

Spacing

Measure the interlinear space—the space between the baselines—using the nib. The example is approximately ten pen widths.

Check the spacing between the letters. The example has generally equidistant parallels and consistent spacing, and spacing between words; although it varies, the example has slightly less than the size of the o.

Check the margins if the example is a full page and note the proportions. In this case, it is cropped so that information is not available. This is where Stan Knight's *Historical Scripts* is helpful, as it shows a full page, an enlargement, and the actual size.

Ductus

Speculate on the ductus, or order of strokes for each letter. The writing instrument and original size has a direct effect on the ductus. For example, small writing with a quill is likely to use fewer pen lifts and have a more cursive rhythm. The Cataneo copy ductus is top to bottom, with right-sloping ascenders. (The original, not shown, has slightly blobby terminations, suggesting a single-entry stroke from the right, which corresponds to the small size of the original.) The ductus is often difficult to determine by simply looking at the example, but it usually becomes more apparent when you make a copy (see following).

Tools and materials

Speculate on what writing instrument may have been used, if there is no indication on the sample. As most samples are from 4th-17th-century manuscripts, it is safe to assume that the instrument is a goose or turkey quill. It is good to know what the substrate is, and what medium was used, but if that information is unavailable it should not affect the accuracy of your script analysis. This is also the case with its provenance—the origin of the sample.

Make a copy

Rule your lines with the same measurements and copy the script sample in the same scale using the same size nib. This is helpful in understanding the possible ductus, character, and rhythm of the script.

The information in "Assessing the script" opposite is more relevant to peer and self-critique, but is also useful for historical manuscripts.

TIPS FOR LEFT-HANDERS

The main issue for left-handed calligraphers is to develop a comfortable method of working that does not smudge wet ink. Most left-handers I have taught seem to find turning the page sideways the best approach for achieving consistent letterforms. This will be awkward at first, especially when you are writing words, but the results justify this approach. The pressure on your wrist is much less than twisting your hand. There are a range of angles between sideways and straight that should be explored. However, everyone is different, so try each method and see what works best for you.

This position is similar to that of a right-handed calligrapher. However, as the pen angle still needs to be correct, the scribe's hand needs to twist to achieve this.

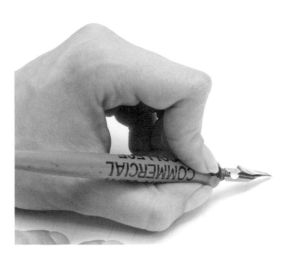

Turning the paper sideways to you may seem odd at first, but many left-handers find this position a good option.

Assessing the script

- Assess the scribe's understanding and uniformity of the letter groups.
- Assess the scribe's understanding and uniformity of letter widths.
- Assess the scribe's understanding and uniformity of negative spaces (the counterspaces).

- Assess the consistency of the pen angle.
- Assess the consistency of the strokes, serifs, and rhythm.
- Assess the consistency of the writing angle (slope).
- Assess the overall impression of the script.

SETTING UP

Allocate yourself a practice area, with a comfortable chair at the correct height so you can keep your feet on the floor or on a footrest. An area where you can leave your calligraphy equipment set up is ideal. Always work with a good source of light, whether natural or artificial.

Many calligraphers prefer to work on a sloping surface, especially over long periods of time. This can be achieved using a board propped against a brick or some thick books, a custom-designed calligraphy table, or a drawing board as used by architects. The sloping board also improves your posture, which reduces neck and eyestrain. Try not to get too close to your work; the ideal position is to sit squarely, with shoulders straight, feet on the floor, and eyes at least 12-16in (30-40cm) from your work surface.

I like to prepare myself for calligraphy with a few indulgences: a pot of freshly brewed green tea, and my MP3 player with my favorite playlist. Music assists me in getting into the state of flow.

Assemble your materials. Ideally, start with a large pen such as a Brause 3mm, Speedball C2, or Mitchell 1. These 3mm nibs are a good size to begin with, as thicks, thins, and pen angle are obvious. Smaller nibs have less contrast between thick and thins and the correct pen angle is harder to check. Any other broad-edged tool of a similar size can be used, including brushes, bamboo pens, balsa wood, Automatic pens, Coit pens, Parallel pens, felt-tip pens, or fountain pens. A large but shallow plastic container is ideal in which to sit your ink bottle, water jar, rag, and pen. Any ink spills are thus easily contained.

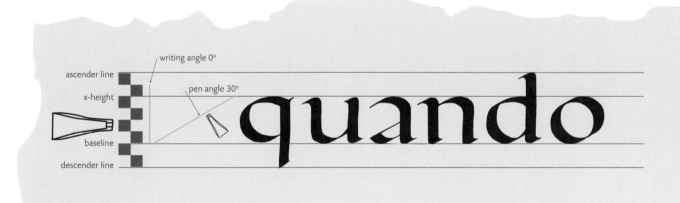

This example shows the word "quando" written in Foundational. It has an x-height of four pen widths, which are the four central squares on the left, with letters sitting on the baseline. Ascenders and descenders of two pen widths each touch the ascender and descender lines. The pen angle of 30° is shown with a blue line, while the writing angle or letter slope of 0° is shown with a pink line.

Ruling up

Ruling up lines is probably one of the less exciting and more time-consuming activities required for calligraphy. However, it is an important skill and is necessary for the completion of finished work. When ruling lines, we are concerned with the x-height and ascender/descender heights. These three sections make up a single unit and are bounded by four lines. This is repeated down the page.

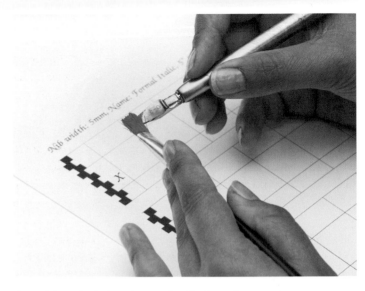

STEP 1

Make a ladder of the correct x-height for the hand that you will be doing. Add on the appropriate ascender and descender heights, above and below the x-height. Measure them accurately; for example, for a Speedball C2 or Brause 3mm (about ⅛in), if your x-height is five pen widths then your x-height will be about ⅝in (15mm).

STEP 2

Draw a margin around the paper of about ⅝-¾in (15-20mm).

The guidelines clearly show the ascender, x-height, and descender areas with the pen loaded and ready to go.

STEP 3

Mark the measurements of the four lines, starting on the left margin at the top of the page and mark the units down the side, always using the top line as the point of reference. This is where your times tables come in handy! Repeat on the right margin and join accurately but lightly with an HB pencil (or black fineliner pen for guidelines, which are a ruled-up sheet that you place behind your practice paper) with a long straight ruler. You can use a computer to rule your lines; this has the added advantage of allowing you to print out multiple copies. You can also work directly on the guidelines for practicing rather than placing them underneath your paper. For finished work, you will still need to rule your guidelines on the page with pencil, unless you can see guidelines of the right size through your final substrate.

If you have difficulty seeing the guidelines under your paper, a lightbox can be a great help. If you do not have a lightbox, you can make your own by shining a portable fluorescent lamp under a frosted glass or Perspex sheet.

A number of guideline generators are available on the internet. One that I have used is:
www.allunderone.org/calligraphy2/calligraphy.php

The instructions are straightforward and the results are of good quality. Each hand has its own sizes for ruling up—refer to the key points box for a ready reference.

Mark-making

When you pick up the pen for the first time, get to know it by making simple marks for 15-20 minutes. Using layout or copy paper and your 3mm pen, enjoy discovering the scope of the pen and what it can do. Consider this introduction a justifiable doodling session; make lines of different thicknesses, zigzags, curves, diamonds—whatever you want.

 cocktail tapas

A section of pencil-ruled guidelines with pen widths in blue to the left, and ascender and descender lines indicated. This Foundational writing was done in gouache with two different colors.

STARTING

Exercises

When you have experimented sufficiently, start with the exercises in Section 2; these are designed to prepare you for learning a specific script or hand. The first exercises establish the pen angle; the rest are the constituent parts of the alphabet. Aim to complete two lines of each exercise consistently before moving on to the next one. It frequently takes two or three hours for beginners to do all of the exercises properly.

Exemplars

Move on to the exemplar with the same pen and the same ruled lines. The letters on the exemplars are arranged in groups based on similarity of stroke rather than alphabetical order. This facilitates rapid progress. Some letters are shown with exploded views to indicate the strokes separately and together. This makes the starting position of the second stroke clearer. The exemplars show the ductus (stroke order) sequentially, and the arrows on the exemplars show the direction of strokes. Take one group at a time and work on each group in isolation. Move on to the next group and repeat the process. Bear in mind that in an eight-week course (a two-hour session per week), you would work on the minuscule of one hand for the whole eight weeks, practicing as often as possible to develop your pen skills. Some people are quick learners and will grasp concepts and forms readily; others will take longer—everyone is different. Take it slowly; the results justify a careful and thorough approach.

When all of the letter groups have been completed, work on words and pangrams (phrases containing all the letters of the alphabet, such as "the quick brown fox jumps over the lazy dog"). Critique and circle the best, noting any weak forms that require review, and concentrate on improving them. Check not only letterforms, but also spacing between letters and words.

In subsequent practice sessions, continue to do warm-up exercises at the start for at least 15 minutes to develop a rhythm and flow. Always warm up, no matter what level of experience or proficiency you have attained—letters produced during the first 15 minutes are usually pretty rough! Cold weather can make warming up take longer.

Correcting mistakes

Mistakes are the bane of every scribe's life! Some are relatively easy to correct, particularly if your paper is of good quality. When the wrong letter is used and a simple substitution is needed, the ink or gouache on the surface of the paper can be very carefully scraped back and the surface cleaned up with an eraser—a hard typewriter eraser or hyperaser followed by a soft white eraser. At this point, the surface will look free of ink but is still not ready for lettering. Smooth it with a burnisher to reseal the broken fibers, give it a light dusting of gum sandarac and reletter (gouache is preferable as it bleeds less than ink), using a nib one size smaller than the original so that if the paper bleeds the letter won't stand out so much.

Unfortunately, not all mistakes are easy to correct. If you have missed a word or more than one letter, there are few options left aside from starting from scratch, or just leaving it in (if it is not important). If you are doing personal work that can be layered over, you may find that it adds an extra dimension to your piece! Another solution is to do two identical pieces at the same time; this takes the pressure off and gives you a spare for future reference. This is particularly useful for a large commission, but requires more time to reach the finished stage.

Tips

- Avoid holding the pen too tightly or pressing too hard on the paper. These two common habits are difficult to shake and will adversely affect your calligraphy.

- Use a guard sheet when working. It protects the surface of the paper from grease and moisture on your hands, which can cause bleeding or feathering of the ink. The guard sheet can be cartridge, blotting, or layout paper, folded longways. The less you handle the surface of the paper, the crisper the writing will be.

- If you have ruled pencil guidelines that need erasing at completion, make a reference mark with your wet medium. Do this on a spare piece of the same paper used for the piece to test the dryness of the medium. This avoids smudging your precious work.

- Assemble a source file of quotes, poems, songs, or any text that appeals to you. These are useful for practice and can later be developed into finished pieces.

- A journal is a valuable tool—it can contain ideas for future pieces, sketches of things that appeal, swatches of color experiments, and comparisons of different nibs, media, and surfaces. Use a hardbound blank notebook—you can work directly into it or glue items into it. Dip into your journal for inspiration.

|||| ||| = ||| +++ |||||| uu
1 2 3 4 5 6 7 8

ilil ccc ooo noun mill
9 10 11 12

minimum onion

These exercises prepare you for the Foundational hand by practicing
the correct pen angle and underlying shapes in the alphabet.

abcdefghijklmn
opqrstuvwxyz

This exemplar format shows the Foundational letters in alphabetical
order with directional numbered arrows indicating stroke order.

coccccccqccdlbjppcoogsss

This letter group is based on the most important shape in Foundational: the o.
The letters here are shown stroke by stroke in their groups.

trans zephrique globum scan
dant tua facta per axem jav wyk

This pangram exercise ensures that you practice all the letters
of the alphabet and allows you to work on your spacing.

BROAD-EDGED PEN ALPHABETS

The broad-edged pen is an extremely versatile tool, responsible for creating most of the significant historical hands. Each of the broad pen alphabets examined in this chapter is presented, after a brief history, with a description of its key characteristics, a series of preparatory exercises, and an exemplar showing the letters with arrows indicating the number and order of strokes.

These broad pen scripts are: Roman Capitals, Foundational, Uncial, Carolingian, Gothic, Versals, Neuland, and Italic. Each of these hands is an interpretation of a historical script that is distinctive, practical, and recognized as significant. In most cases, both minuscule and majuscule alphabets are offered, but in some cases there is only a majuscule as there is no minuscule version. These hands are Roman, Uncial, Versals, and Neuland. Variations of the standard hand, which are often more lively, are shown after the more formal models.

For each of the calligraphic hands, numerals and punctuation vary less than the letters, so once you are familiar with the basic forms you can tweak them to fit each hand.

For numerals, the major variables are: pen angle, x-height, letter slope, and character.

Punctuation has even less variation with the main symbols: the period, comma (which in turn yield the colon and semi-colon), exclamation mark, question mark, and brackets are essentially the same for all hands.

NUMERALS AND PUNCTUATION

1234567890& .,()?!

SUITABLE FOR ROMAN AND FOUNDATIONAL
Main pen angle 30° · x-height 5 pen widths ·
No letter slope · Slightly compressed character

1234567890 .,()!?

SUITABLE FOR UNCIAL AND CAROLINGIAN
Main pen angle 20° · x-height 4 pen widths ·
No letter slope · Round character

1234567890& .,()?!

SUITABLE FOR GOTHIC
Main pen angle 30° · x-height 5 pen widths · No letter slope ·
Compressed and straight-sided character

1234567890 .,()!?

SUITABLE FOR VERSALS
Main pen angle 0° to 10° · x-height same as letters at around 2-4 pen widths · No letter slope
· Slightly compressed character

1234567890 + .,[]?!

SUITABLE FOR NEULAND
Main pen angle varies between 0° and 90° · x-height 5 pen widths · No letter slope ·
Round character with slight squaring-off

1234567890& .,()?!

SUITABLE FOR ITALIC
Main pen angle 45° · x-height 5 pen widths · 5° letter slope · Compressed character

ROMAN CAPITALS

HISTORY

The most significant and well-known example of the Imperial Roman capital, or Capitalis Monumentalis, is the inscription below Trajan's Column in Rome, written in around 114 CE. This well-preserved sample of incised Imperial Roman remains the prime exemplar for calligraphers studying Roman proportion. Edward Catich analyzed the Imperial Roman capital in his groundbreaking book *The Origin of the Serif* (1968). Another excellent reference book on Roman is Tom Kemp's *Formal Brush Writing*. Other forms of Roman capitals include Rustic and Square Capitals; these are both beautiful forms but less common in contemporary calligraphy.

The simplified version of the Roman Capital is the basis for most majuscule companions to the minuscule hands examined in this book. Use it as a capital for Foundational and Carolingian—a compressed and sloping form is used for Italic. It is arguably the most important hand for any calligrapher to learn. Remarkably elastic, Roman variations can range from the traditional formal Roman, to flourished, gestural, manipulated, squat, elongated, chunky, spare, polyrhythmic, and idiosyncratic.

PERSCRIBO

Roman proportions are based on the square, which is divided into halves, quarters, and eighths.

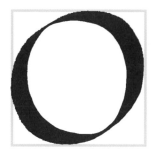

The O occupies the full width of the square.

The N occupies three-quarters of the square.

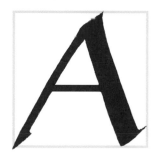

The A occupies three-quarters of the square.

Key points

- Pen angle: uprights 30°, diagonals 45°, horizontals 20°

- x-height: six pen widths

- Forms: upright with a geometric basis

- Arches: symmetrical

- Rhythm: space between letters is based on the volume of internal space

- O: based on a circle

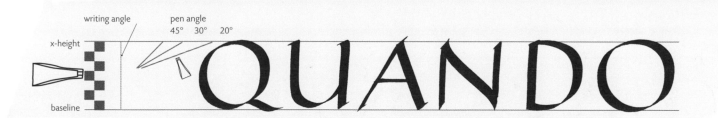

EXERCISES

When you are learning Roman Capitals, you need to begin with exercises designed to prepare you for the angles, strokes, and movement of the hand that are required. Complete about two lines of each exercise consistently before moving on to the next.

Skeleton Roman

Understanding and mastering the skeleton Roman form is one of the keystones of learning calligraphy, as it is the basis for most of the majuscules.

As tempting as it is to skip the pencil skeleton Roman and jump to the broad pen, resist the urge: You will be rewarded with a greater understanding and more accurate execution of majuscule forms.

Start with an HB graphite pencil and copy the skeleton Roman letters. They are arranged in groups containing letters of the same proportion rather than similarity of stroke as with minuscules. Using a set of guidelines with squares and circles of the correct proportion makes it easier to start freehand Roman. Tracing can be very helpful at this point. Practice one group at a time and make sure you are comfortable with that group before moving on to the next.

When you are familiar with skeleton pencil Roman (ideally after about 20 hours of practice), move onto a Brause 3mm, Speedball C2, or Mitchell 1 nib and use the same guidelines and proportions.

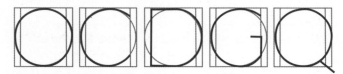 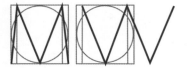

The round letters, or O group, are based on the full circle within the square, but C, G, and D fall short an eighth.

The wide letters, or M group, are based on the V, which occupies three-quarters of the square. The M has a V in the middle with its legs slightly wider than the square at the base; the W is two full Vs, taking up one and a half times the square.

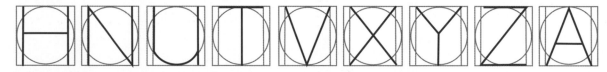

The three-quarter-width letters, or H group, are based on three-quarters of the square, coming in an eighth from each side.

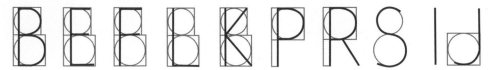

The half-width letters, or B group, are based on half of the square.

Broad pen

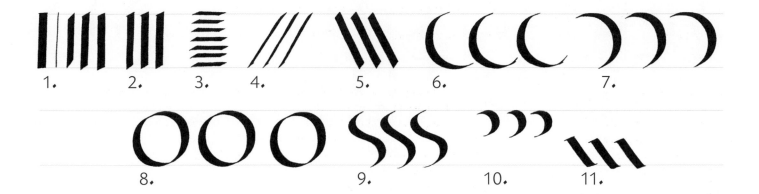

1. 2. 3. 4. 5. 6. 7.

8. 9. 10. 11.

To begin, rule a set of guidelines or use a guideline generator. I have listed two such generators below:

- www.scribblers.co.uk/blog/2008/07/scribblers-guideline-generator
- www.allunderone.org/calligraphy2/calligraphy.php.

Use a height of six pen widths—Roman is a majuscule that has no ascenders or descenders, although free or flourished interpretations often extend beyond the standard height. For a ⅛in (3mm) pen, the measurements will be ¾in (18mm). Use the full height of the measurements so you extend from the baseline to the top of the x-height, otherwise your letters will not be correctly proportioned.

1. Establish vertical reference strokes of 0°, 90°, 45°, and 30°, and 20° pen angle. Hold the pen at 30° unless otherwise indicated.

2. Holding the pen at 30°, create a picket fence of simple vertical downstrokes.

3. Holding the pen at 20°, stack a series of horizontal strokes on top of each other—the horizontals should be noticeably thinner than the verticals.

4. Holding the pen at 45°, draw a series of parallel diagonals starting at the top from right to left; this will be a thin stroke but not a hairline.

5. Still with the pen at 45°, draw diagonals from left to right—this will be a thicker stroke.

6. Holding the pen at 30°, draw a half-circle or crescent-moon shape with a backward lean. This is an important shape that occurs frequently, not only in Roman but in many other hands too.

7. This is the counterpart to exercise 6— a matching half-circle or crescent moon.

8. Combine exercises 6 and 7 to create the Roman O shape.

9. Holding the pen at 30°, begin thin stroke with a curving arc and then swing to reverse it.

10. Still at 30°, create a mini version of exercise 7 with a small, tight arc.

11. Holding the pen at 45°, do a mini version of exercise 5, but flatten the stroke angle a little more.

MAJUSCULES

ABCDEFGHIJKLMN
OPQRSTUVWXYZ

Roman alphabet with directional arrows showing the ductus.

Letterforms

After completing the exercises, begin with the letter groups, using the same guidelines. The pen angle ranges from 10° to 45°: horizontal strokes are at 15°, most of the letters are at 30°, and diagonals are at 45°.

Spacing

Spacing of Roman is critically important for consistency of texture. Volume is a useful concept when spacing Roman letters. Rather than mechanical spacing, where the letters are spaced identically from their closest points, consider the volume of the counterspace as an indicator for the amount of space between letters. Use the internal space inside the H as the standard unit of volume for spacing Roman letters.

As a rough guide, letters with straight stems are generally placed furthest apart (the basic H counterspace); a curve placed with a stem is closer, and curves together are placed closest. This does not account for the myriad combinations of letters that are possible, but gives a useful starting point. Sheila Waters has an excellent section in her book *Foundations of Calligraphy* where she details the difference between the actual space and the optical space.

TRANS ZEPHRIQUE GLOBUM SCAN
DANT TUA FACTA PER AXEM JAV WYK

Use this pangram phrase as a guide to spacing your words and letterforms.

COCCC GCQIDD

ROMAN O GROUP Hold the pen at 30° unless otherwise indicated. Start O, C, G, and Q with the crescent-moon-shaped stroke from the exercises; join the arc to finish the O, and add a flattened arc to finish C and G. For Q, add a tail to the O; for D, start with a simple downstroke, add a stroke like the second stroke of the O, and join at the base with a flattened arc.

IIIH/ΛΛ)ViΛΛiT

LU \X)VY ‾7Z

ROMAN H GROUP Holding the pen at 30°, start H with two simple downstrokes and finish with a horizontal stroke at 10°. At 45°, do the first diagonal of A by veering to the left, balance it by starting at the same point and veering to the right, and finish with a horizontal stroke at 10°. Start V with a diagonal at 45°, then add the second stroke at 30°. Hold the pen at 45° for all of N. Start with a simple downstroke, a wide diagonal, and finish by dropping down directly above the diagonal termination. Create T with a simple downstroke at 30° and cap with a horizontal stroke at 10°. For U, add a sweeping curve to a downstroke and overlap with a simple downstroke. Start Y as you did V, then drop a short stroke to the baseline. Flatten the angle to 10° for the top and bottom horizontal strokes of Z and flatten to 0° for the middle stroke.

IPBBIPPIPRIГFE

IТFILIKSSSIJJ

ROMAN B GROUP Hold the pen at 30° unless otherwise indicated. Start B, P, and R with a simple downstroke, then add a curving arc at the top. For B, add a second slightly larger bottom arc and finish with a flattened arc from the stem. Finish P with a flattened arc from the middle of the stem. To finish R, kick out the leg from the base of the top curve. Start E, F, L, and K with a simple downstroke, then flatten the angle for the horizontal strokes. Finish K with a diagonal, take it into the center, and kick it out. Begin S with a curving arc and swing to reverse it, then add the flattened arcs at the top and bottom.

IΛΝMΙVUW

ROMAN MW GROUP Hold the pen at 45° for these wide letters, which are based on the V. Begin M with a downstroke slightly angled to the left, add diagonals to create a V in the middle, and finish with a downstroke to balance the first, slightly angled to the right. Create W by adding two Vs together.

Minuscules

There are no traditional minuscules for this hand; Roman provides the basis for most majuscule letters.

HANDS

39

VARIATIONS

ABCDEFGHIJKLMN
OPQRSTUVWXYZ

This reference alphabet shows the Roman from the exemplar.

ABCDEFGHIJKLMN
OPQRSTUVWXYZ

This shorter version of Roman using a height of three pen widths has a more solid, denser texture.

ABCDEFGHIJKLM
NOPQRSTUVWXYZ

This is Wendy Tweedie's Roman hand, Royal. This manipulated hand has a strong flavor of Rustic.

PROFILE BARBARA YALE-READ

Calligraphically speaking, I was influenced by Thomas Ingmire, Ann Hechle, and John Stevens, who is the epitome of technical and design skill. I have been fortunate to study with many of these artists because of my friends Jim and Joyce Teta, who bring the best calligraphers in the world to Camp Cheerio. I only have to drive 60 miles on the Blue Ridge Parkway to get to this marvelous place and study for a week at a time. I have studied with Sheila and Julian Waters, Brody Neuenschwander, Ewan Clayton, and many others. I have also been influenced by artists such as Cy Twombly, Wassily Kandinsky, Paul Klee, Mark Tobey, and Jackson Pollock.

My work is inspired by reading poetry, feeling something that I really connect with, and working from that. Other times I will start with watercolor or some other medium and look for an appropriate poem. I am inspired by the poetry of Mary Oliver, T.S. Eliot, and Marge Piercy. I would like to include more self-generated writing in my pieces.

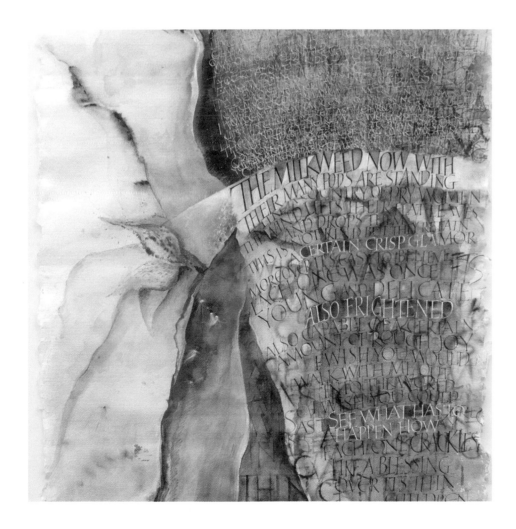

Gouache and watercolor on St. Armand paper with a pronounced deckle; built-up Roman capitals; 29 x 38in (737 x 965mm)

Text by Mary Oliver. I did several layers beneath the top layer using large freely done caps. There are milkweed seeds on the piece and a drawing of the pods.

One approach is to find a poem I really like, look for the theme, work with watercolor, and think about the colors that the poem evokes. Sometimes I find a complementary poem, or I repeat the same poem, and layer it over and over. I want it to be expressive like polyphonic music, with some words emerging and others becoming background sound, weaving in and out of each other. I emphasize words by painting the negative space around and inside them, so they emerge from the layers. It's different every time. Sometimes I get partway through a piece and don't know what to do next. That's the time to stop, evaluate, and sometimes work on other pieces. Other times a piece comes together quickly.

I started with the objective of learning all of the historical letterforms as well as traditional gilding and illumination on vellum. My first layered piece was done in 1988, but I felt unsure of it because it was quite different from "arranged" letters on a background—was this an "appropriate" thing to do with letters? Painting with letters, making the negative space as important as the positive space; I wanted to make it all interact, not just have letters sit on a background. I like to work in Roman Capitals in a painterly manner. I don't like to plan something in advance, designing and executing it. I'm drawn to Roman Capitals because they seem to have less intrinsic meaning; they are not "pretty" calligraphy and provide more opportunity to be expressive.

A big challenge is knowing where to start and knowing when to stop. When to stop is difficult, because I like depth and complexity. I like St. Armand watercolor paper because it lends a sense of depth to the work. Simplicity is difficult for me, yet I admire it in the work of others.

I am experimenting with making abstracted forms based on capitals, making up my own forms. I am also doing creative journaling. It's a great place to try new things. I am also researching encaustic painting, using wax to create layers and real depth in a piece, to see what possibilities it offers.

For those starting out in calligraphy, my advice is practice, practice, practice. Learn as many styles as you can; find the one that represents you and the way you want to work. I assign my students projects that involve layering, but I also assign traditional projects like certificates and invitations. It's important not to just practice letters, but to put them together to make something, be it a traditional approach or a more expressive style. You should not wait until you are perfect, because you never will be. You will never make the perfect letter. You will always think that it can be better, but that just makes it a continual challenge and keeps it alive.

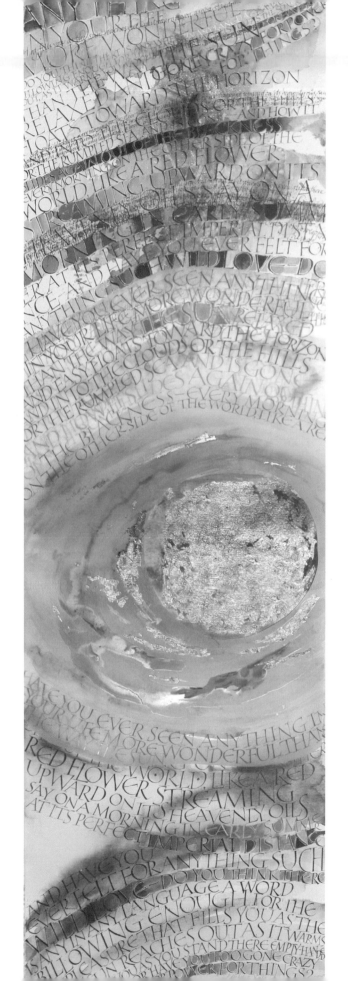

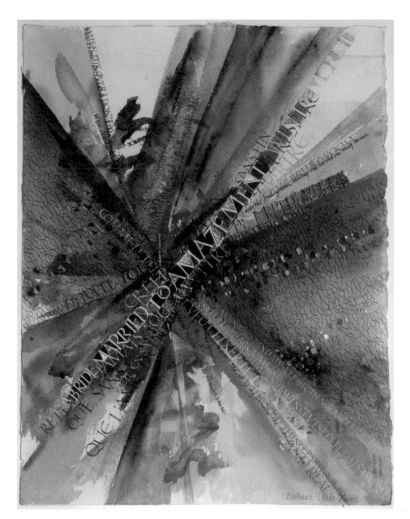

Watercolor and gouache wash; copper gouache applied with cardboard strips; variegated copper leaf; gold leaf; 14 x 18in (356mm x 457mm)

Text by Mary Oliver, *When Death Comes.*

Layered Dura-Lar and Mylar; copper leaf, gouache, colored pencil, and watercolor on watercolor paper; 12 x 36in (305 x 914mm)

The original piece was just the top part, but I wanted to continue it, so I sewed on another piece of longer paper. I then sewed a piece of Dura-Lar over the original and lettered on that. I cut a hole in the layer to show the copper-leaf sun beneath, and used some of the copper leaf on top of the Mylar. The layer ends about three-quarters of the way down the piece.

FOUNDATIONAL

HISTORY

Foundational is the ideal minuscule script with which to commence calligraphic study. It was created by Edward Johnston (see p. 15), who modified it from the *Ramsey Psalter*, an outstanding high-grade English Carolingian manuscript written in southern England around 974–986 CE. Johnston justifiably considered it an ideal choice to deconstruct and recreate in a more usable modern form.

The Foundational used by most calligraphers today varies considerably from Johnston's original alphabet, which has a dense, almost Gothic feel, with sharp, hackle-shaped serifs and tight spacing. Most versions of Foundational now tend to be more pared-back and minimal, pruned of distracting serifs, more generously spaced, and possibly closer to the *Ramsey Psalter* than Johnston's version. Although it is a restrained script with little in the way of embellishments, Foundational has an economy of form and simple clarity that, when well executed and spaced, reminds us that sometimes simple is best.

LETTER GROUPS: MAIN CHARACTERISTICS

To understand the shape of the o, imagine a full circle inside a square.

The letters of the n group have symmetrical arches that branch from high in the stem.

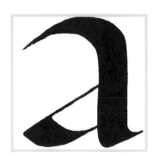

The underlying shape of the a is the n shape.

Key points

- Pen angle: mainly 30°
- x-height: four pen widths
- Ascenders and descenders: two pen widths
- Forms: round and upright
- Arches: branch from high in the stem
- Rhythm: undulating and round with equidistant parallels
- O: based on a circle

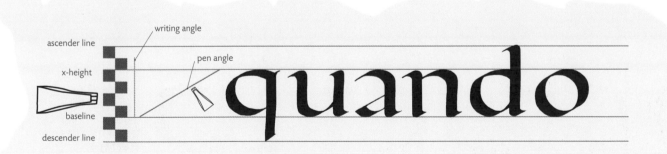

ascender line

writing angle

x-height

pen angle

baseline

descender line

quando

EXERCISES

When you are learning Foundational, begin with exercises designed to prepare you for the angles, strokes, and movement of the hand that are required. Start with a large, broad-edged pen, such as a Brause 3mm, Speedball C2, or Mitchell 1.

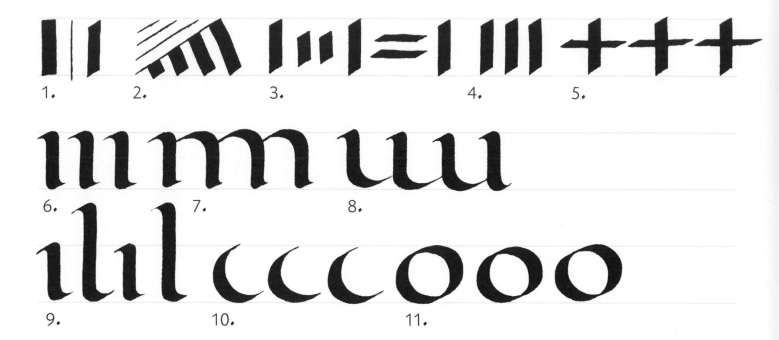

Rule a set of guidelines or use a guideline generator. Use an x-height of four pen widths, and ascender/descender heights of three pen widths. For a ⅛in (3mm) pen, the measurements will be ⅜in (9mm) ascender, ½in (12mm) x-height, and ⅜in (9mm) descender.

1. Establish vertical reference strokes of 0°, 90°, and 30° pen angles. This provides a direct visual context for understanding the differences in the strokes created when holding the pen at different angles. Hold the pen at 30° unless otherwise indicated.

2. Stay on the thin edge of the nib and travel up left to right for four strokes, coming down the other way with thick strokes.

3. Make a series of simple vertical downstrokes (two short ones in the middle, then two horizontal strokes bookended by plain verticals).

4. Create a "picket fence" of simple vertical downstrokes.

5. Make a cross shape—at 30°, horizontals should be noticeably thinner than verticals.

noun mill

12.

minimum

onion

6. Add gentle arcs to the simple downstroke for starting and finishing serifs.

7. Repeat exercise 6, then branch the second stroke of the n shape high off the stem of the first stroke and continue the pattern.

8. Make the u shape the inverse of the n shape.

9. Repeat exercise 6, but add an ascender.

10. Form the first stroke of the o with a crescent-moon shape leaning backward.

11. Complete the o with a second downstroke overlapping each end on the other side.

12. Combine the exercises to form words.

MINUSCULES

abcdefghijklmn
opqrstuvwxyz

Minuscule alphabet with directional arrows showing the ductus.

Letterforms

After completing the exercises, begin with the minuscule letter groups, using the same guidelines. The pen angle ranges from 15° to 45°: horizontal strokes are at 15°, most of the letters are at 30°, and diagonals are at 45°.

Spacing

The rhythm of Foundational is regular undulating arcs with equidistant parallels. To maintain this rhythm, careful spacing is very important. Beginners frequently space minuscules too far apart and allow too much space between words.

Interlinear space needs to be at least eight pen widths from baseline to baseline to ensure that ascenders and descenders don't clash. However, as you progress, you may wish to change the texture of the writing block and decrease it for a denser texture or increase it for ease of legibility.

trans zephrique globum scan
dant tua facta per axem jav wyk

Use this pangram phrase as a guide to spacing your words and letterforms.

cocccecccqiccdlbippccoogsss

FOUNDATIONAL o GROUP

Hold the pen at 30° unless otherwise indicated. Start o, c, e, q, and d with the same stroke: the crescent-moon shape. Join the arc to finish the o and add a flattened arc to finish the c. Add a curving hook to finish the e, a flattened arc for the top of q, and finish q with a simple descender. For d, add a flattened arc and a simple ascender. Continue the same round shape to finish the b and p. Start g like a short o, add the horizontal stroke at 15° and swing the descender down and around in one stroke. Give s a similar swing but tighten it up and add the flattened top and bottom arcs at 15°.

íinmlhraairluuyjʃſfttlk

FOUNDATIONAL i GROUP

Start r, n, and m with the same simple stroke. Spring from the base and branch high and symmetrically. H follows this pattern after a simple tall ascender. Create u by traveling down then up to the top of the x-height, then travel back down the upstroke. For the j, make a simple long descender with a gentle curve. Start f with an ascender but stop short of the full descender area. Add the flattened arc at the top at 10°. Do the crossbars on f and t at 10°. For the bowl on the k and r, make the second stroke spring from the base, tuck around a wide teardrop countershape, and spring back out.

vvwvxvy‾7z

FOUNDATIONAL v GROUP

Start v, w, and y with the 45° diagonal and give them a sharp flick at the base. Finish y at 30° with a descender. Start x with the same 45° diagonal stroke, but kick it up and add the second stroke at 30°. For z, do the top and bottom strokes at 15° and the middle stroke at 10°.

Majuscules

Note that Foundational majuscules are the same as Roman majuscules (see pp. 38–39).

VARIATIONS

Minuscules

abcdefghijklmn
opqrstuvwxyz

This reference alphabet shows the minuscule from the exemplar.

abcdefghijklmn
opqrstuvwxyz

A version of the Foundational minuscule based on Edward Johnston's original form, with sharp hackle-shaped serifs.

aabcdefghijkklmn
opqrrstuvwxyyz

A modernized version of the 11th-century Cnut charter hand, with pen angle at 25° to 30°, x-height at five pen widths, and ascenders and descenders at two pen widths. This hand springs from the stem, with symmetrical branching and sharp finishing strokes.

Majuscules

ABCDEFGHIJKLMN
OPQRSTUVWXYZ

This reference alphabet shows the Roman Capital, which is a suitable majuscule for Foundational.

ABCDEFGHIJKLMN
OPQRSTUVWXYZ

A version of the Foundational majuscule based on Edward Johnston's serifed form, with the addition of tapered slab serifs.

ABCDEFGHIJKLMN
OPQRSTUVWXYZ

A majuscule to accompany the modernized Cnut majuscule, with a height of seven pen widths.

◆ PROFILE HILARY ADAMS

As a child, I was enchanted by the ornately decorated covers of old Boosey & Hawkes sheet music. There is nothing more visually seductive than the combination of illustration, lettering, and music notation; I often use sheet music in my collage work. My first art book purchase was *More Than Fine Writing: Irene Wellington: Calligrapher (1904–84)*. Other influences include stumbling across the work of the painter Alferio Maugeri in a Paris gallery, taking up life-drawing classes, attending workshops facilitated by calligrapher/text artist Brody Neuenschwander, and watching Carl Rohrs wield a brush and Yves Leterme the "humble" Speedball.

Making letters is inspirational; merely to be doing, to attempt, to experiment, and possibly create is enough. That there may or may not be success at the end of the process is irrelevant. Response to external stimuli might prompt me to pick up a pen with the intention of making a "great work," but I usually end up practicing letterforms. This is fine with me. It is a way of keeping calligraphically fit.

Customer-driven work typically involves composition resolution through a series of thumbnails, followed by trial lettering. Layouts are tweaked with the aid of a computer: I scan and import the trial lettering into CorelDRAW, or substitute a typeface that I know will translate spatially once I start lettering. Depending on the scale of the work, I rule up for two final pieces, which I work on simultaneously.

Sometimes a client might ask me "to go mad," in which case my approach is free. I work on two or three pieces simultaneously on good-quality stretched paper or canvas. Layers of lettering, blocks of color, gesso, and collage elements are applied in no particular order until I feel I have a suitable ground to work with. Only then do I start to tackle composition and final lettering. Except for demarcating margins, I seldom rule lines.

Experimental work on substrates other than paper is challenging and rewarding. I am right-handed, but enjoy the challenge of using my left hand to both write and draw.

Sometimes I think I have regressed from when I first started calligraphy. Not in terms of competence as a crafter of letters, but I regret a certain loss of exuberance that often characterizes the early work of an artist. At some stage in my development I became land-bound by the rules of good calligraphic behavior. The struggle has been to take ownership of the knowledge and skill, to not merely imitate. I hope I am evolving.

If you are just starting your calligraphic journey, write, write, write, every day. It doesn't matter what. Become as proficient as possible, one hand at a time. Join a local guild; don't work in isolation. Attend as many workshops and master classes as possible. Master the art of composition.

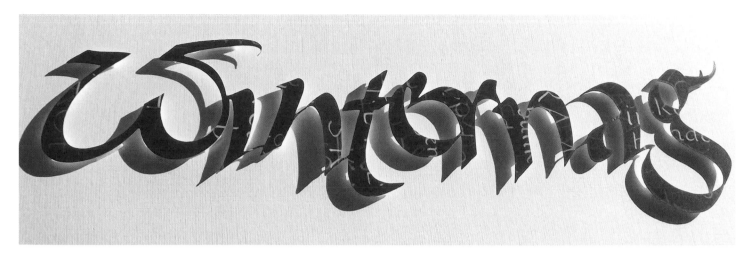

Chinese ink, gouache, and acrylics on commercial coated stock;
lettering in black ink on commercial stock; scanned, vectorized,
and laser-cut from a printed copy of the original collage and floated
onto linen-textured cardstock; 16½ x 11¾in (420 x 297mm)

Text by Eugene Marais.

Chinese ink, gouache, and acrylics on commercial stock;
lettering in black ink on commercial stock; scanned,
vectorized, and laser-cut from black mount board and
floated onto a digitally enhanced print copy of the
original collage; 15¼ x 7in (390 x 180mm)

Text by Arthur Rimbaud.

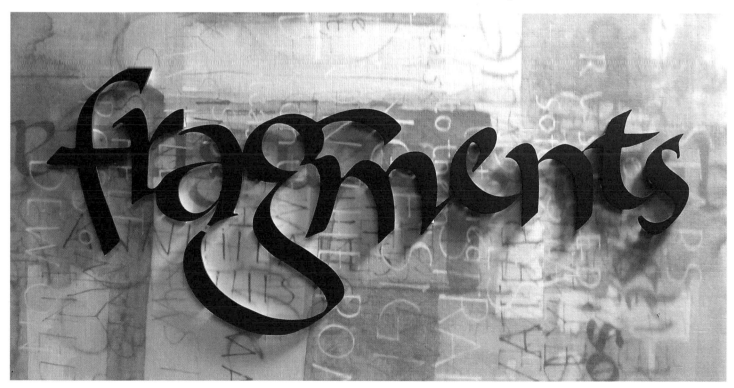

UNCIAL

HISTORY

Uncial emerged in the 4th century CE, and became associated with the spread of Christianity due to its extensive use at this time. Much faster to write than the Roman Square Capital or Rustic, this impressive legible script, with a pen angle of 10° to 20°, was a practical choice for a manuscript bookhand. In use until roughly the 9th century, it underwent a series of developments that reoccurred later with most of the major scripts.

Over time, the simple form of Uncial was modified by a flattening of the pen angle. This gave greater contrast between thicks and thins and made it more ornate, but also made it slower and more difficult to write. The Artificial Uncial emerged, increasingly manipulated, but elaborate and majestic with maximum contrast, ample rotundity, and sharp serifs. However, it was much more time-consuming and impractical as a bookhand. By the 11th century, it had all but disappeared, occasionally popping up as a decorative capital for headings. Uncial is considered to be a majuscule alphabet, having no accompanying minuscule. The Half Uncial is not the minuscule of Uncial, but is a majuscule alphabet in its own right.

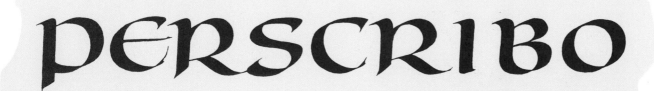

LETTER GROUPS: MAIN CHARACTERISTICS

To understand the shape of the o, imagine a circle inside a square squashed from the top to make a wide, squat circle.

In the letters of the n group, the arches spring from low in the stem, but branch relatively high and symmetrically.

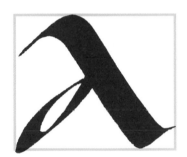

In the letters of the a group, the pen angle is increased for the diagonal strokes.

Key points

- Pen angle: mainly 20°
- x-height: four pen widths
- Ascenders and descenders: one pen width
- Forms: round, wide, and upright
- Arches: spring from high in the stem, mainly symmetrical
- Rhythm: the underlying rhythm is undulating and round with equidistant parallels
- O: based on a circle

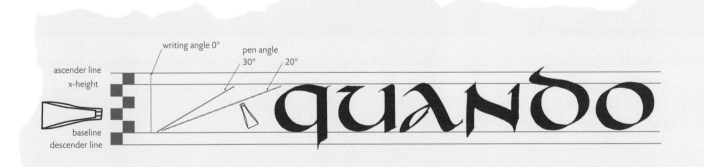

writing angle 0°

pen angle 30° 20°

ascender line
x-height

baseline
descender line

EXERCISES

When you are learning Uncial, begin with exercises designed to prepare you for the angles, strokes, and movement of the hand that are required. Complete about two lines of each exercise consistently before moving on to the next. Start with a Brause 3mm, Speedball C2, or Mitchell 1.

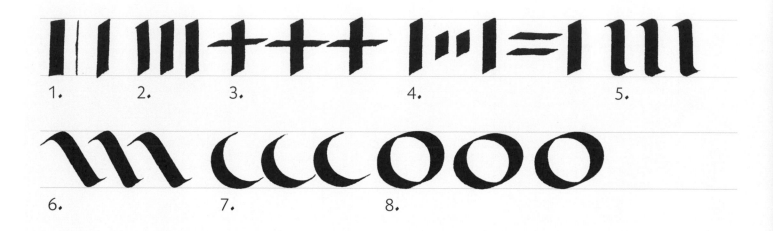

Rule a set of guidelines. Use an x-height of four pen widths, and ascender/descender heights of one pen width. For a ⅛in (3mm) pen, the measurements will be ⅛in (3mm) ascender, ½in (12mm) x-height, and ⅛in (3mm) descender.

1. Establish vertical reference strokes of 0°, 90°, and 20° pen angle. Hold the pen at 20° unless otherwise indicated.

2. Create a picket fence of plain vertical strokes.

3. Make a cross shape. At 20°, horizontals should be noticably thinner than verticals.

4. Make simple vertical downstrokes (two short ones in the middle, then two horizontal strokes bookended by plain verticals).

5. Add gentle arcs to the simple vertical downstrokes for starting and finishing serifs.

6. Holding the pen at 40°, draw a diagonal line. This forms the a and the x.

SSSAAAAANN

9. 10. 11.

COMIC MOO

12.

7. Form the first stroke of the o with a crescent-moon shape leaning backward.

8. Complete the o with a second downstroke overlapping each end.

9. At 30°, start a tight arc and swing around; this forms the middle stroke of the s.

10. At 20°, start with an arc like a narrower version of exercise 7, overlap the second stroke, and continue straight down.

11. At 20°, start a vertical stroke by curving in from the right and overlap the second stroke and continue in an arc.

12. Form letters and words using the exercises.

MAJUSCULES

AABCDEFGHIJKLMN
OPQRSTTUVWXYZ

Uncial alphabet with directional arrows showing the ductus.

Letterforms

After completing the exercises, begin with the letter groups, using the same guidelines. The pen angle ranges from 10° to 40°: horizontal strokes are at 10°, most of the letters are at 20°, and diagonals at 40°.

Spacing

The underlying rhythm is undulating and round with equidistant parallels. To maintain this rhythm, careful spacing is important. As the ascenders and descenders in Uncial are very short, interlinear space can vary depending on what texture is required. For greater legibility, use a longer interlinear space; for a more densely textured body of text, use a shorter space.

TRANS ZEPHRIQUEGLOBUM SCAN
DANT TUA FACTA PER AXEM JAV WYK

Use this pangram phrase as a guide to spacing your words and letterforms.

COCCCCELCCGCCQLDSSS

UNCIAL O GROUP
Hold the pen at 20° unless otherwise indicated. Start o, c, e, g, q, and d with the crescent-moon-shaped stroke. Give c, e, g, and q flattened arcs at the top, add a central crossbar at 10° for e, and a sloping downstroke for g. Start s with the swing of exercise 9, add the flattened top arc, then the bottom one at 10°.

UNCIAL M GROUP

Start M with exercise 10 and overlap exercise 11 to complete it. Spring from the base and branch high and symmetrically. Follow this pattern for H after a simple ascender. Start W with a short horizontal serif, then the first stroke of exercise 10; overlap with a vertical downstroke that swings wide, and overlap it with another curving downstroke. Start U as you did W but finish with a simple vertical. The Y is identical, but continue the downstroke into the descender area. Follow the first curve of U to make the T, but finish with a wide horizontal stroke at the top of the x-height. Make a simple vertical downstroke for I. Begin P with a simple vertical downstroke and continue to the descender area; add a wide curve like the second stroke of O, then travel from the stem to meet the arc. Start R with a downstroke, then spring around into a generous arc tucked in to the stem, and kick out with a diagonal. Begin B with a downstroke but swing out into a wide curve at the base; finish it with a shape like a 3, making it as full as you can.

UNCIAL I GROUP

For the J, make a simple short descender with a gentle curve. Start the second, more Roman, T with a simple vertical downstroke and cap it with a wide horizontal stroke at the top of the x-height. Start L with a simple downstroke in the ascender area and finish with a short horizontal stroke at the base of the x-height. Start F with a simple vertical downstroke and continue to the descender area. At 10°, add the flattened arc at the top and crossbar. For K, start a simple vertical downstroke in the ascender area, change the pen angle to 30° for the diagonal strokes that travel in, meet the stem, and kick back out.

UNCIAL X GROUP

Start X with exercise 6 at 40° and add the opposing diagonal. Begin A in the same way, but add a tight, narrow loop from the center of the stroke at a tangent, touching the baseline. Give the second A a sharper point. Start V at 40° with exercise 6, but veer to the left with a sharp flick, flatten to 30° for the second diagonal, and meet just above the flick, maintaining sharpness. Begin Y like a short version of V, then add the short vertical tail. For Z, make the top and bottom strokes at 10° and the middle stroke at 0°.

Minuscules

Uncial is considered a majuscule hand, although minuscule characteristics are present in some letters. There is no minuscule Uncial form; one of the many pleasures in learning Uncial is that there is only one hand to learn!

VARIATIONS

ΛΛBCDEFGHIJKLMN
OPQRSTTUVVWXYZ

This reference alphabet shows the Uncial from the exemplar.

ABCDEFGHIJKLMN
OPQRSTUVWXYZ

Artificial Uncial or Flat Pen Uncial requires a very flat pen angle of 0° to 10°; all other details are the same.

ABCDEFGHIJKLMNO
PQRSTTUVWXYZ

Italicized Uncial adds certain qualities of Italic—elongation, steeper pen angle, slope, and speed—but maintains the unique shapes of Uncial. Use a pen angle of 40°, an x-height of five pen widths, and ascenders and descenders of one pen width.

◆ PROFILE GEORGIA ANGELOPOULOS

The Arts & Crafts movement is a great influence on my work. I also enjoy studying historical manuscripts and ancient writing, particularly Greek. Understanding how letters evolved is like putting a finger on the pulse of civilization; it furnishes a rich perspective on written communication and a way of understanding the present. The work of calligraphers such as Edward Johnston, Irene Wellington, Ann Hechle, Donald Jackson, Christopher Haanes, Sue Hufton, and Martin Jackson is inspiring. Studying non Western writing traditions is enriching, not just for the visual rewards, but for insights into the process and philosophy of calligraphy itself.

How I approach my work depends on what that work is: whether it is formal, traditional work, what its purpose is, who will see it, and what it is meant to do. After clarifying these intentions, I consider the text, paying close attention to the thoughts and feelings it evokes; this concentration usually yields ideas. Next I consider the script; ideally I aim to express the feeling of the text through the character and quality of the script: will it be upright and commanding, loose and whimsical, strong or soft, rough or smooth? I like to play with the script, hoping to invest it with energy and spirit, and thinking of its pattern and presence in the composition. Then come the other considerations: which tools and materials to use, which colors, illustration, and layout.

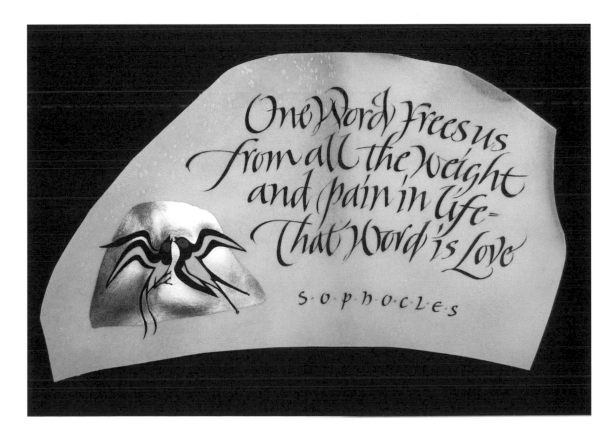

Gouache and 23K moon gold on deerskin parchment; 5 x 7in (127 x 178mm)

I enjoy scribing on three-dimensional objects and parchment, exploring the possibilities of stitching and layering it to create quasi-sculptural constructions. Since I first studied calligraphy, studying historical scripts with the intention of revitalizing them for my purposes has been a focus.

What excites me most about calligraphy is doing something that gives me such pleasure; if my work strikes a chord in others then that pleasure is doubled. I would advise newcomers to calligraphy to remember that although writing may be something we think we know how to do, calligraphy is different—in many ways, it is a specialized form of drawing. It is a discipline and a craft with its own set of skills to be acquired; be patient and do not try to hasten or diminish your progress, but try to enjoy the process.

Gouache and 22K gold on Fabriano Artistico watercolor paper; 6½ x 12in (165 x 300mm)

Text by Albert Einstein.

Gouache, gesso sottile, and 22K gold on Fabriano Artistico watercolor paper; 7 x 16in (128 x 406mm)

Text by Albert Camus.

Painted concave cast cotton form;
acrylic and mineral pigments,
acrylic gouache, and palladium;
11in (279mm) in diameter

Text in Greek from Sappho, c. 600 BCE:
"Love shook me wildly, like a mountain
wind that falls upon the oaks."

CAROLINGIAN

HISTORY

Carolingian, or Caroline minuscule, derives its name from the Holy Roman Emperor Charlemagne, under whose auspices the script developed. Charlemagne's advisor, Alcuin of York, effectively standardized the disparate national scripts in use prior to the early 9th century. Alcuin became Abbot of St. Martin at the monastery of Tours, France; he developed a clear, legible hand and introduced punctuation, use of capitals, and standardized page formatting for manuscripts. An excellent example of Carolingian is the *Grandval Bible*, produced at Tours in the 9th century. The *Ramsey Psalter* (see p. 44) is a significant 10th-century English Carolingian manuscript.

Carolingian was often overlooked as a calligraphic script until Sheila Waters modified the *Grandval Bible* hand for her *Under Milk Wood* project (1961–1978). This work demonstrated the clarity, legibility, and practicality of Carolingian as a bookhand, which needs to remain legible while written at speed and at a relatively small size. Although seldom used as an expressive hand in the way that Italic or Gestural scripts are, Carolingian can lend an oriental flavor to a piece, particularly when combined with oriental-style pointed-brush painting.

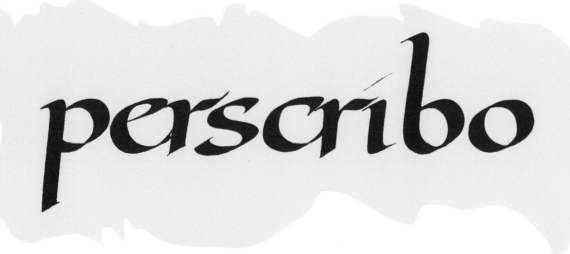

LETTER GROUPS: MAIN CHARACTERISTICS

To understand the shape of the o, imagine a circle inside a square...

...squashed from the top to make a wide, squat circle.

The letters of the n group arches spring from low in the stem, but branch relatively high and symmetrically.

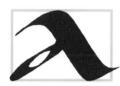

The letters of the a group are diagonals with the pen held at 40°.

Historical Carolingian uses clubbed ascenders. There are two options: the traditional thick club, or the modified Johnstonian hackle-shaped serif.

Key points

- Pen angle: mainly 20° to 25°
- x-height: two and a half pen widths
- Ascenders and descenders: four pen widths
- Ascenders: tall with a simple hook (the traditional form is clubbed)
- Forms: round, wide, and squat with a slight forward slant
- Arches: spring from high in the stem, mainly symmetrical
- Rhythm: undulating with a cursive bounce
- O: a wide, squat circle, wider than it is tall
- Spacing: interlinear space must be generous—at least four x-heights

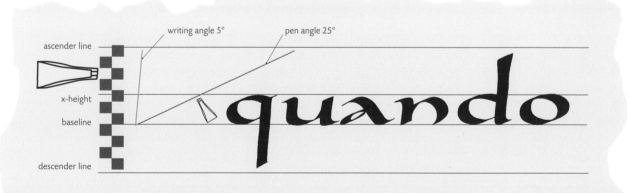

EXERCISES

When you are learning Carolingian, begin with exercises designed to prepare you for the angles, strokes, and movement of the hand that are required. Complete about two lines of each exercise consistently before moving on to the next. Start with a Brause 3mm, Speedball C2, or Mitchell 1.

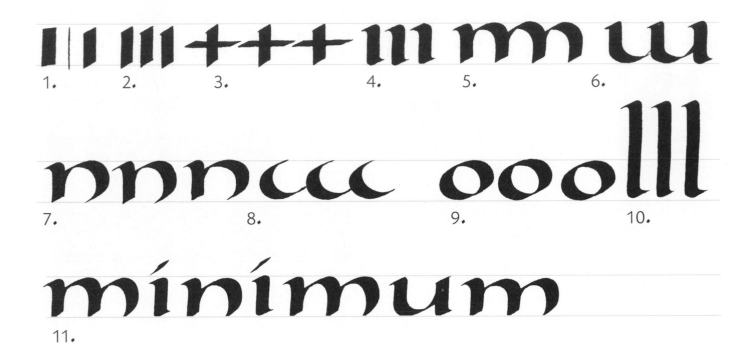

Rule a set of guidelines or use a guideline generator. Use an x-height of 2.5 pen widths and an ascender/descender height of four pen widths. For a ⅛in (3mm) pen, these measurements will be ¼in (6mm) for the x-height and ½in (12mm) for the ascenders/descenders.

1. Establish vertical reference strokes of 0°, 90°, and 20° for the pen angle. Hold the pen at 20° unless otherwise indicated.

2. Create a picket fence of near-vertical strokes.

3. Make a cross shape. At 20°, the horizontals should be considerably thinner than the verticals.

4. To your simple downstroke, add gentle arcs for starting and finishing serifs.

5. Spring from the base of the stem and branch high and symmetrically—this is the cursive bounce rhythm.

6. Allow the downstroke to curve in a wide arc and overlap the finish with the next downstroke.

7. As with exercise 5, spring from the base of the stem but continue around in a circular arc.

8. Form the first stroke of the o with a crescent-moon shape leaning backward.

9. Complete the o with a second downstroke overlapping each end.

10. Keep the tall ascenders consistent and evenly spaced.

11. Form letters and words using the exercises.

abcdefghijkklmn

opqrrsttuvwxyz

Carolinigan minuscule alphabet with directional arrows showing the ductus.

Letterforms

After completing the exercises, begin with the minuscule letter groups, using the same guidelines. The pen angle ranges from $10°$ to $40°$: horizontal strokes are at $10°$, most of the letters are at $20°$, and the diagonals are at $40°$.

Spacing

The rhythm of Carolingian is undulating with a cursive bounce; maintain the regular pattern of equidistant parallels. Interlinear spacing should be at least ten pen widths from baseline to baseline to allow room for the long ascenders and descenders. This aids in legibility and speed of reading, and allows breathing space for the script.

trans zephrique globum scan dant tua facta per axem jav wyk

Use this pangram phrase as a guide to spacing your words and letterforms.

cocccectccqccd

lbjppcoogss

CAROLINGIAN o GROUP Hold the pen at 20° unless otherwise indicated. Start o, c, e, t, q, and d with the same crescent-moon-shaped stroke. Continue a corresponding round shape from the top for the b and p and finish the p with a short flattened arc.

Start g like a short o, add the horizontal stroke at 10°, and swing the descender down and around in one stroke. Give s a similar swing, but tighten it up and add the flattened top arc at 10°.

iirinmllhuujſſfιtlkir

CAROLINGIAN i GROUP Start r, n, and m with the same simple stroke. Spring from the base and branch high and symmetrically. Follow this pattern for h after a simple tall ascender. Create the u by traveling down then up to the top of the x-height, then travel back down the upstroke. For the j, make a simple long descender with a

gentle curve. Start f with an ascender but stop short of the full descender line. Add the flattened arc at the top at 10°. Do the crossbars on f and t at 10°. For the bowl on the k and second r, make the second stroke spring from the base, tuck around a wide teardrop countershape, and spring back out.

ιιιιxwwιy¯zz

CAROLINGIAN a GROUP Start a and x with the same 40° diagonal stroke. For a, add a tight loop; for x, add a second stroke at 30°. Start v, w, and y with the 40° diagonal and give them a sharp flick at the base. Finish y at 40° with a twist at the end of the descender. For z, do the top and bottom strokes at 10° and the middle stroke at 0°.

MAJUSCULES

ABCDEEFGG

HIJKLMMNO

PQRSTTUU

VWWXYYZ

Majuscules

Use Roman majuscules, shown above, with Carolingian minuscules. Uncial forms also work well with Carolingian minuscules. For a stroke-by-stroke breakdown, see the Roman and Uncial sections (pp. 38–39 and pp. 58–59). To customize them for Carolingian, make them five pen widths high with a slight forward slope and a pen angle of around 20° to 25°.

VARIATIONS

Minuscules

abcdefghijklmn
opqrsttuvwxyz

This reference alphabet shows the minuscule from the exemplar.

abcdefghijklmn
opqrstuvwxyz

A more traditional version of Carolingian using clubbed serifs. All other details are the same as the exemplar.

abcdefghijklmn
opqrstuvwxyz

A version of Charles Pearce's Running Book Hand, which appears somewhere between Foundational and Carolingian.
It has a pen angle of 25°, an x-height of three pen widths, and ascenders and descenders of three pen widths.

Majuscules

ABCDEFGGHIJKLMMNO
PQRSTTUUVWWXYZ

This reference alphabet shows the Carolingian majuscule from the exemplar.

ABCDEFGHIJKLMN
OPQRSTUVWXYZ

A majuscule to accompany the traditional clubbed Carolingian minuscule.

ABCDEFGHIJKLMN
OPQRSTTUVVWXYZ

A majuscule to accompany the minuscule version of Charles Pearce's Running Book Hand, with a height of five pen widths.

◆ PROFILE JOKE BOUDENS

I grew up in the medieval city of Bruges. My father, Jef Boudens, was a calligrapher, and my mother an art teacher. They owned an interior decoration shop in the city center where I spent a lot of time hanging around after school. I loved being surrounded by beautiful art and craft objects from all over the world.

Calligraphy was not an option for me at that time—maybe by growing up with it, seeing it every day, I wasn't fascinated by it. I signed up for my first calligraphy workshop in 1987 and became totally addicted to it. For years I focused on different hands, trying to develop better skills. But once I mastered them all, the hardest part was finding my own way in the world of lettering arts. I tried arranging and combining text elements and small drawings, blending them to develop my own style of fine lettering through a variety of media, including gilding.

Besides writing, I also draw letterforms; I am influenced by people such as David Jones and Jean-Claude Lamborot, who build pleasant, warm, kind letterforms that are full of life. Color is very important in my work, although I also like the contrasts and graphic look of black and white. My work includes non-commercial pieces and commercial items.

I made my first concertina book in 2001. The book parts all have the same measurements: 5½ x 29½in (140 x 750mm), folded in three. My approach to both books and unique pieces is the same: there is never a well-defined plan, unless it is a commission. I usually start with one element, calligraphic or illustrative, somewhere in the middle of the paper, and then work toward the sides. This makes the start easy, but it can be a real puzzle as I advance!

Ink, aquarelle, and gouache; detail of panel; 5½ x 10in (140 x 250mm)

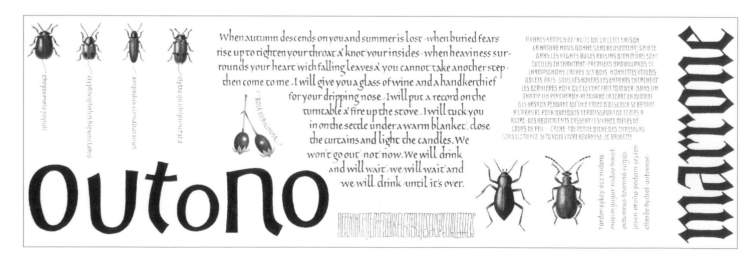

Two important features in my work are beauty and simplicity. I am constantly inspired by beauty in nature. Simplicity is the reason I have always been inspired by outsider art—art made by people who have little or no contact with the mainstream art world, in many cases living on the margins of society, but nevertheless creating things that come straight from the heart. I am very taken by the naiveté and the repetitiveness encountered in such work.

Ink, aquarelle, and gouache on Arches watercolor paper; 10¼ x 13in (260 x 330mm)

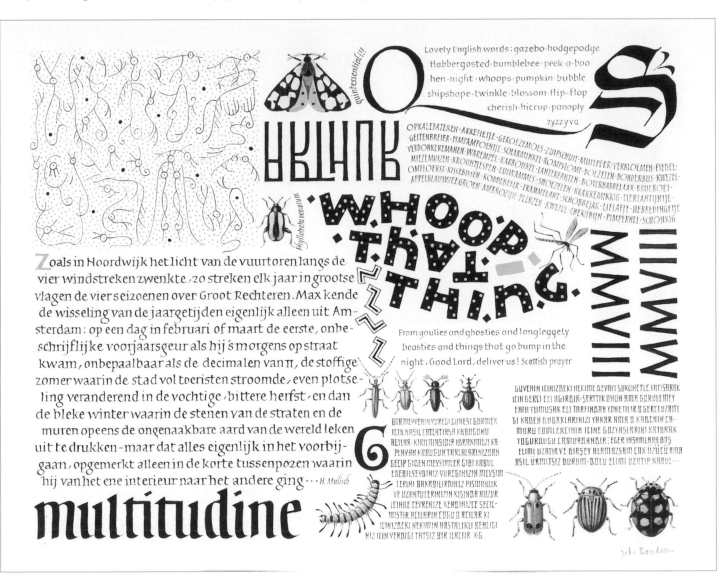

GOTHIC

HISTORY

To understand the evolution of Gothic, it is helpful to return to Carolingian. The Carolingian form changed slowly from the 9th to the 11th centuries from a wide, round, and squat shape to become increasingly vertically compressed. Around the 11th century, the first hints of Gothic emerged with transitional or proto-Gothic scripts, which blossomed into fully developed Gothic in the 12th century. Books of Hours produced in France and Belgium in the 13th and 14th centuries reveal some of the most stunning examples of Batarde or Gothic cursive ever produced. Gothic cursive is a hybrid or bastard script combining qualities of Gothic with a more cursive and therefore faster script. Textura is the most commonly used Gothic script. The elegant Textus Quadratus, the flat-footed Textus Prescissus, and the generously curved Rotunda are three other very distinct forms of Gothic. *The Metz Pontifical* (MS 298 Fitzwilliam Museum, Cambridge University) represents the very zenith of Textus Quadrata, while *The Bedford Hours* is an excellent example of Textura (see Stan Knight's *Historical Scripts*).

Gothic remains popular with calligraphers, who exploit its textural qualities and strikingly graphic form. The design trend of maximalism utilizes ornate Gothic and its decorations in a modern context, which is still apparent in advertising and graphic design.

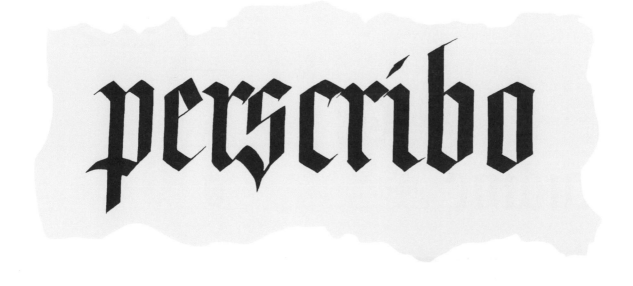

LETTER GROUPS: MAIN CHARACTERISTICS

To understand the shape of the o, imagine a circle inside a square...

...compressed from the sides inside a tall rectangle...

...then remove the curves to make a compressed hexagonal shape inside a tall rectangle.

Key points

- Pen angle: mainly 30°
- x-height: five pen widths
- Ascenders and descenders: two to two and a half pen widths
- Forms: Straight-sided and upright
- Arches: spring from high in the stem
- Rhythm: equidistant parallels
- O: based on a compressed hexagon

The letters of the n group fit inside a tall rectangle.

The letters of the a group also fit inside a tall rectangle.

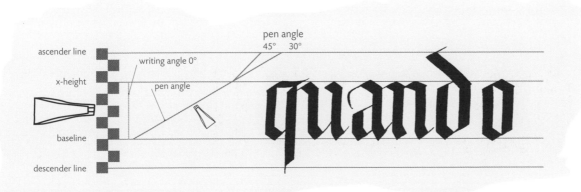

ascender line

writing angle 0°

x-height

pen angle

pen angle
45° 30°

baseline

descender line

EXERCISES

When you are learning Gothic, begin with exercises designed to prepare you for the angles, strokes, and movement of the hand that are required. Complete about two lines of each exercise consistently before moving on to the next. Start with a Brause 3mm, Speedball C2, or Mitchell 1.

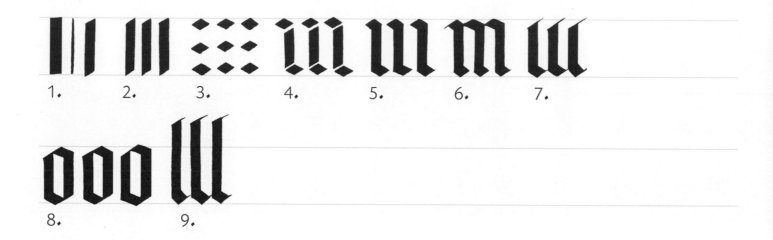

1. 2. 3. 4. 5. 6. 7.

8. 9.

Rule a set of guidelines or use a guideline generator. Use an x-height of five pen widths, and ascender/descender heights of two pen widths. For a ⅛in (3mm) pen, the measurements will be ¼in (6mm) ascender, ½in (12mm) x-height, and ¼in (6mm) descender.

1. Establish vertical reference strokes of 0°, 90°, and 30° pen angle. Hold the pen at 30° unless otherwise indicated.

2. Create a "picket fence" of simple vertical downstrokes.

3. Make three diamonds in a vertical row.

4. Take out the middle diamond, leave a small space, do a short stroke, leave a small space, and finish with a diamond.

5. Take out the spaces to form a diamond-downstroke-diamond shape. This is the key Gothic stroke.

6. Join a series of these key strokes to form an m shape.

noun minimum

million

10.

7. Come in from the right with a hairline, downstroke, diamond to form the first stroke of o.

8. Complete the o with a second downstroke overlapping each end on the other side.

9. Start at the top of the ascender line for a long downstroke to form an l.

10. Combine the exercises to form words.

MINUSCULES

Minuscule alphabet with directional arrows showing the ductus.

Letterforms

After completing the exercises, begin with the minuscule letter groups, using the same guidelines. The pen angle ranges from 15° to 45°: horizontal strokes are at 15°, most of the letters are at 30°.

Spacing

The rhythm of Gothic is equidistant parallels. It is essential to space Gothic accurately, or it loses its textural impact—one of its most distinctive qualities. Paradoxically, the more accurate your spacing is, the harder it is to read! This is clear with the word "minimum" (see exercise 10 on p. 77); however, most words written in Gothic have sufficient variation of form to be readable. To increase legibility, space between letters can be increased very slightly, although too much space can lose the striking effect. If you have a large body of text to write out that needs to be easily read, Gothic is not the ideal script.

Use this pangram phrase as a guide to spacing your words and letterforms. You can see the softening effect of adding curved hairlines to t, a, f, p, r, and e, and a flicked ascender to h and d.

ololelelcqaqgiuygld

GOTHIC o GROUP Start o, c, e, q, g, and d with exercise 7 and finish o with exercise 8. Finish c with a long diamond, extending the hairline. For e, make the second stroke steeper and send a hairline stroke back to the stem. With q, flatten the second stroke, then drop a downstroke to the descender line. Do the same top on the g, but swing the third stroke out and back. Pull a diagonal hairline out from the base of the first stroke until you hit the descender and swing around to meet the third stroke. This should resemble a bell on its side. Start y with a diamond-downstroke-diamond, then finish as you did with g. Begin d like o but start the second stroke at the top of the ascender line, and drop into a downstroke when level with the first stroke.

iinmiuivw

GOTHIC i GROUP Start i with exercise 5, the diamond-stroke-diamond. Add a dot in the form of a short diagonal hairline or a diamond. Start n, m, u, v, and w with the same stroke. Give n two of these and m three, taking care not to overextend the base diamonds as they can be mistaken for u or w. Likewise, with u, v, and w, keep the top diamonds short so they don't join at the top. Give u and v two diamond-downstroke-diamonds, finishing u with a diamond at the base, but without the diamond for v. Do w by overlapping a u and a v.

lhjlbjppſſfit

GOTHIC l GROUP The l is exercise 9; make h the same with a longer diamond; drop into a vertical downstroke veering to the left on a hairline, but stop short of the descender line. Make j a longer version of this stroke extending to the descender line. Start b like l, then do a diamond-downstroke to meet the first. Begin p with a diamond-downstroke that extends to the descender line. The second stroke is identical to b—finish it with a flattened arc at the baseline. Start f at the top of the ascender line and finish at the descender line. The second stroke is a longer diamond sitting along the top; finish it with a crossbar at 20°. Begin t with a downstroke-diamond and finish with a crossbar at 20°.

laaʼsʂ irʀʇ‾7zʐlk

GOTHIC a GROUP Start the a with a hairline stoke at the top of the x-height, then a longer diamond-downstroke-diamond. Join a short downstroke-diamond directly under the first hairline to the stem with a hairline downstroke. The a is a difficult letter to balance as it needs one pen width between the stems. Begin s like a lightning bolt; add the longer diamond topstroke and finish with a strong diagonal with a sharp point. Start r and x with a diamond-downstroke-diamond, then add a thin curve at the base and a crossbar at 20°. Start z with a horizontal at the top, a diagonal, then another horizontal, and finish it with a crossbar at 20°. Begin k with an l, add a tiny z shape at the top, and finish with a downstroke-diamond.

MAJUSCULES

Majuscule alphabet with directional arrows showing the ductus.

Letterforms

Gothic majuscules, unlike most capitals featured in this book, have departed significantly from the parent Roman form. They are elaborate and decorative with letters that are often hard to distinguish from one another. For this reason, it is advisable never to use all majuscules together as you would with Roman capitals. Clearly no one told singer Robbie Williams of this design taboo, as he sports "MOTHER" on one arm and "ILOVEU" on the other in Gothic majuscules stacked vertically, impressively achieving a second design no-no! This has spawned a series of copycat Gothic capital tattoos and I have at the insistent request of a client designed an all-Gothic capitals tattoo myself.

Every calligraphy book has a different version of Gothic minuscules, and this is even more apparent with Gothic majuscules. To some degree, we are able to customize these majuscules to our aesthetic, but we should do so with careful consideration, paying attention to family stroke consistency and legibility. Additional decorative features such as hairlines and hackles, which are usually unique to Gothic, should be standardized within the majuscule—for example, if you use two hackles, make sure all the majuscules have two hackles.

Spacing

This is the same as for the minuscule of this hand—equidistant parallels. Accurate spacing is essential to achieve the characteristic textural impact of Gothic. As discussed under minuscules, the more accurate your spacing, the harder your lettering will be to read. This is clear with the word "minimum" (see exercise 10 on p. 77). Most words written in Gothic have sufficient variation of form to be readable, but you can increase space between letters very slightly if you need to improve legibility. Note, however, that you will lose impact if you add too much space.

GOTHIC M GROUP

N, M, U, V, W, and Y are similar to the minuscules; the main difference is a slight curve to the left on the first downstroke with a long, softened horizontal serif. Make the finishing serifs sharper with an angle change to 45° and use the corner of the pen.

For N, make the second stroke at the top a long flattened one. With M, the middle downstroke has no diamond at the base. Give U, V, W, and Y a long angled stroke at the baseline, and finish Y with a similar descender to its minuscule.

LLLDIBBKRPPNP

GOTHIC L GROUP Start L with a curve to the left, straighten in the middle, and then counterswing to finish at the baseline. The second stroke is a curving horizontal with a twist of the pen to finish on a hairline. Finally, flatten the horizontal stroke at the top with a pen twist to a hairline. Start D in a similar fashion, then swing the last stroke around from the left to meet the second stroke at the baseline. Start B, R, and P with a diamond, a downstroke, and a long, softened horizontal serif. B and R can have a concave or curved top bowl. Relate the second version of P to the N, then finish with the addition of the angled horizontal serif.

CCCGOQT

GOTHIC O GROUP Begin C, G, O, Q, and T with the familiar crescent-moon shape from Roman (p. 38). The second stroke is a simple vertical downstroke that starts at the same point as the first and veers to the left. Finish C with a flatted arc. Give G a flattened arc and a hairline diagonal to the left where it hits the second stroke, then curve back out to meet the first stroke. For O and Q, make their third strokes curve around to meet the first. Finish T with a horizontal stroke at the top.

IHK/AASSIFF7Z

GOTHIC I GROUP Start I, H, and K with a horizontal serif at the top, downstroke, and horizontal serif at the base. For H, make an identical stroke then add a crossbar. Give K a diagonal that meets the stem just above the middle and kicks out farther than the top. Begin A with a diagonal at 45° and a flattened horizontal serif at the base. A longer horizontal serif at the top drops into a diagonal with a sharpened diamond finish then adds a crossbar at 20°. For S, swing to the left and counterswing to the right. Start the second stroke at the top for a concave arc, make a diagonal hairline to the left, then a counter-convex arc following the first stroke. Overlap the first stroke with an angled arc to finish. Treat X and Z as larger versions of the minuscules.

VARIATIONS

Minuscules

abcdefghijklmnopqrstuvwxyz

This reference alphabet shows the simple Textura Gothic from the exemplar.

abcddefghijklmn
opqrstuvwxyz

The Rotunda minuscule retains angled curves on many letters, with flat tops and feet, and sharp-angled finishes on certain letters. This is achieved by filling in the corner of the letter with the edge of the pen, or changing the pen angle from 0° to 30° (a more difficult option). The x-height is shorter than Textura at four pen widths, and the letters are wider. Ascenders and descenders remain at two pen widths, and the pen angle is also mainly 30°.

abcdefghijklmn
opqrstuvwxyz

Batarde minuscule has an x-height of four to five pen widths, depending on your preference. Ascenders and descenders are two to two and a half pen widths, and the pen angle is mainly 30° with some pen manipulation.

Majuscules

ABCDEFGHIJKLM
NOPQRSTUVWXYZ

This reference alphabet shows the simple Textura Gothic from the exemplar.

ABCDEFGHIJKLMN
OPQRSTUVWXYZ

The Rotunda majuscule height is six pen widths and the pen angle is mainly 30°.

ABCDEFGHIJKLMN
OPQRSTUVWXYZ

Batarde majuscule has a height of six to seven pen widths, depending on the x-height of the minuscules.
The pen angle is mainly 30° with some pen manipulation.

PROFILE JULIA BAXTER

My biggest influences are contemporaries who use creative calligraphy, such as Thomas Ingmire, whose works challenge me to take risks. I am equally inspired by examples of highly skilled lettering that celebrate the discipline of this craft. Words with an atmospheric resonance that I respond to are a source of inspiration. An element that I see in a painting, an image, a landscape, or an element of a contemporary's work might kick off a design idea to explore.

Typically my work begins with a rough pencil sketch, to record words or imagery or a scribble to indicate a challenging idea based on pure lettering. This allows me to capture the whole design with room for exploration and keep focused on my first thoughts. The next stage involves making decisions about scale, materials, tools, or lettering style(s). If imagery is involved, I often use visual references or my own imagination. Unless I am working on a commission with a large amount of lettering requiring a rough proof and pasteup, I generally prefer to work directly on the final piece without a rough.

Color and texture have always excited me and, combined with the discipline of my graphic design training, have given my pieces an increased strength and structure and a confidence with design and layout. Because I have always painted and drawn, the bringing together of imagery with text was never far away.

The Italic script was the first one I felt confident with, having been taught Italic handwriting at primary school. When I first began learning this hand, I wasn't enamored with its dated and dominant character. This changed when, triggered by a workshop led by Prof. Ewan Clayton, I saw the lively and decorative possibilities of a modern Gothic based on Textura script; I have enjoyed celebrating its qualities and challenges as a modern script even though it echoes a medieval one. I'm looking forward to more challenges with modern Gothic and acquiring a deeper knowledge of the traditional skills of the medieval scribe. I also want to explore working on canvas and alternative surfaces.

I would advise new students of calligraphy to continue with beginners' classes for at least two years and consider joining a local group that meets sociably as well as running regular workshops. Sign up for residential courses and look at the work of as many contemporary calligraphers as possible for inspiration.

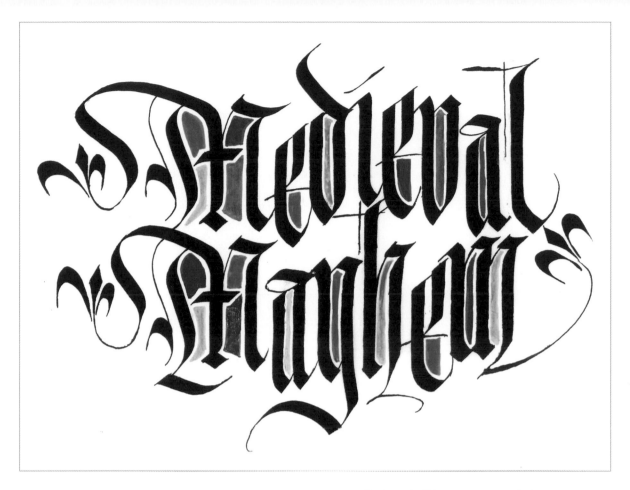

*Gouache on layout paper;
brushes and metal nib;
10 x 5in (254 x 127mm)*

Logo design commission for
reproduction.

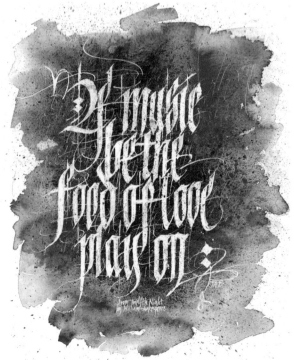

*Watercolor and resist on
watercolor paper; Automatic pen;
12 x 10in (305 x 254mm)*

VERSALS

HISTORY

Versals are built-up compound capitals based on Roman forms. Although they are generally executed with a fine broad pen, Versals are drawn and filled in rather than done in a single stroke. They can also be considered double-stroke letters and left open, although this reveals any inconsistencies for all to see. Traditionally, there was no minuscule Versals form, only majuscules, although the principles could be applied to a basic Foundational minuscule form if desired. They can be just as effectively created with a pointed pen or brush; on challenging substrates such as fabric, wood, stone, glass, or plastic, a pointed brush is often a more viable option.

Versals are a wonderfully elastic letterform. They can range from a thin, virtually monoline form, to a traditional filled-in form with hairline serifs, to double strokes filled with decorative patterns, and, at the other extreme, the almost comically rotund and very distinctive Lombardic shape. As with Italic, the versatility of the hand lends itself to a wide range of applications. Not only are Versals the ideal accompanying decorative capital for virtually every hand in more formal pieces, they can also be an expressive modern letterform to suit many texts. However, bear in mind that for long texts Versals will take much longer to do than single-stroke letters.

PERSCRIBO

Versals are built up by drawing them in a fine pen. They can be left open or filled in.

The Versals O is constructed with four strokes and is based on a circle—Versals are based on Roman proportions.

The Versals N is constructed with nine strokes and occupies three-quarters of a square.

The Versals A is constructed with eight strokes and occupies three-quarters of a square.

Key points

- Pen angle: 0° to 10°; occasionally 90°
- x-height: about 24 pen widths, but this can vary
- Forms: upright with a geometric basis
- Arches: symmetrical
- Rhythm: the space between letters is based on the volume of the internal space
- O: based on a circle

HANDS

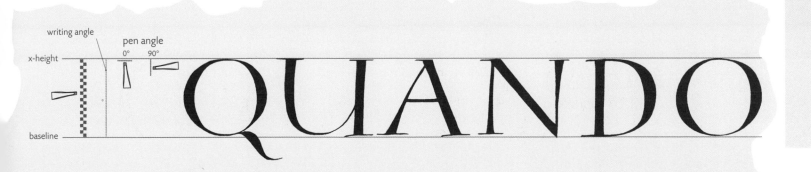

EXERCISES

When you are learning Versals, you need to begin with exercises designed to prepare you for the angles, strokes, and movement of the hand that are required.

To begin, rule a set of guidelines or use a guideline generator. Use a height of ¾in (20mm). Complete the skeleton Roman practice from the Roman section (p. 36) before proceeding with Versals. As two fine parallel strokes form the outer structure of the letter, Versals require accuracy and consistency. Start with a small broad-edged pen: Brause 1mm, Speedball C5, or Mitchell 4.

1. Holding the pen at 0°, create a picket fence of simple vertical downstrokes.

2. Turn the pen to 90° and draw a horizontal line using the thickest part of the pen along the top of the x-height. Continue stacking horizontals underneath until you reach the baseline.

3. Turn the pen back to 0° and draw horizontals on the thin of the pen—this is much harder.

4. Holding the pen at 0°, start the basic Versals stroke sequence with a short horizontal stroke.

5. Drop a thick vertical downstroke from about a third along the thin stroke.

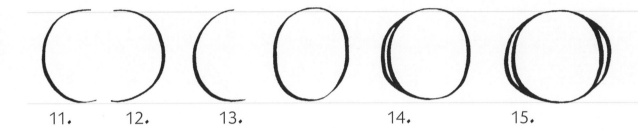

11. 12. 13. 14. 15.

6. Add another vertical downstroke parallel to the first.

7. Finish it with a matching short horizontal stroke: this is the standard Versals keystroke.

8. Add a third downstroke to fill the letter in (Versals can be left open or filled in).

9. Holding the pen at 0°, pull a diagonal from left to right and keep the pen set at 0°.

10. Add a parallel stroke—this is a difficult exercise.

11. Holding the pen at 10°, draw a half-circle from top to bottom.

12. Do the same thing in reverse.

13. The o sequence starts with exercise 11, then overlap it with exercise 12 to form the inside of the letter.

14. Add the left outside arc.

15. Add the right outside arc, taking care with the joins.

MAJUSCULES

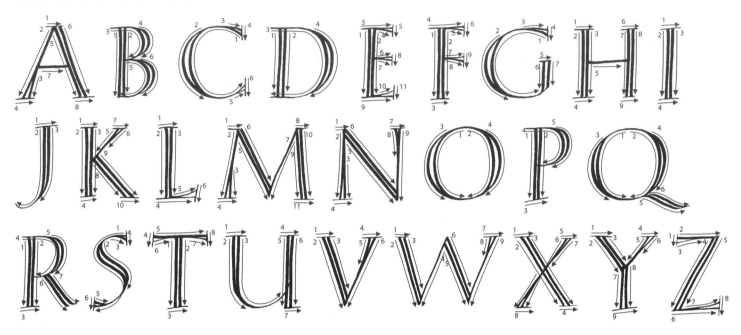

Versals alphabet with directional arrows showing the ductus.

Letterforms

The Versals on the exemplars are left open so you can clearly see the construction; however, you may choose to fill in the forms with a third (and sometimes fourth) stroke. Both forms are equally acceptable, but remember that the open version will reveal any inconsistencies in execution. In these versions, the ends are capped with hairline serifs—an exception is the third variation, where the thin modern Versals have none.

Spacing

Use Roman proportion and spacing for Versals. Use the volume of the counterspace as an indicator for the amount of space between letters.

TRANS ZEPHRIQUE GLOBUM
SCANDANT TUA FACTA PER
AXEM JAV WYK

Use this pangram phrase as a guide to spacing your words and letterforms.

VERSALS M GROUP

VERSALS M GROUP Begin M with a slightly angled downstroke (somewhere between the slope of an A and an N) and thicken slightly at the end. Add a V shape with exercise 10 and an opposing diagonal slightly thickened at the top; finish with a double downstroke that mirrors the angle of the first stroke. Create a W by adding two Vs.

VERSALS B GROUP

VERSALS B GROUP Start B, P, and R with the standard keystroke. For B and R, add a short bowl at the top, inside arc then outside arc. To finish B, add a slightly larger bowl, inside then outside arc. To finish R, add a short diagonal double-stroke leg. Cap with hairline serifs. For P, make the top bowl slightly larger. Begin E, F, L, and K with the standard keystroke. For E, F, and L, add exercise 2 at 90° with a slight thickening at the end—two for E, three for F, one at the base for L, and cap with hairline serifs. Finish K with a double-stroke diagonal coming in to just above the center, then kick out with another. Start S with a curve and countercurve, then add another parallel curve to make it a double stroke. Extend, slightly flatten and thicken the start and finishing strokes, and cap with hairline serifs. I is the simplest Versal letter of all—the standard keystroke. For J, make a stroke like the second side of the U, but allow it to go below the baseline. Cap the top with a hairline serif.

Minuscules

Traditionally, there was no minuscule Versals form, although the principles of Versals construction could be applied to a basic Foundational minuscule form if desired.

VERSALS H GROUP

VERSALS H GROUP Start H with the standard Versals keystroke (exercise 7), repeat, and add a crossbar with the pen held at 90°. Begin A with a diagonal to the left, then add a slight thickening about a quarter from the baseline. Add exercise 10, a double-stroke diagonal the other way, then a crossbar at 90°. Finish off with hairline serifs closing the open ends. Start V with exercise 10, then add the first strokes of A, but with the thickening at the top of the letter. N begins with exercise 5 and a thickening at the baseline similar to the A, but more vertical. Add exercise 10, then finish with exercise 5 with thickening at the top. Start T with the standard keystroke (exercise 7),

add exercise 2, the horizontal stroke at 90°, add a slight thickening at each end, and cap with a hairline serif. Start U with a double downstroke that curves gently to the right and finishes on the baseline. Meet it in the middle from the other side and give the top a slight thickening stroke. Begin X with exercise 10, the double diagonal, then cross it through the center with an opposing diagonal. Thicken each end slightly and cap each open end with a hairline serif. Start Y with a short V, then add a short double downstroke. Begin Z with exercise 2, a short horizontal at 90°, and thicken from the left side. Add a reversed exercise 10 then a reversed first stroke.

VERSALS O GROUP

VERSALS O GROUP Begin the O and Q exactly as described in the exercises: Start with exercise 11, then overlap it with exercise 12 to form the inside of the letter, add the left outside arc then the right outside arc, taking care with the joins. For C and G, start with exercise 11, but extend the top and bottom arcs out further. Add the outside arc, exercise 14, extending and slightly flattening these arcs as well, then finish with hairline strokes at 90° to close off the edges. Finish the G with twin vertical strokes that begin about halfway up the letter and level with the top serif. Start D with the standard Versals keystroke (exercise 7), then add exercise 12—first an internal half-circle, then the external half-circle.

VARIATIONS

ABCDEFGHIJKLMN
OPQRSTUVWXYZ

This reference alphabet shows the Versals from the exemplar.

ABCDEFGHIJKLMN
OPQRSTUVWXYZ

Lombardic Versals are full-bodied with exaggerated curves based on a generous oval shape.

ABCDEFGHIJKLMN
OPQRSTUVWWXYZ

These thin modern Versals have no hairline serifs.

◆ PROFILE GEMMA BLACK

Growing up in a bulging household of nine children, plus parents, we were surrounded not only by prints of famous artworks but by some fabulous originals as well. Books filled the shelves, among them many art books. Drawing was my thing and from the age of about 14, I was designing posters for my father's surgery.

These days I concentrate on three things: mindfulness, personal technique, and structure. Versals, accompanied by support hands, feature in my work in all their forms, from the playful and gestural through to the formal. I try to practice mindfulness every day. I find this stimulates my mind and my subsequent actions and works. Ideas and concepts arrive as if out of nowhere, and as long as I have a notepad handy they sometimes come to be a calligraphic reality.

Like all things that evolve, my progress in calligraphy has been varied. Always a student of letters, I work with as many tutors as I can. I take from them a little of their essence and mix it with my own. I spit out the bad and hopefully retain the structurally and technically good.

Seeing, and hopefully creating, good structure excites me in lettering. Good letterform structure is essential, but more and more I am concentrating on the geometric structure and process of the whole work. To see sound geometry in a piece of work excites me. A simple line well placed on a canvas will do it for me, but a complex whole, well proportioned and balanced on a page, can be stunning. I see myself moving toward simplicity and pureness of letterform. Mastering a good "s" is one of my challenges— I am not there yet!

I always do roughs for commissioned work. I have a brief and sometimes a quite limited process to follow. The approach is usually straightforward. The approaches vary for work of my own. The creative process may be a moment-by-moment inspired technical application. Time and varying thought processes come into play here. Other works may be a harder slog, where I need to create rough after rough until the piece is visually and structurally right.

The best advice I can give anyone wanting to improve their calligraphy is to learn to draw and to draw every day. Drawing is the basis for everything we create with our brushes and pens. Becoming well versed in formal hands will give you an ongoing folio of strong forms to fall back on. Keep learning, studying, and learn good research methods, and you will create wonders.

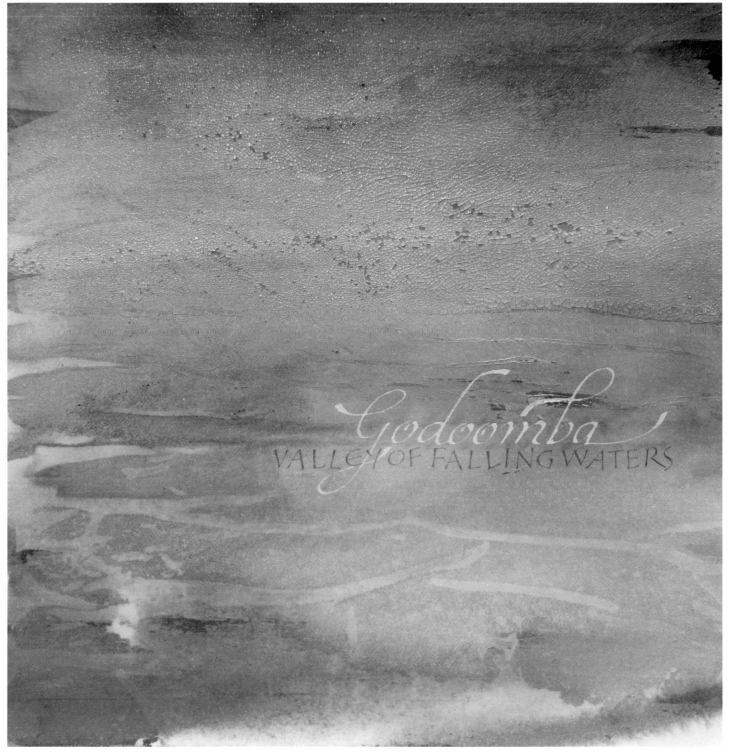

Godoomba
VALLEY OF FALLING WATERS

Ink ground on 300gsm Arches cold press paper;
pen and white ink; 11 x 15in (280 x 380mm)

NEULAND

HISTORY

Typefaces developed from historical hands and were intended to imitate the scripts found in manuscripts. More recently, this procedure has been reversed, with some hands based on typeface forms achieving an accepted calligraphic status. One such hand is Neuland. Neuland was developed by Rudolf Koch (a calligrapher and type designer) in 1927. It requires considerable manipulation: Unlike many hands, where manipulation exaggerates contrast between thick and thin strokes, Neuland requires relative uniformity of stroke width. This is achieved by turning the pen so most of the strokes are the thickest width of the pen, which leads to a very solid, chunky letter.

Following the definition of blackletter, most often used when referring to Gothic, Neuland fits the category as it has far more blackness or letter than white space or counterspace. It also has a particular quality of emphasis, not unlike using a bold typeface to indicate importance.

One of the interesting qualities of Neuland is its rustic, handmade aspect. It retains a unique sense of immediate, organic energy and responds actively to the other letters, not striving for mechanical perfection and smoothness. Neuland is often used in the background of layered pieces, as it provides a striking contrast to more delicate hands.

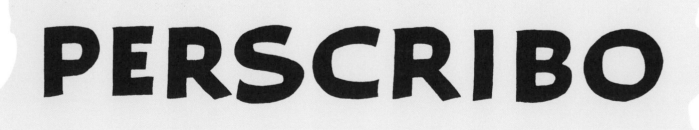

LETTER GROUPS: MAIN CHARACTERISTICS

Neuland letters, although based loosely on Roman proportions, tend to fit into a square.

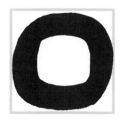

The O has a slightly squared-off form and may be slightly wider than a square.

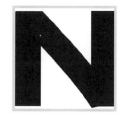

The N occupies the full square.

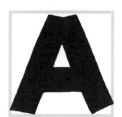

The A occupies the full square.

Key points

- Pen angle: varied—mainly 0° and 90°; also 30° and -30
- x-height: four pen widths
- Forms: thick, chunky, and upright with overlapped strokes
- Rhythm: close—tighter than Roman
- O: based loosely on a circle

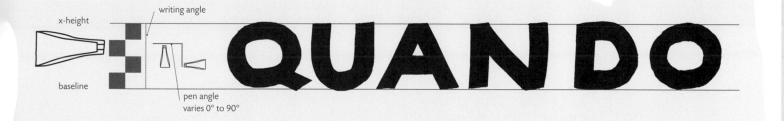

EXERCISES

When you are learning Neuland, you need to begin with exercises designed to prepare you for the angles, strokes, and movement of the hand that are required. Complete about two lines of each exercise consistently before moving on to the next. Start with a Brause 5mm or Speedball C0, or anything larger, such as an Automatic, Coit, or Pilot Parallel pen 6mm. A Neuland shape executed with a round-ended nib such as a Speedball B series will give a different look, more like a thick monoline Roman.

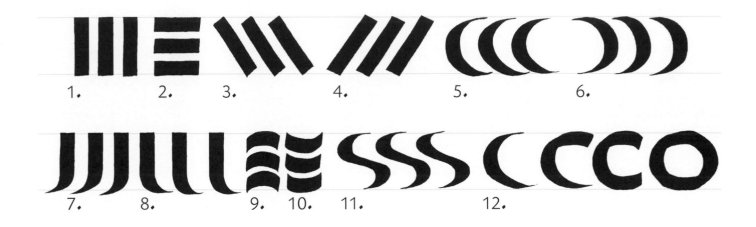

To begin, rule a set of guidelines. Use an x-height of four pen widths. For a ¼in (6mm) pen, this will be ¾in (20mm).

1. Holding the pen at 0°, create a picket fence of simple vertical downstrokes.

2. Turn the pen to 90° and draw a horizontal line using the thickest part of the pen, along the top of the x-height. Continue stacking horizontals underneath until you reach the baseline.

3. Turn the pen to 30° and pull a diagonal from left to right.

4. Changing your pen to -30°, pull a diagonal stroke the opposite way.

5. Holding the pen at 0°, make a half-circle shape, aligning top to bottom.

6. Still at 0°, make a matching half-circle going the other way.

7. At 0°, do a simple vertical downstroke, then taper into a slight curve at the baseline.

8. Still at 0°, do a matching downstroke and taper going the other way.

9. Holding the pen at 90°, draw a convex horizontal arc.

10. Holding the pen at 90°, draw a concave horizontal arc.

11. At 0°, do a curve and swing back into a countercurve.

12. Make an O in four strokes starting with exercise 5, add exercise 9, then exercise 10, and join up with exercise 6.

Neuland alphabet with directional arrows showing the ductus.

Letterforms

Like Versals, Neuland is a compound letterform rather than a single-stroke form, with a range of different pen angles. Letters such as O require at least four overlapping strokes, and all curves require extra strokes. You may need to neaten your joins with the corner of the pen; sometimes additional overlapping strokes are required to even out the thickness of the letters. The second variation presented is a simpler form of Neuland, which uses mainly $0°$ and $90°$ pen angles and so has a lighter texture.

Spacing

Neuland spacing, like Roman, relies on volume rather than mechanical distance between points. As Neuland is intentionally dense, a fairly tight spacing is required to keep interletter spacing consistent with the volume of the counter.

TRANS ZEPHRIQUE GLOBUM
SCAN DANT TUA FACTA
PER AXEM JAV WYK

Use this pangram phrase as a guide to spacing your words and letterforms.

CCCGOQILED

NEULAND O GROUP Holding the pen at 0°, begin O, C, G, and Q with exercise 5, a half-circle shape. Turn the pen to 90° and add the top stroke (exercise 9), then the bottom stroke (exercise 10). For G, turn the pen to 0° to finish with a thick downstroke that joins the bottom curve. For O and Q, turn the pen to 0° and join the top and bottom strokes (exercise 6). Add overlapping strokes to neaten the curves. To finish Q, turn the pen to 30° and add a short diagonal tail. Start D at 0° with a thick downstroke (exercise 1), turn the pen to 90° for a top arc (exercise 9) and a bottom arc (exercise 10), turn the pen back to 0°, and finish with exercise 6, a half-circle that overlaps top and tail strokes.

IIIH/ΛΛWINN
LU\X\VY⁻7Z

NEULAND H GROUP Holding the pen at 0°, begin H with exercise 1, two thick downstrokes, then turn the pen to 90° for the crossbar (exercise 2). Start A with exercise 4, a diagonal at 0°, add a matching diagonal on the other side (exercise 3), then turn the pen to 90° for the crossbar (exercise 2). Start V at 30° (exercise 3) and draw a diagonal to the baseline, then turn the pen to -30° and meet it in the center (exercise 4). For N, hold the pen at 0° for a thick downstroke (exercise 1), turn the pen to 30° for the diagonal and pull it across to the bottom of the baseline (exercise 3), then back to 0° for the final downstroke (exercise 1). Begin T at 0° with a thick downstroke (exercise 1), then turn to 90° for the top bar (exercise 2). Start U at 0° with a downstroke that curves to the right (exercise 8). Turn the pen to 90° for a thick bottom arc (exercise 10), then back to 0° for a downstroke to join at the base (exercise 7). Start X by holding the pen at 30°, draw it down diagonally (exercise 3), then turn the pen to -30° to cross right through the middle (exercise 4). At 30°, start Y with a tiny V at the top, then turn to 0° to add the final stroke. Hold the pen at 90° for the first stroke of Z (exercise 2), turn to 0° for the diagonal (exercise 4), then back to 0° for the final stroke (exercise 2).

ICEPBIFPRICEF

ILIYKSSSIJJ

NEULAND B GROUP Holding the pen at 0°, begin B, P, and R with a thick downstroke (exercise 1), turn the pen to 90° for the top and bottom strokes, which have a slight curve inward (exercises 9 and 10). Still at 90°, add the middle stroke, which curves up and at 0°, join the top and middle strokes with an arc, which completes P. Do the same at the bottom to complete B. For R, turn the pen to 30° and kick out from the bowl (exercise 3). E, F, and L begin at 0° with a thick downstroke (exercise 1), then turn the pen to 90° for horizontal strokes (exercise 2)—three for E, two for F, and one at the bottom for L. K begins at 0° with a thick downstroke (exercise 1). Turn the pen to -30° for a diagonal that meets the center of the stem (exercise 4), then turn to 30° for another diagonal that finishes at the baseline (exercise 3). Begin S at 0° for a curve and countercurve (exercise 11), turn to 90° to add the top arc (exercise 9), and stay at 90° to add the bottom arc (exercise 10). Start J at 0° with a thick downstroke, then swing onto a curve to the left (exercise 7). Turn the pen to 90° to curve back into the stem (exercise 10).

IANMIVNW

NEULAND M GROUP To make an M, hold the pen at 0° and make a slight diagonal to the left, then turn the pen to 30° (exercise 3) and make a diagonal to the right (exercise 3). Go to -30° for the third stroke (exercise 4) and then back to 0 for the final stroke. Form the W by making two Vs, first stroke 30° diagonal (exercise 3), second stroke -30° (exercise 4), third stroke 30°, and the final stroke -30°.

Minuscules

Rudolf Koch's Neuland has been used as a majuscule, although the principles of Neuland construction could be applied to a basic Foundational minuscule form if desired.

VARIATIONS

ABCDEFGHIJKLMN
OPQRSTUVWXYZ

This reference alphabet shows the version of Neuland from the exemplar.

ABCDEFGHIJKLMN
OPQRSTUVWXYZ

This variation of Neuland is the other commonly used version where the pen is kept
at 90° or 0°. It has a lighter texture than the turned-pen version from the exemplar.

ABCDEFGHIJKLMN
OPQRSTUVWXYZ

Neuland can work as an outline form for a much lighter texture. Use a nib such as a Brause 3mm or 4mm,
a pointed pen, or even a fineliner such as a Pigma Micron or Copic marker. Letters can be traced to begin with:
A good technique for drawing Neuland outlines freehand is to visualize the solid letter on the page and imagine
drawing around it. Outlined Neuland can take on its own form, as the curves are not restricted by your ability
to manipulate a broad pen.

PROFILE PETER EVANS

My art teacher at school introduced me to lettering with a pen and also encouraged me to go to art school. I followed the art-school curriculum for the first two years; this included drawing, design, anatomy, and the craft of silversmithing, from which I learned about using, adapting, and making tools, engraving in metal, and the design process. After this I undertook National Diplomas in Design in Writing, Illuminating, and Lettering; Lettercutting in Stone; and Engraving Lettering on Metal. The art school principal demonstrated a Foundational alphabet, capitals, and minuscules. He had attended Edward Johnston's classes while studying at the Royal College of Art. I worked for the next two years on my own with Johnston's *Writing, Illuminating, and Lettering* as my teacher and guide. I still have the demo alphabet and the book.

I continued on my own work, making sculpture, watercolors, and calligraphic work, and over the years have completed several formal calligraphic commissions. I have worked with various alphabets as a basis for multilayered works. To me, calligraphy is a branch of drawing. I prefer to work on full-sized hot-pressed watercolor paper stretched on boards, and usually have four or five on the go at any one time.

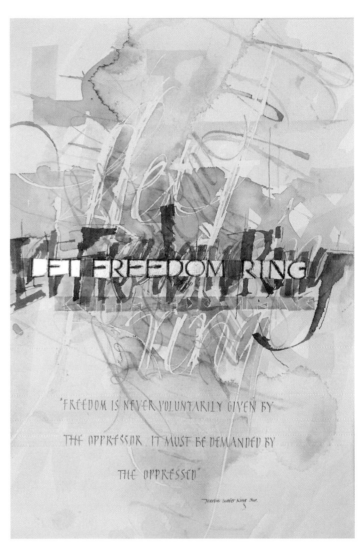

Watercolor, gouache, and gold on washed-off paper; homemade pens; metal nibs; 13 x 19¾in (330 x 500mm)

103

Watercolor washes, panels of lettering, resist and washing off, scratching and scrubbing the surface, and experimenting with colors and textures are often a starting point. I rarely prepare roughs, as I prefer to work spontaneously and intuitively, freely responding to text. I may work with pen or brush, but I also like to use my own homemade tools—folded cola pens, extremely large folded brass pens—and will also use whatever comes to hand, such as rollers, spray guns, sponges, or sticks. I enjoy the expressive possibilities of the 26 letters in words and also as abstract shapes.

If you are starting calligraphy, learn how to analyze a script using Johnston's method. It is a skill that will give you everything you need to make your own interpretation of a script. Look at the work of skilled calligraphers with a critical eye and investigate other art forms such as painting, sculpture, and textiles. Drawing is one of the most useful skills for calligraphers: Draw as often as you can, but most of all learn to look and see what is really there. Freely copying other peoples' work is fraught with danger unless a formal analysis is made first—follow Johnston's advice!

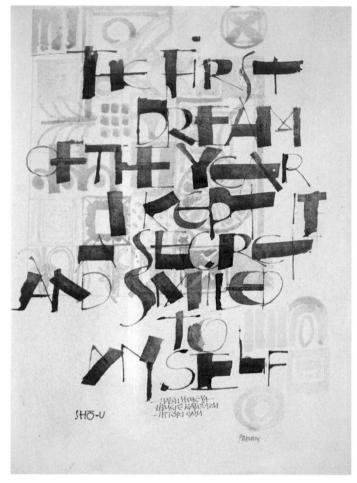

Watercolor on paper; homemade folded pen; 10 x 14in (260 x 360mm)

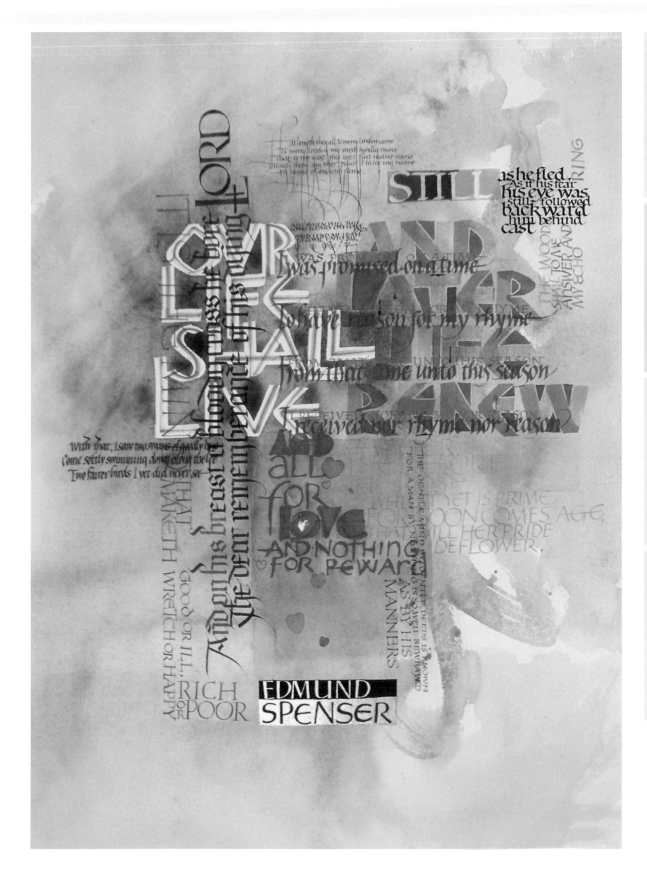

Watercolor, gouache, and gold on paper; homemade pens; brush; metal nibs; 20½ x 27½in (520 x 700mm)

ITALIC

HISTORY

The Italic hand originated in 15th-century Italy. It evolved from the highly legible and rounded 10th-century Carolingian hand, but acquired many of its characteristics as a result of speed of writing: the slight forward slope, and the elongated and compressed shape. It was adopted in the chanceries of Rome and Venice in the mid-15th century and became known as the *Cancellaresca corsiva*, or Chancery Cursive. This is the model for the Italic hand in use today.

Writing manuals by Italian masters began to appear from 1514 and, due to the invention of the printing press, multiple copies became available to a wider range of the population than monks and clerks. The production of deluxe editions of manuscripts caused the writing masters of the day to compete with each other for virtuosity. Significant writing masters of the era include Fanti, Arrighi, Tagliente, Cataneo, Palatino, Cresci, Yciar, Brun, Amphiareo, Lucas, and Mercator. I recommend studying and analyzing their work, using the method described on pp. 22–25.

LETTER GROUPS: MAIN CHARACTERISTICS

To understand the shape of the o, imagine a circle inside a square...

...that is compressed into a rectangle...

...and tilted to become a parallelogram.

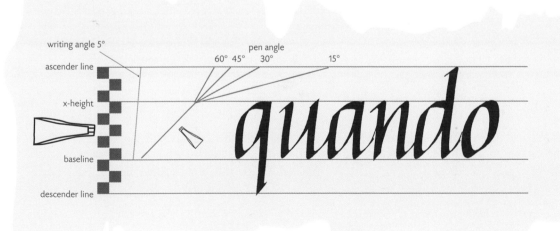

The a form is based on a triangle with the corners rounded off. The underlying shape of the a group (a, q, g, and d) is the same—only the finishing stroke changes.

The letters of the n group all have the second stroke starting at the bottom of the first stroke and traveling about halfway up before branching out.

Key points

- Pen angle: mainly 45°
- x-height: five pen widths
- Majuscule height: seven pen widths
- Ascenders and descenders: three pen widths
- Forms: compressed and sloping
- Arches: spring from low in the stem
- Rhythm: equidistant parallels
- O: based on a compressed and tilted ellipse
- A: a rounded-off triangle

HANDS

writing angle 5°

ascender line

pen angle
60° 45° 30° 15°

x-height

baseline

descender line

107

EXERCISES

When you are learning Italic, you need to begin with exercises designed to prepare you for the angles, strokes, and movements of the hand that are required. Exercises 1 to 5 will help you establish the correct pen angle of 45°; exercises 6 to 19 will help you master the constituent parts of many letters. Start with a Brause 3mm, Speedball C2, or Mitchell 1.

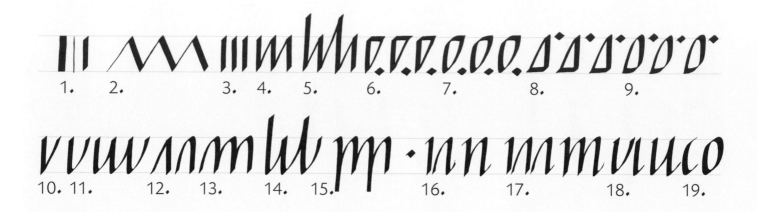

To begin, rule a set of guidelines or use a guideline generator. Use an x-height of five pen widths, and ascender and descender heights of three pen widths. For a ⅛in (3mm) pen, these measurements will be ⅝in (15mm) for the x-height, and ⅜in (9mm) for the ascender and descender.

With the exception of exercises 5, 14 (ascender), and 15 (descender), all of these exercises occupy only the x-height area.

Note that while many of these exercises appear to be done as a continuous line without pen lifts, stopping after each unit is recommended to maintain a consistent pen angle. For a smooth join, overlap the next stroke over the previous. Most exercises have a sharp form followed by a rounded-off form and are inversions of each other—this assists with consistency.

1. Establish vertical reference strokes of 0°, 90°, and 45° pen angle. Hold the pen at 45° unless otherwise indicated.

2. The zigzag exercise shows the effects of holding the pen at 45°. The first stroke of the zigzag is a thin hairline and the second a very thick stroke.

3. Create a picket fence of simple vertical downstrokes.

4. Add an upstroke to exercise 3. This will be thicker than a hairline, as the stroke angle is about 60° while the pen angle is 45°.

5. Extend every first and third stroke to hit the ascender line. Try to maintain even spacing.

6. Make a triangle taller than it is wide in one stroke, starting at the top right corner and moving anticlockwise to enclose the shape. This exercise forms the base triangle shape of a, q, g, and d.

7. Soften sharp corners and curve the final part of the upstroke into a gentle arc.

8. Start at the bottom left corner and move clockwise to enclose the shape in one stroke. This exercise forms the base triangle shape of b and p.

noun union moon minimum

20. 21. 22. 23.

9. Start with a more vertical arc but soften the sharp corners.

10. Start with a downstroke, then go up all in one stroke.

11. Round off this shape slightly.

12. Start with an almost vertical upstroke, then go back down in one stroke.

13. Round off this shape slightly.

14. Follow the same process as for exercise 5; slightly round off the corners and extend every first and third stroke to hit the ascender line.

15. Extend every first and third stroke from exercise 13 to the descender line.

16. To form an n, start with a single downstroke and then, resuming at the base of this stroke, continue with the exercise 13 shape.

17. Create an m exactly as you did for the n, but with two arches instead of one.

18. To form a u shape, the inversion of the n, start and finish at the top on the x-height line, then finish with a downstroke.

19. Create an o with two strokes. Draw a c shape with a fairly flat back, working top to bottom, then join this with the inversion of the c shape top to bottom.

20–23. Combine exercises to form words and join up with exercise 6.

109

MINUSCULES

Minuscule alphabet with ductus shown with directional arrows.

Letterforms

After completing the exercises, begin working with the Italic minuscule letter groups, using the same guidelines. If you use flourishes, you need to increase the ascender and descender areas to at least five pen widths. The pen angle ranges from 15° to 60°, horizontal strokes are at 15°, most of the letters are at 45°, and diagonals are at 60°.

This version of Italic is my personal interpretation of the Chancery Cursive and varies considerably from standard formal Italics found in instructional manuals. The ductus has been adapted to allow for speed and simplicity, specifically with the a-group letters, which are made in one stroke. Note the use of long, overlapping finishing strokes that often give the appearance of a cursive or joined hand.

Spacing

The rhythm of Italic is equidistant parallels. To maintain this rhythm, careful spacing is very important. Beginners frequently space minuscules too far apart and allow too much space between words.

trans zephrique globum scandant tua facta per axem jav wyk

Use this pangram phrase as a guide to spacing your words and letterforms.

il j lt ʃʃ f ʃʃ f

ITALIC i GROUP Hold the pen at 45° unless otherwise indicated. Do i and l in a single stroke. Make the main stem of t and f at 45°, but introduce an angle change to 15° to flatten their crossbars. The j and the f have gently curving descenders— slow down and finish with care on the descender line.

nn mm hh b b p p k k r r

ITALIC n GROUP Create the arch of the n, m, and h using the stroke pattern in exercise 13. Start at the bottom of the first stroke and travel halfway up the stem before branching out. Create the bowls of the b and p following exercise 9. For the k and r, start at the bottom of the first stroke and travel halfway up the stem before branching out.

a a a a a q g g g o l d u u u y y c c e e o o

ITALIC a GROUP To create the bowl of a q, g, and d, follow exercise 9 but use a different finishing stroke. The u and y are exercise 11. Keep the back of the c, e, and o fairly straight.

v v v w w x x y z z s s

ITALIC v GROUP This group is generally the most difficult due to the frequent angle changes. Each letter has different angles for the first and second strokes. Do the first stroke of v, w, x, and y at 60°. Make a sharp flick down and to the left for v, w, and y, which creates the sharp point. Do the second stroke at 45°. Do the second stroke of x at 30°. For z, make the top and bottom strokes at 15° and the middle stroke at 5° to 10°. Do the second stroke of s slightly flattened to about 30°.

MAJUSCULES

Majuscule alphabet with directional arrows showing the ductus.

Letterforms

Italic majuscules are a compressed and sloping form of the Roman Capitals (see pp. 38-39) and follow the same groups, based on proportion. The pen angle ranges from 20° to 45° and, while the height can range from six to eight pen widths, a good size is seven pen widths.

Spacing

Correct spacing between majuscules is essential. To calculate the spacing unit, consider the size of the internal or counterspace within the H. The average space should be about three-quarters of that area. Spacing between letters is a matter of volume rather than mechanical distance—for instance, imagine the standard spacing between letters is a cup of water. Each combination may be different, but the volume should remain consistent. Beginners frequently get majuscules too close together, particularly letters with vertical stems. Although these majuscules are simple and restrained, they can be highly effective and striking when used alone. When no minuscules are present, there is no need for ascender and descender areas, so minimal interlinear space is required. This can produce a tighter text block, which may be desirable from a design point of view.

ITALIC O GROUP Hold your pen at 30° to 40° for the O group majuscules. This will give more substance to the majuscule form—flattening the angle effectively thickens the letter. They have a more oval shape than the corresponding minuscules.

IIH /\A W INN IT LU
IX WY ¯7Z

ITALIC H GROUP Hold your pen at 30° to 40° for the upright stems of the H group
majuscules to give the forms more substance. There are many angle changes in this group;
this is to ensure that all strokes, regardless of direction, are approximately the same thickness.
Diagonal strokes such as those in A and N are done at 45°; V, W, X, and Y have their first stroke
at 45° and their second at 30°, with the crossbars on A and H at 20°.

IPBB IP IPR IΓFE IΓF IL
IK SS IJ

ITALIC B GROUP Hold your pen at 30° to 40° for the upright stems of the B group
for substance. The horizontal bars on E and F are 20° to reduce the thickness of the stroke for
a pleasing contrast with the upright stems.

I\ΛΜ VΜ VΛΛW

ITALIC M GROUP These letters have V as their basis. To create an M, hold the pen
at 45°—it has a V in the middle supported by two legs. Note that the angle of the legs is neither
vertical nor wide, but balanced in between the two. The W is two Vs with the first stroke at 45°
and the second stroke at 30°.

VARIATIONS

Minuscules

abcdefghijklmnopqrstuvwxyz

This reference alphabet shows the Italic from the exemplar.

abcddefghijklmnopqrsttuvwxyz

A lively variation of the Italic minuscule. It is written at a faster speed and involves more movement, angle changes, and pen manipulation, using the corner of the nib to create fine extended hairlines: the d, g, and o in particular rely on a fine hairline. Ascenders approach from the right rather than the left, creating possibilities for extension and flourishing. This hand is also sharper than the standard version.

Flourished variations of Italic minuscules. Flourishes are possible on most letters, but don't overdo it—one or two well-placed flourishes are generally enough to enhance a piece. As Sheila Waters put it, "Flourishes are especially beloved by beginners, loved but respected by intermediates, and treated as strong design elements, with discretion, by professionals." Using the corner of the pen creates a more subtle flourish.

Majuscules

ABCDEFGHIJKLMN
OPQRSTUVWXYZ

The first reference alphabet here shows the majuscule from the exemplar.

ABCDEFGHIJKLMN
OPQRSTUVWXYZ

This is a more lively interpretation of the majuscule, requiring faster, more dynamic writing, and more pen manipulation.

ABCDEEFGHIJK
LMNOPQRSTUVWXYZ

This example adds hairline flourishes, using the corner of the nib, to embellish the forms. If you look closely you will see that only four flourishes are used to create this variation.

◆ PROFILE DAVID McGRAIL

My calligraphic awakening began with seeing Denis Brown's work in the early 1980s; I came to appreciate the craft in its fullness through his classes and workshops. I've been influenced by all the major calligraphers—Western, Eastern, and Middle Eastern—and their distinctive approaches to the art. Most recently, I have been impressed by the fluidity of Yves Leterme's gestural work and the vibrancy of the Italian calligrapher Luca Barcellona.

I am inspired by two complementary aesthetics: the modest beauty in many diverse things, the simple, the unadorned, the austerity of empty space; and the refinement and elegance that is the essence of skill and craftsmanship. The restrained role of ambiguity also intrigues me; the art of subtle suggestion that arouses curiosity.

As my main business is design, calligraphy happens when I am relaxed and free. My calligraphy is more of a personal quest than a series of works. One thing grows out of another and mostly nothing reaches a point that I could call finished. That may sound unsatisfactory—there is no moment where I can put down my pen with a contented sigh. But I think of my calligraphy as an exploration, with the objective of gently probing the possibilities.

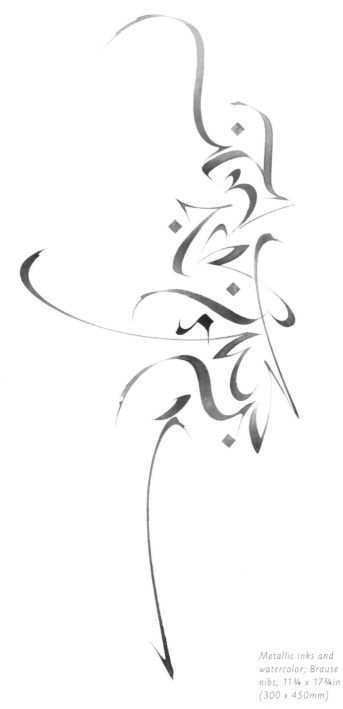

Metallic inks and watercolor; Brause nibs; 11¾ x 17¾in (300 x 450mm)

Freestyle pen manipulation.

Concertina booklet; watercolor, sumi ink, gold leaf on Saunders HP watercolor paper; Brause nibs and sable brushes; 12 x 4in (300 x 105mm)

Concertina booklet (detail); watercolor, sumi ink, and gold leaf on Saunders HP watercolor paper; Brause nibs and sable brushes; 15¼ x 3¼in (385 x 85mm)

A visual impression of Pablo Neruda's poem.

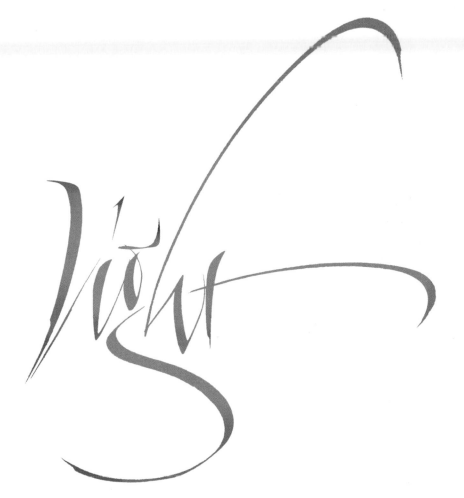

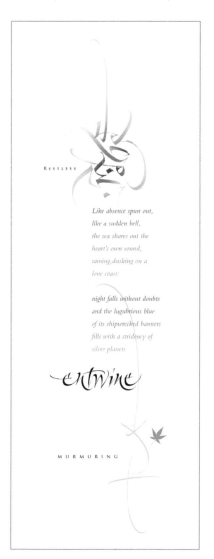

RESTLESS

Like absence spun out,
like a sudden bell,
the sea shares out the
heart's own sound;
raining, dusking on a
lone coast:

night falls without doubts
and the lugubrious blue
of its shipwrecked banners
fills with a stridency of
silver planets

entwine

MURMURING

Like most calligraphers, I began by learning the traditional faces and stayed within those strict confines until I felt comfortable breaking out and bending the rules. I found it rewarding to fuse my design skills with my calligraphy. In time they became, and remain, symbiotic. My design work embraces a calligraphic understanding and vice versa.

I am excited by risky work, work that reveals the human qualities of uncertainty, vitality, and a questioning mind. When I sit down with a piece of work, I let the work lead me. I prefer the surprise of that to having clear a vision of the road ahead.

GALLERY EXPRESSIVE

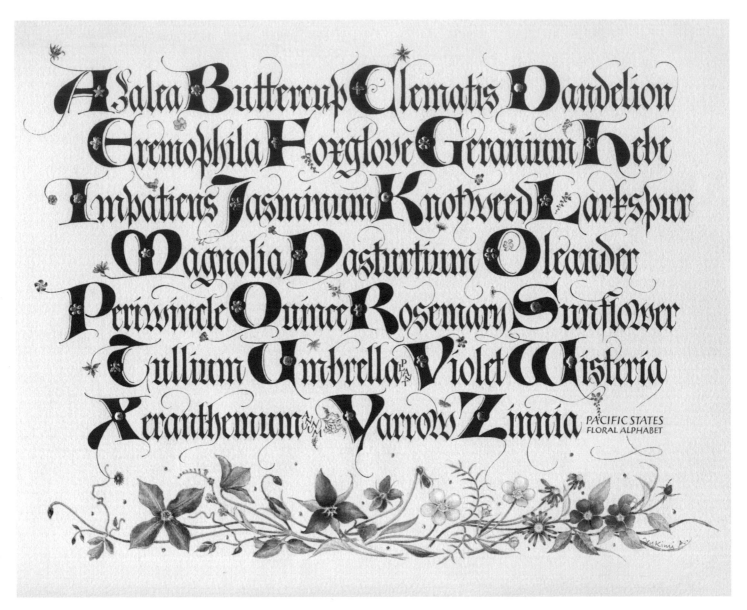

YUKIMI ANNAND (GOTHIC)
Gouache and gold on Fabriano Rome paper;
9½ x 11in (241 x 279mm)

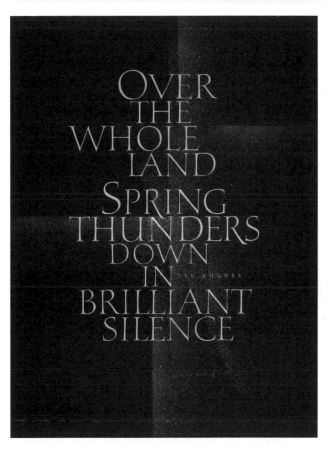

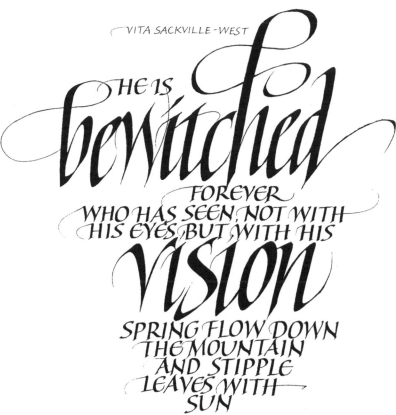

YUKIMI ANNAND (ROMAN CAPITALS)
Gouache on German Ingres paper;
23¼ x 15in (559 x 381mm)

Text by Ted Hughes.

GAYE GODFREY-NICHOLLS (ITALIC)
Italic; ink on paper; Brause nibs; 8 x 8in (200 x 200mm)

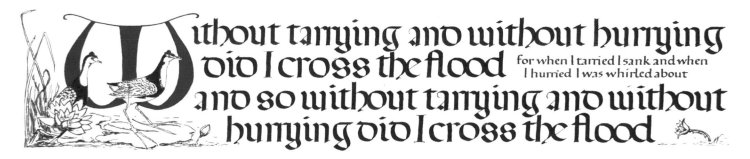

MARIAN WATSON (GOTHIC)
Ink and gouache on paper; Mitchell nibs and
pointed pen; 7½ x 22½in (190 x 570mm)

Text by the Buddha.

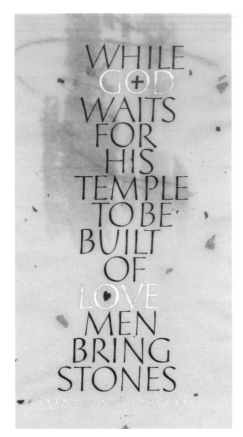

YUKIMI ANNAND (ROMAN CAPITALS)
Gouache on Chiri paper and applied 24K gold;
15 x 9½in (381 x 241mm)

Text by Rabindranath Tagore.

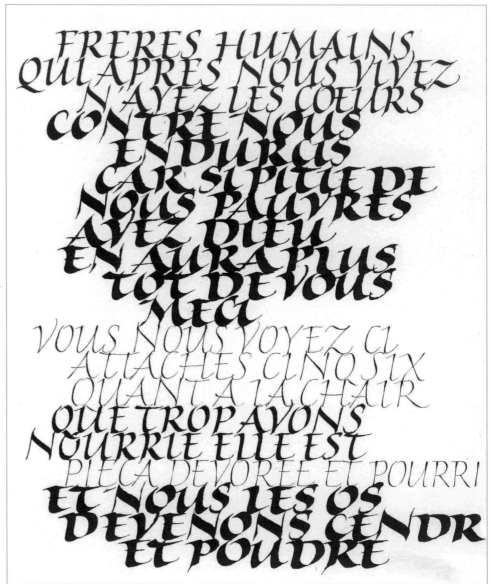

SOPHIE VERBEEK (ROMAN)
Ink on paper; 9½ x 12½in (240 x 320mm)

Text by François Villon (1463).

BETINA NAAB (FOUNDATIONAL)
Gouache on Fabriano Ingres paper with Japanese-style binding; Mitchell nibs; 8¼ x 11¾in (210 x 297mm)

This was Betina's final piece for Foundational when she studied at Roehampton University in the UK.

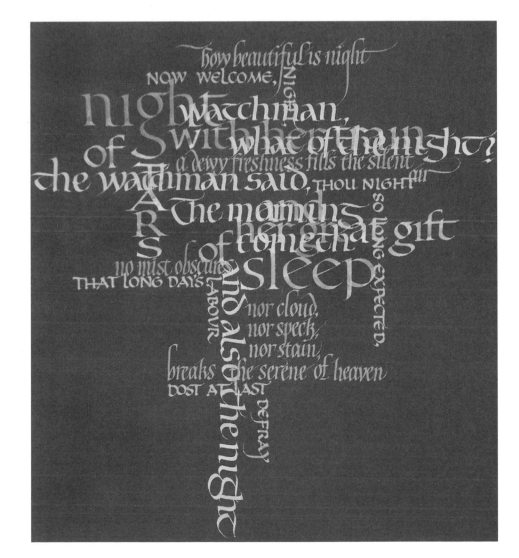

PETER EVANS (FOUNDATIONAL)
Gouache on Canson paper; 14 x 15¾in (360 x 400mm)

BETINA NAAB (NEULAND)
Pastel crayons, ink and collage on canvas;
ruling pen; 8 x 19¾in (200 x 500mm)

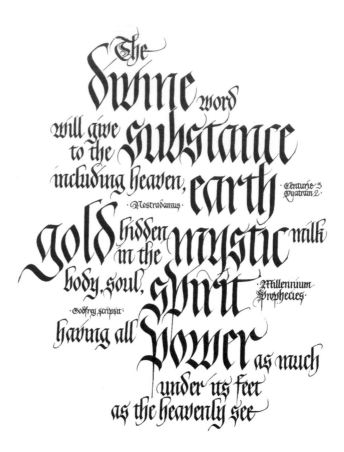

GAYE GODFREY-NICHOLLS (GOTHIC)
Ink on paper; Brause nibs;
8¼ x 12in (210 x 297mm)

MARIAN WATSON (UNCIAL)
Gouache collaged on watercolor paper;
metal nibs; 10 x 11½in (250 x 290mm)

Text by Michael Gullick and Leuan Ree.

Letters and words~

LETTERS AND WORDS ARE EVERYWHERE ABOUT US. THEY DIRECT AND INFORM US, OFTEN SO UNCONSCIOUSLY THAT WE ARE UNAWARE OF THEIR POTENCY AND POWER, RECORDING THE LOFTIEST AND MOST BANAL THOUGHTS OF MANKIND

AND IN WRITING WE ALL MAKE OUR OWN, A LOVE LETTER, A SIGNATURE, A SHOPPING LIST, SOMETIMES WITH CARE AND AN EYE FOR BEAUTY, SOMETIMES ILLEGIBLY

MORE AND MORE PEOPLE ARE TURNING TO THE SENSOUS ENJOYMENT OF THE MANIPULATION OF TOOLS AND MATERIALS IN THE CREATION OF WRITTEN AND LETTERED THINGS, PHYSICAL EXPRESSIONS OF INTELLECTUAL AND TACTILE RESPONSES TO WORDS AND LETTER SHAPES.~

MICHAEL
GULLICK
&
1EUAN
REES

FROM·GOULIES
AND·GHOSTIES
AND·LONGLEGGETY·BEASTIES
AND·THINGS·THAT·GO
BVMP·IN·THE·NIGHT
GOOD·LORD
DELIVERUS

JOKE BOUDENS (VERSALS)
Concertina book (detail); gouache and Chinese stick
ink on BFK Rives paper; 5½ x 9¾in (140 x 250mm)

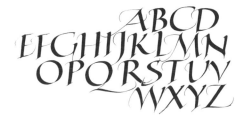

ABCD
EFGHIJKLMN
OPQRSTUV
WXYZ

GAYE GODFREY-NICHOLLS
(ROMAN CAPITALS)
Roman; ink on paper;
Brause nib and pointed brush;
12 x 16½in (297 x 420mm)

GARGAN
TUA

mis lecteurs qui ce livre lisez
Despouillez vous de toute affection
Et, le lisant ne vous scandalisez:
Il ne contient mal ne infection.
Vray est qu'icy peu de perfection
Vous apprendrez, si non en cas de rire :
Autre argument ne peut mon cueur elire
Voyant le dueil qui vous mine et consomme
Mieulx est de ris que de larmes escripre
Pour ce que rire est le propre de l'homme.

rabelais

SOPHIE VERBEEK (CAROLINGIAN)
Gouache, watercolor, and gold leaf on paper;
12½ x 12½in (320 x 320mm)

Text by François Rabelais (1535).

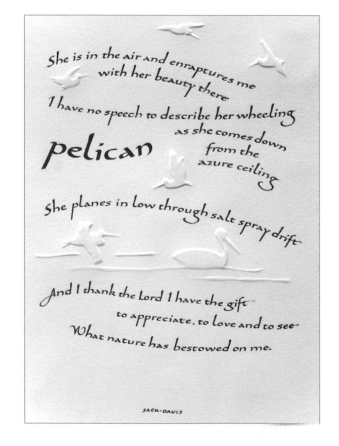

MARIAN WATSON (CAROLINGIAN)
Gouache and hand-embossing on
watercolor paper; 10½ x 14½in
(270 x 370mm)

Text by Jack Davis.

"It is admirable against surfeits... an antidote to the mischief of mushrooms and henbane..." *Culpepper*

MUGWORT

Artemesia vulgaris

One of the Nine Sacred Herbs, mugwort has an extensive list of attributes, medicinal and magickal. Native Americans have been known to rub the leaves on their bodies to keep away ghosts and wear a necklace of the leaves to avoid dreaming of the dead. In the Middle Ages, a crown of mugwort leaves, worn on St John's Eve, was thought to prevent demonic possession. A remedy against fatigue and an insect repellent, mugwort was also used to protect travellers against evil spirits and wild animals. However, mugwort's most widely known magickal attribute is its ability to induce lucid dreaming – to increase the intensity and level of control of dreams and their recollective upon waking. It can be taken in the form of a tincture prior to sleeping or dried and placed under the pillow.

From the family ASTERACEAE, mugwort is known by many names. In Germany it is known as Beifuß, in the Ukraine, it is Chornobylnik – the Russian city of Chernobyl was named for it as it grew abundantly there. Cronewort, motherwort, felon herb, sailor's tobacco Carline thistle, St John's plant, Cingulam Sancti Johannes, Old Uncle Henry, Naughty man, wild wormwood, chrysanthemum weed old man and muggons are some of its English synonyms. It was used to flavour beer before the introduction of hops. In China there are references to it in songs and poems that date back to 3BC. In Mandarin, it was called Lou Hao. It is still used in traditional Chinese medicine, where it is pulverised, aged and lit in the practice of moxybustion. In Sanskrit it is called nagadamni and is used in Ayurvedic medicine.

nervine
antiseptic
digestive
tonic
emmenagogue
haemostatic
anthelmintic
antibacterial
purgative
carminative
diaphoretic
vermifuge
antispasmodic
expectorant
cholagogue
anti-inflammatory
stimulant
stomachic

Woden's Nine Herb Charm

Anglo-Saxon Old English Gemynt ðu, mucgwyrt, hwæt þu ameldodest

REMEMBER MUGWORT, WHAT YOU HAVE REVEALED

hwæt þu rendest æt regenmelde

WHAT YOU ESTABLISHED AT THE MIGHTY PROCLAMATION

Una þu hattest yldost wyrta

UNA YOU ARE CALLED, OLDEST OF HERBS

Ðu miht wið III and wið XXX

YOU MAY AVAIL AGAINST THREE AND AGAINST THIRTY

þu miht wiþ attre and wið onflyge

YOU MAY AVAIL AGAINST POISON AND AGAINST CONTAGION

þu miht wiþ þa(m) laþan

YOU MAY AVAIL AGAINST THE LOATHSOME ONE

ðe geond lond færð

WHO TRAVELS THROUGH THE LAND

The first verse of Wodens Nine Herb Charm, from the 10th c Anglo Saxon manuscript BL Harley 585 Lacnunga LXXIX - LXXXII, translation by Benjamin Slade 2002

GAYE GODFREY-NICHOLLS (CAROLINGIAN)

Ink, watercolor, and Moonshadow Mist on Saunders watercolor paper; Brause nibs, pointed pen, and brush; 11¾ x 16½in (297 x 420mm)

This piece also uses Uncial, Gothic, Pointed Pen script, and a free interpretation of Anglo Saxon/Insular minuscule hybridized with Italic.

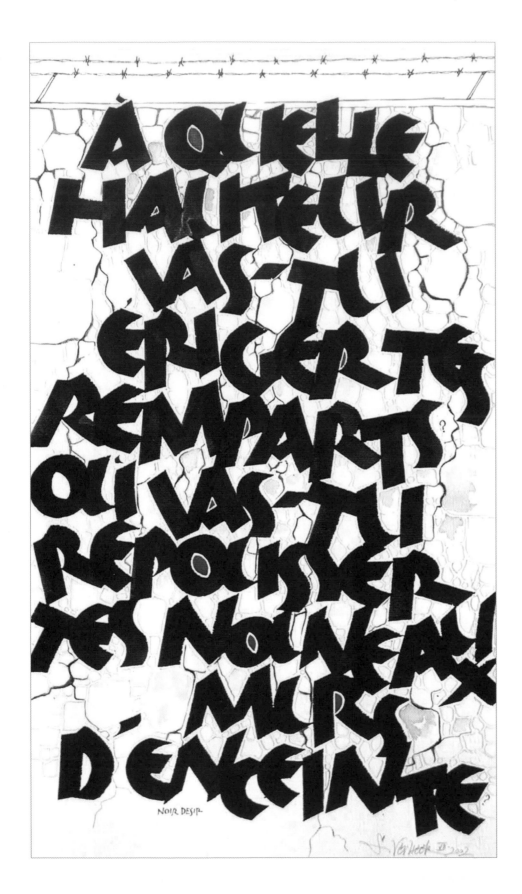

SOPHIE VERBEEK (NEULAND)
Ink on paper; 9¾ x 19¾in (250 x 500mm)

Text writen for the exhibition *Going Beyond Borders*.

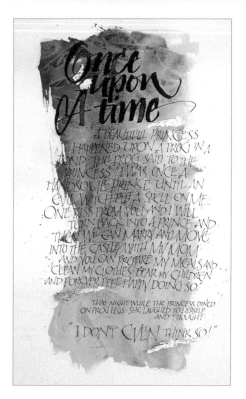

BARBARA CLOSE (VERSALS)

*Watercolor and gold leaf on
watercolor paper; brush and pointed
nibs; 18 x 24in (457 x 610mm)*

Text. Fractured Fairy Tales.

SOPHIE VERBEEK (VERSALS)

*Ink and gouache on paper;
9½ x 12½in (240 x 320mm)*

This piece was created for the exhibition
Going Beyond Borders.

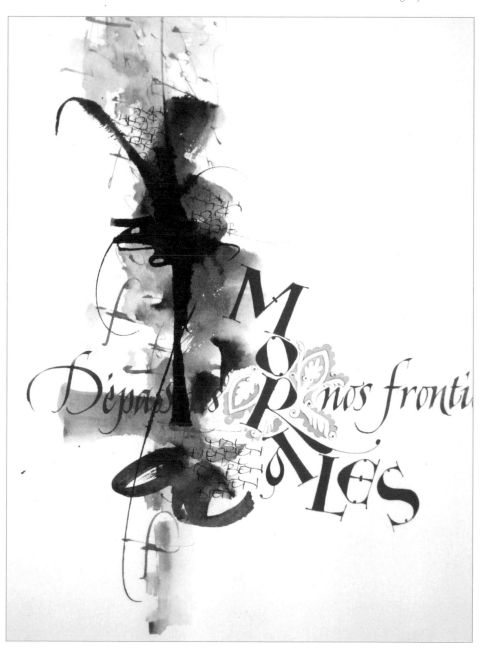

MANNY LING
(ITALIC)
*Calligraphy written freely with
Automatic pen; design sandblasted
onto glass bowl*

This commemorative bowl was made for
the Chairman of the UK's Design Council,
Sir George Cox. Text by Paul Rand.
Artwork © Manny Ling.

MANNY LING (ITALIC)
*Written freely with Automatic pen then
scanned in Photoshop. The blob was created
by blowing through a plastic straw.*

GAYE GODFREY-NICHOLLS (ITALIC)
*TW pearlescent ink on black Ingres paper; Brause 1mm nib;
10 x 16½in (250 x 420mm)*

Letters were written and flooded with drops of different colored pearlescent inks,
creating an iridescent effect. This piece ignores the warning about restraining
flourishes as an exercise in overindulgence! The text was chosen for the maximum
number of ascenders and descenders, and every extension was flourished. This
approach is possible only in a situation where a single line of text is used, making
sufficient space for flourishing.

GEORGIA ANGELOPOULOS (ITALIC)
Gouache, ground pigments, gesso sottile,
gum ammoniac, 22K gold leaf on calfskin;
10½ x 14½in (267 x 368mm)

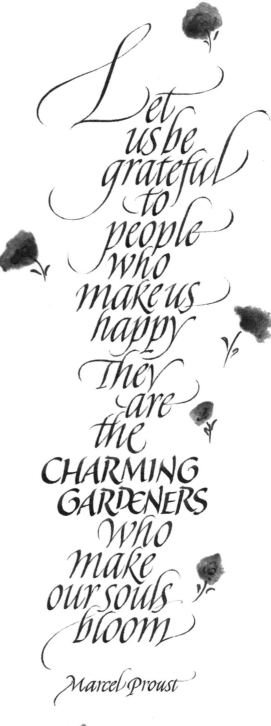

YUKIMI ANNAND (ITALIC)
Gouache and watercolor on Arches hot
press paper; 5 x 13in (125 x 330mm)

Text by Marcel Proust.

GALLERY COMMERCIAL

GAYE GODFREY-NICHOLLS (ITALIC)
Ink on paper; Brause nibs and collage of clip art;
8¼ x 16½in (210 x 420mm)

GAYE GODFREY-NICHOLLS (ITALIC)
Ink on paper, reversed for print;
Brause nib; 18¹/₁₆ x 3³/₁₆in (180 x 80mm)

GAYE GODFREY-NICHOLLS
(FOUNDATIONAL)
Ink on paper, reversed for print;
Brause nibs; 8¼ x 3⁷/₈in (210 x 99mm)

VITALINA AND VICTORIA LOPUKHINA
OF VISUALIZERS (ITALIC)
Ink on card; pointed pen (dimensions not available)

GAYE GODFREY-NICHOLLS (ITALIC)
Sakura fineline marker on paper;
18⅟₆ x 10¾in (180 x 270mm)

Menu

·ENTREE·
Sate Prawns
or
Avocado Raspberry Viniagrette

·MAIN·
Tornados Rossini
or
Spinach and Ham in
Chicken Fillets with White Wine
and Tomato Coulis Sauce

·DESSERT·
Individual Pavlovas
or
Fruit Fool

❖

20 Year Service Recognition Luncheon
Wild Orchid, Joondalup
Friday 10th October 1997

GAYE GODFREY-NICHOLLS (ITALIC)
Sakura fineline marker on paper;
5¾ x 8¼in (148 x 210mm)

GAYE GODFREY-NICHOLLS (ITALIC)
Sakura fineline marker on paper;
8¼ x 3⅞in (210 x 99mm)

GAYE GODFREY-NICHOLLS (COPPERPLATE)
Walnut ink on paper; EF Principal nib;
artwork designed by Wren Press, Perth, Australia;
2½ x 3½in (65 x 90mm); cropped section shown

GAYE GODFREY-NICHOLLS (COPPERPLATE)
Walnut ink on paper; EF Principal nib;
artwork designed by Wren Press, Perth, Australia;
3½ x 2in (90 x 50mm)

NON-TRADITIONAL ALPHABETS

You will find no definitive form for the Gestural and Ruling Pen hands in calligraphy books or exhibitions; they are not rooted in tradition but have evolved over the last few decades. Gestural calligraphy covers any writing with any instrument; each tool imparts its own character and qualities to a script. I find my Ruling Pen script is essentially the same as my third variation on the pointed brush (see pp. 218–219), with the ruling pen injecting its unique marks into the hand. My Emiline script done with a pointed pen is quite different to a Speedball C6 or a ruling pen, but it shows the same underlying movement and form.

An interesting development in abstract gestural circles is asemic calligraphy. This is defined as writing with no semantic content—a purely gestural form. The concept is that the form itself is the content or message, creating a vacuum for the viewer to interpret as they will. Malik Anas al-Rajab (see pp. 274–275), traditionally trained in Arabic calligraphy, has also created transcultural works of art digitally using Arabic and abstract calligraphic shapes.

NUMERALS AND PUNCTUATION

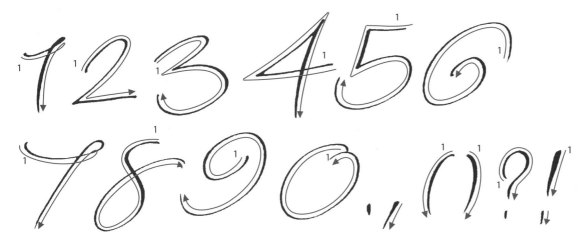

SUITABLE FOR GESTURAL x-height slightly shorter than majuscules • Variable letter slope •
Slightly compressed character

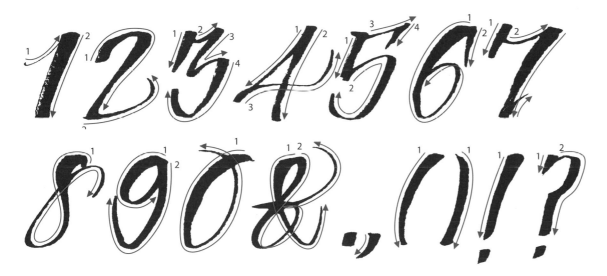

SUITABLE FOR RULING PEN Sideways pen hold • x-height slightly shorter than majuscule •
Variable letter slope • Compressed character

GESTURAL

HISTORY

Gestural calligraphy is relatively modern. The nature of calligraphy is that, even when an exemplar or model is used, everyone develops a distinct hand. Theoretically, any hand is already gestural. However, what we consider to be gestural calligraphy has a recognizable form: loose, swinging, and often polyrhythmic. The offspring of handwriting idiosyncrasy and Italic discipline, gestural writing usually involves a whole-arm or whole-body movement. It requires unselfconscious freedom combined with consideration of space and rhythm that only practice, experience, and experimentation can bring. Achieving effective asymmetrical balance is one aspect of successful gestural forms. An extension of stroke and a sweeping release of a previously controlled movement are some of the most pleasing aspects of a confident, expertly executed gestural form.

Yves Leterme's *Thoughtful Gestures* identifies aspects of effective gestural writing: choice of letterforms, joins, rhythm, size of letters, guidelines (use, nonuse, adapting), ascenders and descenders (height and shapes), slope, line character, spacing within word, writing instrument, and retouching. Use these to make your own gestural alphabet. Analyze every quality example; copy it and try to find your own personal movement. The exemplar in this section is simply one approach out of a wide variety of possibilities.

LETTER GROUPS: MAIN CHARACTERISTICS

The letters shown here are just one approach to a Gestural alphabet from many possibilities. This example uses a horizontally emphasized form.

The o shape is a compressed ellipse that occurs as a result of speed.

The letters of the n group have asymmetrical arches that branch from low in the stem.

The a shape relates directly to the o shape.

Key points

- Pen angle: varies
- x-height: varies
- Ascenders and descenders: varies
- Forms: vary
- Arches: varies
- Rhythm: polyrhythmic
- O: varies

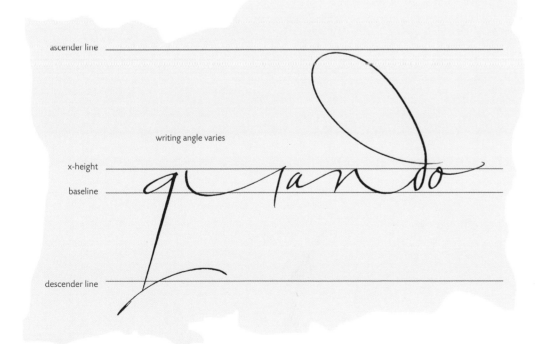

One version of gestural minuscule letters within guidelines showing the x-height, ascender and descender heights, and writing angle.

EXERCISES

A first step toward Gestural writing is to experiment with polyrhythms, so we will begin with a series of exercises to accustom you to polyrhythmic writing. For this interpretation of a Gestural hand, we will approach the exercises from a different direction, taking a form loosely based on Hans Joachim Burgert's Akim Cursive as inspiration. This hand is usually written with a monoline tool. After exploring some variants with the monoline pen, we will use different tools with the same movement. The key objective is to find your own Gestural movement.

1. *abcdefgghijklmnopqrsttuvwuxyyz3*

2. *a aa bbb cc ddd ee ff f gggg g*

3. *hhh h ii j j kk k l ll mmm m*

4. *n nn oo o pp p qq q rr r*

5. *s s s tt u u u v v wu w a*

6. *x xx yyy yy zz 333*

7. *polyrhythmic writing*

8. *polyrhythmic writing*

9. *polyrhythmic writing*

10. *polyrhythmic writing*

11.

12.

13.

Rule up guidelines with an x-height of ⅛in (3mm), and ascenders and descenders of ¾in (20mm). Pen or brush widths are not relevant to these proportions. Although many different tools can be used to create Gestural forms, start with a monoline tool—a fineliner such as Copic, Zig Millennium, or Sakura Pigma Micron of 0.1, 0.2, or 0.3 thickness. A biro or graphite pencil could also be used.

1. Line 1 shows the reference alphabet—a ball and stick with a horizontal emphasis (i.e., the standard letter size is wider than it is tall, excluding ascenders and descenders).

2–6. Lines 2-6 show variants of each letter, usually standard, wide, sweeping finish, occasionally looped ascender or descender.

7–10. Write some phrases where you combine letters of different widths: there are many permutations possible. Line 7 shows the words "polyrhythmic writing" in the reference alphabet; lines 8, 9, and 10 show possible interpretations using a fineliner.

11. Choose a long word of seven letters or more and write it in ten different ways. Line 11 uses a Speedball C5. There is more of a vertical emphasis in this example, with taller letters.

12. Using a Speedball C5, write out your word and phrases, observing the difference between the monoline pen and the fine broad-edged pen. Line 12 uses a Gillott 303. There is more of a horizontal emphasis and a slower, more considered movement to avoid ink splattering. This example has many similarities with the Emiline variation in Contemporary Pointed Pen (see p. 188).

13. Using a pointed pen, write out your word and phrase, noticing the differences. Line 13 uses a ruling pen on its tip and a very similar movement to line 11: less contrast of line width is present.

You can develop the exercises further. Using a ruling pen, write out your word or phrase, noting the differences. Try other tools such as a carpenter's pencil or pointed brush with the same movement. Copy these forms as a starting point, then see where your own gestures take you. It can take time to "deformalize" your hand, especially if you have been working hard to achieve a consistent historical form. This progression of exercises is intended to provide you with one possible pathway to Gestural writing.

MINUSCULES

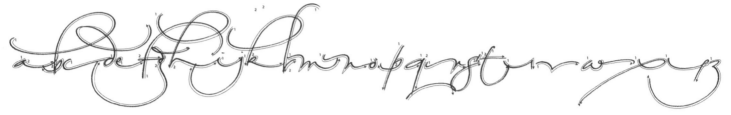

Minuscule alphabet with directional arrows showing the ductus.

Letterforms

After completing the exercises, begin working with the minuscule letter groups using the same guidelines. With the objective of creating an authentic Gestural hand, I have endeavored to do the letters in as few strokes as possible, and occasionally reverse the stroke direction in letters such as f and s.

Spacing

The rhythm of Gestural will vary, although polyrhythms are dominant.

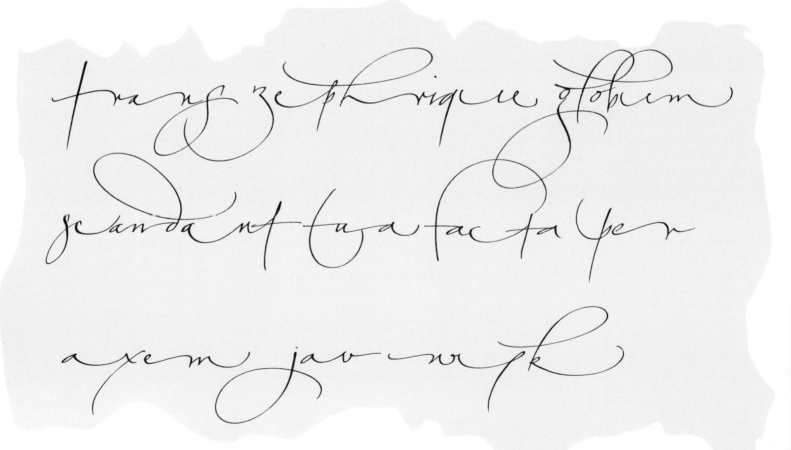

Use this pangram phrase as a guide to spacing your words and letterforms.

GESTURAL i GROUP

Begin i, u, and y with the same extended stroke curving to the right. Finish i with a dot, finish u with a short vertical, and finish y by flicking around into a short descender. Start j by curving to the left in a sweeping descender and add a dot.

Begin t higher than the previous letters and follow the same sweep to the right. Finish with a crossbar. Just to make things different, start f at the bottom of the stroke and curve up, sweeping around into a generous ascender and finish with a crossbar.

GESTURAL n GROUP

The letters n, m, and r are one-stroke letters. Begin with a swing and counterswing; finish n with a sharp arch, m with a softened then a sharp arch, and r as you did the n but cut short of the baseline. Start l, h, b, and k with a sweeping anticlockwise ascender loop that finishes at the baseline. Finish l with a short light

upstroke and finish h with an extended arch. The letters b and p share the same bowl: give p a short simple descender (alternatively, use a sweeping descender like a j). Finish k with a clockwise bowl and kick out the leg in an extended stroke.

GESTURAL a GROUP

The letters a, q, g, and both forms of d are one-stroke letters. Begin a with a short elongated bowl and finish with an elongated curve like the i. To finish q, add to the elongated a bowl a straight long ascender with a tangential flick to the right. Finish g with a long descender. Begin the first d as you did a, then continue up and curve around into an anticlockwise loop. The second d has the same movement, but change the angle and swing the loop around so it crosses around the x-height. The o is another one-stroke letter; make

an anticlockwise bowl loop around and finish with an extended stroke to the right. Begin the second g as you did the o but with a smaller bowl; then add a long sweeping descender with a curve and countercurve. Start z with a short downstroke, then a clockwise curve, and finish with a big swinging descender. Start c with an anticlockwise curve and finish with an extended stroke like an i. Begin e with a small loop for the bowl and finish as you did c.

GESTURAL s GROUP

Start s with a short downstroke and finish with a sweeping descender like that of the second g. Begin v with an extended arc, touch the baseline, and spring back into another arch. Start w almost like an a, but keep the bowl shape open, swing up and

loop around, and finish with an extended stroke. Make the x in one stroke by pulling a diagonal stroke from left to right, curving into an anticlockwise loop and finish by extending to the left.

MAJUSCULES

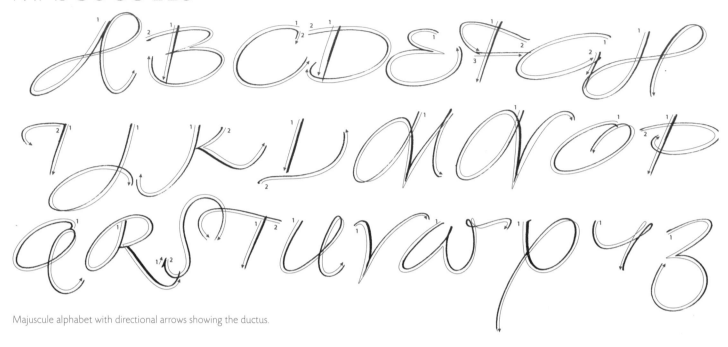

Majuscule alphabet with directional arrows showing the ductus.

Letterforms

As with the minuscules, I have used as many one-stroke majuscules as possible and used a wide form that matches the horizontal emphasis of the minuscules. This means there is little relation to the standard proportions of the Roman.

Spacing

As with the minuscules, rhythm and spacing of majuscules in Gestural styles will vary considerably, with polyrhythms a popular and effective approach.

GESTURAL I GROUP

The near-vertical stroke is the basis for this group. Start I, T, F, E, L, P, B, and D with a fast, heavy downstroke. Finish I with a westerly flourish. Start at the top of the first stroke, swing out quickly to the left, and curve around. Begin T as you did I, then add the rest of the top horizontal stroke, overlapping to avoid visible joins. Continue F and E with a westerly flourish that starts further to the right than the I; add the center crossbar to finish F, and to complete E add the bottom horizontal, which sweeps up in an arc. Finish L with a similar stroke to the final E stroke. Finish P with a large bowl that starts and finishes to the left of the stem. Continue B in the same way with a smaller bowl and another larger bowl at the bottom. Form D with the same movement as the P, but make it bigger.

GESTURAL H GROUP

Begin H at the top and travel down, swinging into a clockwise loop, cut through the middle of the stem, then add an anticlockwise loop, swing around, and finish below the baseline. Start A as you did H but make the angle more diagonal; swing through the stem around a third from the base, then swing around in an anticlockwise loop to form the other diagonal leg, finishing below the baseline. Begin M at the top with a big loop that dips just below the baseline, curves around, crosses the first stem about a third from the top and touches the baseline. Continue the stroke up (forming a V-shape), hit the top, and come straight down in a near-vertical stroke, finishing just below the baseline. Start your N exactly as you did M, but finish with a sweeping extended stroke instead of coming back down. Form a V by taking the V-shape out of the N. Start your J exactly as you did H, but dip the loop below to the descender area and finish around the baseline with the stroke pointing downward. Begin K like a version of J without the loop, then add the diagonals, kicking the bottom stroke out. Start R as you did H, but instead of cutting through the stem, curve around just above the starting point, swing around into a bowl, then kick the leg out as you did K.

GESTURAL O GROUP

Begin O and Q with an anticlockwise spiral. Finish Q with a tail that sweeps up to the right. Start C, G, and the first of the alternative Es with a similar curve, but stop short of the starting point so the shape is left open. Finish G with a downstroke and the first E with a crossbar. Form the second E as you would a backward 3.

GESTURAL U GROUP

Begin U at the top with a bowl and anticlockwise loop, finishing around the baseline. Start W as you would a minuscule a, curve around with a tiny loop, and finish with an extended stroke curving to the right. Do the X in one stroke by pulling a diagonal stroke from left to right, curving into an anticlockwise loop and finish by extending to the left. Form Z like a large 3 that dips below the baseline. This version of S is the same as the Ruling Pen version (see p. 157)—make a short stroke at the baseline, then do the stroke backward from bottom to top, curving around to finish about halfway down to the baseline.

VARIATIONS

Minuscules

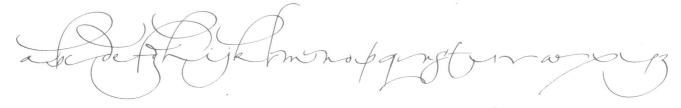

This reference alphabet shows the Gestural alphabet from the exemplar.

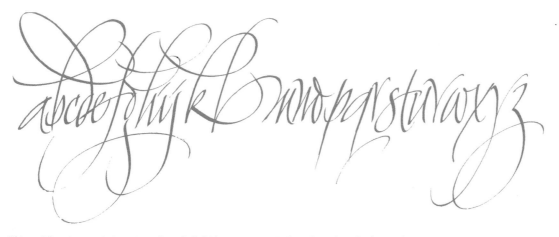

This rapidly written variation using a Speedball C4 has a more vertical emphasis than the first, with oversized ascenders and descenders freely intersecting and a sense of movement with shifting verticals.

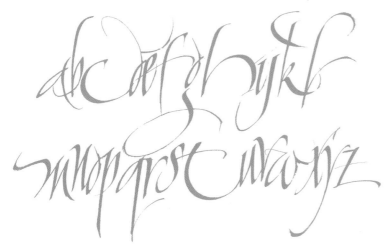

This variation using a Speedball C0 (showing greater contrast between thicks and thins than the other examples) has more deliberated forms with certain letters expanded and variations in downstroke angle and widths. Written without a baseline, it moves in gentle arcs with each letter placed as a response to the previous one.

Majuscules

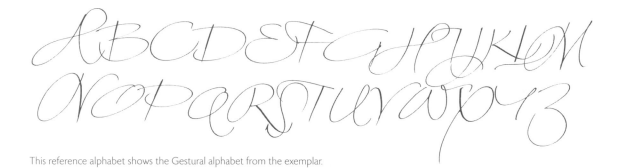

This reference alphabet shows the Gestural alphabet from the exemplar.

This rapidly written variation using a Speedball C4 has a more vertical emphasis than the first. It is intentionally unflourished so as not to compete with the minuscule.

This variation using a Speedball C0 is essentially a fast, dense Italic majuscule with weighted flourishes. I left in the ink splatter at the end of the Q as I thought it added character!

PROFILE SOPHIE VERBEEK

The Abstract Expressionism movement has been one of the biggest influences on my art. Asian painters such as Zao Wou Ki and Chu Teh Chun have also impressed me with their use of color and their ability to let go and express their emotions on the page. This enhances my comprehension of the outside world and allows me to question my own artistic approach.

I like working around a theme connected with my own experience. I've worked around: "Why 9/11?" (2001), "Going beyond borders" (2002), "Solomon's song" (2004), "Flowers of evil" (2005) by Charles Baudelaire, "Musical calligraphy" (2006), "Walking through textured vegetation" (2008), "Saint John's the Evangelist" (2009), "Silence, matter, and transparency" (2010), and "Writing lines and threads" (2009–2011).

My daily silent walks in a nearby forest have been a great source of inspiration, just as the practice of yoga and meditation have helped me to take a step back, allowing my work to evolve quietly. I used to work nonstop just to get the technique right. Before I knew it, I had terrible tendonitis in my right arm. That taught me a lesson about myself and how I had gone beyond my own limits. With time, I have learned to be less excessive and to allow things to come to me rather than to force my creativity. My work has gained in simplicity and strength.

Gouache and ink on paper; 29½ x 41¼in (750 x 1050mm)

Work for the exhibition Scriptural Visions held in Geneva.

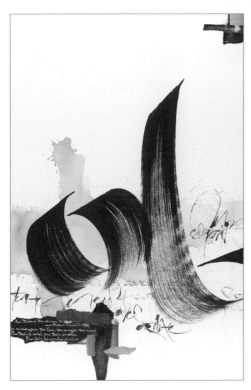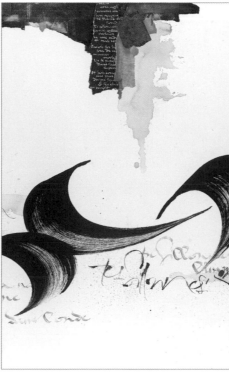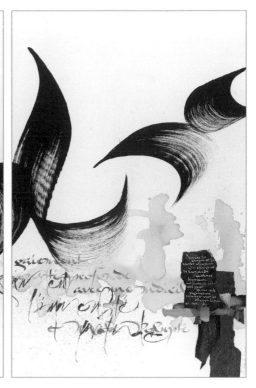

Mixed media on wooden panel; 82¾ x 39¼ in (2100 x 1000mm)

Text by Charles Baudelaire.

When I start work I visualize the essential structures and forms, allowing myself to let go and abandon my gestures to caress the surface of the page. My latest pieces have evolved around the concept of writing and its metamorphosis into lines and threads. By allowing my hand to free itself from legibility, my body becomes a dancing instrument bursting with a range of emotions. Lines are thrown on the surface with a delicate vitality, creating a series of overlapping lines. The supple marks create a new language on the page, far from traditional calligraphy.

Perseverance is probably the most important virtue one has to develop when one starts calligraphy. It's a long, difficult, and strenuous path, but it will help you to discover your own inner beauty. So, *Viva la pluma*!

◆ PROFILE YUKIMI ANNAND

I took two semesters of a lettering class while at art college in Japan. The teacher was a typographer and lettering designer who admired Herman Zapf. He introduced me to font design, lettering, and typography, and he shared with me the pleasure of drawing beautiful letters both in Japanese and Roman alphabets. After I graduated, I worked as a graphic designer in Tokyo. Visualizing concepts and meanings into design was the most challenging part of my work, and I learned how good design products can communicate an effective message to the public. These experiences were major influences in my becoming involved in calligraphy in the United States.

I get inspiration from poems, novels, music, films, fine art, Japanese tradition, and nature. The calligraphers who have inspired me most are Brody Neuenschwander, Thomas Ingmire, and Gottfried Pott. The works of Yves Leterme, Monica Dengo, Kitty Sabatier, Yuko Wada, and Torsten Kolle also inspire me.

When I start a piece, I usually have words, texts, or lyrics that attract me. I then imagine the final pieces from sketching or finding images from photos or art pieces. I often develop calligraphic marks with different tools, or design original letterforms. Sometimes I have an image first, and then find words or text that fit the image.

Sumi ink, acrylic, and gouache on Japanese handmade paper; 20 x 30in (508 x 762mm)

Text by William Carlos Williams.

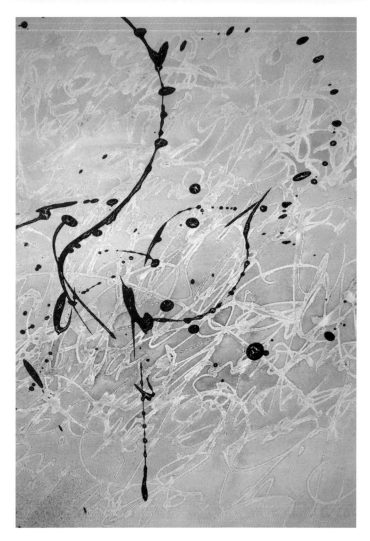

*Glue, watercolor, and sumi ink on Arches text wove paper;
19 x 12in (483 x 305mm)*

At the moment, I am developing calligraphic marks with different tools and making texture with them. Making marks with a different rhythm or speed, and finding unexpected textures, are a real pleasure for me.

I was initially attracted to Roman alphabets because of how systematic they are compared with Japanese letters. Each stroke must be carefully executed, as strokes turn to letters, and letters make words. I followed the traditional rules of learning letterforms at the beginning and, although I am still learning, I am now breaking the rules and creating different patterns and personal marks.

The best advice I can give new calligraphers is to learn letterforms from good examples. Find the secret of their beauty by yourself. Be patient with your practice and work on your strokes to write beautiful letters. At the same time, train your hand and body to be free to make marks. Pay attention to the composition and colors of any object or scene in everyday life. Make notes of the words or text that inspire you. Be yourself.

*Sumi ink on Arches text wove paper;
8½ x 25in (216 x 635mm)*

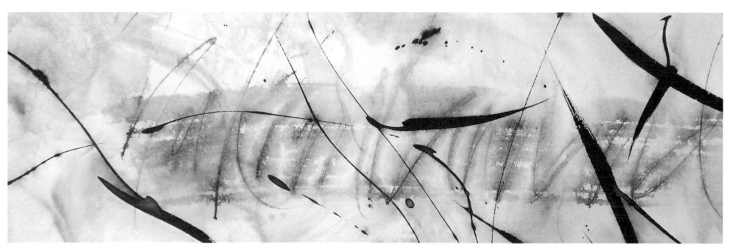

RULING PEN

HISTORY

The ruling pen was invented to draw precise, thin lines and used mainly by cartographers, engineers, and draftspeople. Today it is favored by calligraphers for the variation in strokes it allows when used in a dynamic and gestural fashion. The traditional ruling pen has two metal parts that converge at the end, fastened together with an adjustable screw that allows a finer or thicker line to be drawn. These act as a reservoir and the pen is dipped into (or loaded with a brush filled with) ink, gouache, or watercolor. Ruling pens developed specifically for calligraphers include the ruling writer, the folded ruling pen, and the homemade cola pen, made from aluminum cut from a soda can, folded, shaped, and attached to a pen holder.

One of the unique characteristics of the ruling pen mark is the striated splatter pattern that occurs when it is used at speed. This is a most undesirable effect in Copperplate, but is sought after with Ruling Pen scripts. Heavily textured substrates can enhance this. The ruling pen can be used with different grips, exemplars, and levels of precision. We will begin with the traditional ruling pen, holding it sideways to obtain a thick downstroke. The exemplar here is gestural, as are most Ruling Pen hands; you may find other versions that suit your hand movement. It is much harder to achieve consistency with the ruling pen than with any other tool, so extra practice is necessary to feel confident with this tool. Consider this one of the tool's endearing qualities: within a range of forms, variation is inevitable.

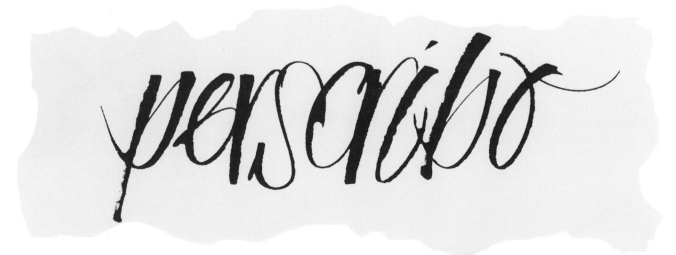

LETTER GROUPS: MAIN CHARACTERISTICS

The o is mandorla- or almond-shaped.

The letters of the n group have low arches.

The a shape relates directly to the o shape.

HANDS

Key points

- Pen position: mainly held sideways
- Writing angle: varies
- x-height: varies
- Ascenders and descenders: extended and usually simple
- Forms: usually compressed and sloping
- Arches: asymmetrical, branching from low in the stem
- Rhythm: polyrhythmic

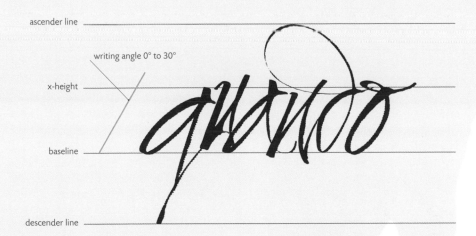

ascender line

writing angle 0° to 30°

x-height

baseline

descender line

One version of Ruling Pen minuscule letters within guidelines showing the x-height, ascender and descender heights, and writing angle.

EXERCISES

When you are learning Ruling Pen, begin with exercises designed to prepare you for the angles, strokes, and movement of the hand that are required. Complete about two lines of each exercise consistently before moving on to the next.

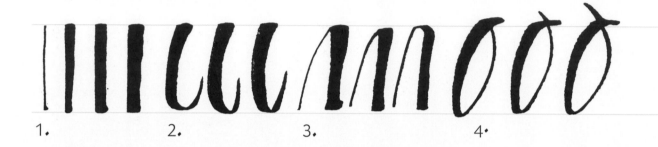

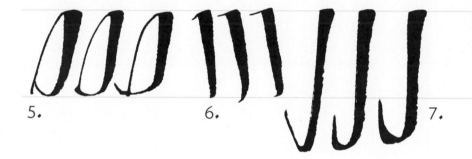

Rule up guidelines with an x-height of ¾in (20mm), and ascenders and descenders of ⅜-¾in (10-20mm). As with Copperplate (see p. 168) and Contemporary Pointed Pen (see p. 180), pen or brush widths are not relevant to these proportions. Pick up your ruling pen, load it with ink, and start with the exercises.

1. Establish downstrokes in four different widths by changing the amount of pen edge in contact with the substrate. Start out vertically, then gradually flatten the pen for the thickest stroke.

2. Aim for heavy downstrokes of between the third and fourth thickness as the standard. Finish this one with a light upward flick.

3. With the tip of the pen, make a light diagonal upstroke, then pull into a heavy downstroke, finishing at the baseline.

minimum

onion

8. 9.

4. Holding the pen fairly flat in the sideways position, drag a diagonal arc down to the baseline, then flick up with a light upstroke.

5. Start as you did with exercise 3, then pull in to meet the stem at the baseline with a flat light stroke.

6. Holding the pen sideways, pull a thick diagonal from left to right, finishing at the baseline.

7. This is the standard descender stroke. Start as you did exercise 2, but then continue below the baseline and hook up to the left, easing the pressure off so the stroke tapers.

8. The westerly flourish is used mainly in majuscules. Make a fast stroke starting at the top of the stem of the letter and pull to the left and down in a tapering curve—this can be horizontal (first two examples) or more diagonal (third example), depending on your preference.

9. Create letters and words using the strokes of the exercises.

MINUSCULES

Minuscule alphabet with directional arrows showing the ductus.

Letterforms

After completing the exercises, begin working with the minuscule letter groups using the same guidelines.

Like Gestural, Pointed Brush, and Contemporary Pointed Pen, this Ruling Pen script is shaped primarily by the instrument rather than by a historical form. As with those scripts, the two main hands that are most suited for adaptation are Italic and Copperplate. This particular Ruling Pen script has characteristics of Italic and its own unique flavor with marks that only a ruling pen can make. When working on this exemplar, I found that to achieve satisfactory results I needed to work flat, work large (minuscules about 2in/50mm, majuscules 3¼in/80mm high), use textured paper, and stand up, otherwise the work looked cramped and stilted.

Spacing

The rhythm of Ruling Pen is polyrhythmic, with downstrokes intentionally varying in thickness. A possible approach to harmonious arrangement is to balance each stroke to the last and chunk them in groups of three, considering each group of three a unit that is balanced against the last. To increase legibility, make interlinear space larger or, to exploit the textures achievable with Ruling Pen, decrease interlinear space, as shown in the pangram example on the right.

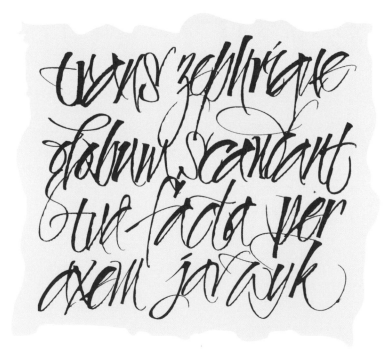

Use this pangram phrase as a guide to spacing your words and letterforms.

iljittff

oaqgdovuyccco

RULING PEN i GROUP Begin i with exercise 2 and add a dot. Start l at the top of the ascender line and proceed exactly as you did with i. Begin j with a simple descender (exercise 7) and add a dot. Start t above the x-height, but finish as you did with i and add a hairline crossbar on the x-height line. Begin f at the top of the ascender line on a curve, then pull an angled downstroke to the bottom of the descender line. Add a short tapered serif at the top, then a hairline crossbar on the x-height.

RULING PEN a GROUP Hold the pen in the sideways grip unless otherwise indicated. Start a, q, g, and d with the exercise 4 shape (note that the finish does not overlap the start). To finish a, add exercise 2; to finish q, extend the heavy downstroke to the descender line. To finish g, add a simple descender (exercise 7). Finish d with an angled heavy downstroke like an l. An alternative is to loop around and finish just above the x-height. Begin u, y, and the curved w with exercise 2, extending it up to the x-height. Finish u with another exercise 2 and y with the simple descender of exercise 7. Start c and e with exercise 4; to finish c, add a short tapering downstroke. For e, finish with a short curving downstroke that meets the stem at the halfway point and a light crossbar. The o is exercise 4.

nvumirllhlbbppllk

RULING PEN n GROUP Start n, m, and r with a heavy downstroke. To finish n and m, add the arch from exercise 3, then exercise 2. For m, add another arch before the final finishing stroke; finish r with a short tapering downstroke. Begin h, b, and k with a tall version of exercise 1; to finish h, add the arch from the n. To finish b, add exercise 5; I have added a quick flick to the left to balance out the heavy top. To finish k, add a clockwise loop and kick the leg out. Start p with a short upstroke, then a long version of exercise 1 finishing at the descender line, then add exercise 5.

IVVW LXZZS

RULING PEN v GROUP Start v with the angled downstroke from exercise 6; to finish v, add a quick light diagonal stroke to the x-height. Begin w as you did u, then finish with a round bowl that almost touches the x-height and finish with a flourish to the right (keep it short if there are letters following); balance this with the flourish at the start of the letter. Start x with exercise 6 but curve to the right and taper off. Finish with a cross-stroke, then taper and swing at the baseline. Make a z by holding the pen sideways and pull a short tapering vertical stroke down. Do a short version of exercise 5, then curve into a looped descender, easing the pressure off as you go around the corner. Start the first s with fine hairline upstroke at a stroke angle of about 45°, then finish with a heavy downstroke that curves to the left and tapers up to a point. Begin the second s with a curve and countercurve, then flick upward. Add the short tapering downstroke to finish.

MAJUSCULES

Majuscule alphabet with directional arrows showing the ductus.

Letterforms

Many of the strokes that are required for the majuscules are simply proportionately larger versions of the minuscules, with extra pressure to thicken the strokes.

Spacing

As with the minuscules, rhythm and spacing of majuscules in Ruling Pen styles will vary considerably, with polyrhythms a popular and effective approach.

RULING PEN O GROUP O and Q begin with a bigger, looser version of exercise 4; to complete Q, add the final tail, allowing it to taper to the right. Start C and G with the same downstroke but finish shorter than O. Finish C with a short tapering downstroke; this is the same as the minuscule on a larger scale. To finish G, do a short horizontal stroke, then add a thick tapering downstroke below the baseline. Begin X with a reverse C shape, then add a standard C shape, finishing with a quick light stroke through the middle. Start U and W with a tall version of exercise 2, add a westerly flourish (exercise 8), then another exercise 2 stroke. Finish W with a backward-leaning O that does not touch at the top.

RULING PEN I GROUP

RULING PEN I GROUP Most of the letters in this group begin with a heavy downstroke and a westerly flourish (exercise 8) starting from the stem and curving to the left—this is the I. Turn the I into a T by continuing the stroke along the x-height and finish with a flick up to the left. Start E and F the same way, adding a crossbar and a horizontal stroke at the baseline to finish E. Start L with a heavy downstroke but do not add the westerly flourish; instead, use a short tapered serif and a thicker horizontal at the baseline. Note the striations and breakup in the L—this is a result of speed and pressure. Start D, B, and P with the heavy downstroke/westerly flourish combination, then for D add a sweeping curve to the right, touching the baseline and tapering to a point. Finish B with a smaller bowl at the top and a larger one at the bottom. For P, make the bowl slightly larger than the B. Begin H with a heavy angled downstroke that curves up to the left and tapers to a point; add the westerly flourish, then another downstroke and a light crossbar through the middle. Begin R and K as you did H; finish R with a q bowl and a kickout. For K, add a light quick upstroke from just below the center of the stem, then a similar kick to the R to the baseline. Start Z with a short diagonal downstroke, then a curving horizontal; add a heavy fast diagonal downstroke, and finish with another tapering horizontal at the baseline. Start S, unusually, at the baseline, make a short vertical upstroke, then make your curve from the baseline (the opposite of most hands' ductus) and finish with a short upstroke serif.

RULING PEN A GROUP

RULING PEN A GROUP Start A, M, and N with a lighter, curving diagonal downstroke flicking up to the left; for A, add an opposing heavy diagonal downstroke from the starting point, easing the pressure off and flicking up to the right. Add the thinner horizontal crossbar and finish with the westerly flourish. For M, add a heavy diagonal downstroke, then an opposing light diagonal downstroke that meets the second at the baseline, and finish with a heavy downstroke, easing the pressure off, flick up to the right, and finish with the westerly flourish. For N, pull a diagonal heavy downstroke to the right, add a light upstroke, overlapping the second stroke at the baseline, and finish with the westerly flourish. V and Y begin with a light upstroke curving into a vertical heavy downstroke. Finish both with a light curving upstroke, starting at the baseline for the V and about halfway up for the Y. Complete the Y with a short, light horizontal serif at the baseline.

157

VARIATIONS

Minuscules

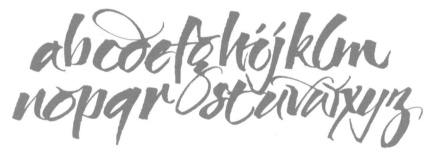

This reference alphabet shows the minuscule from the exemplar.

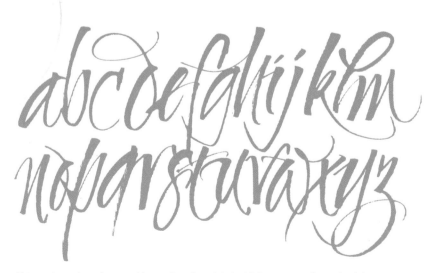

A heavier variation of the minuscule.

This version is done faster and larger than the original, with less concern for maintaining consistent strokes; as a result it has more energy.

Majuscules

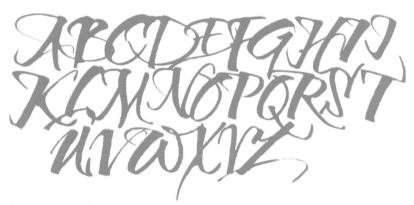

This reference alphabet shows the majuscule from the exemplar.

A heavier version of the majuscule.

A more vertical emphasis is used in these majuscules—this can increase legibility.
It could be used successfully with minuscule variation 1 or 3.

◆ PROFILE BETINA NAAB

My artwork is a combination of my graphic design background, six years of painting studies, and formal calligraphy studies. Working with my colleague Maria Eugenia Roballos [see pp. 178–179] also has a big influence on my style. Words are usually the starting point for new ideas, or I start with a theme and try to find the words afterward.

I love to sketch before starting a piece. I write down words and ideas that come into my head. This helps me overcome the fear of the empty page. I note comments about colors, styles of writing, size, format, and so on. I keep a sketchbook where I try to put everything, including paper samples.

My current passion is collage on canvas. It has given me the opportunity to reuse material I like but that didn't become a final piece, and combine it with all sorts of techniques. I usually start on paper, mount it on canvas, and add color, more writing, and so on. It is a lot of fun and gives me room to discover new things and a three-dimensional element.

I am able to combine artwork and calligraphy better now than when I started doing calligraphy. I have been evolving two styles in particular: an Italic cursive, and capital letters written with all sorts of tools including pencils and homemade ruling pens. My challenges have been to find my own voice and to keep evolving without having calligraphy tutors. My commercial work and teaching has helped with this. What excites me in calligraphy and lettering is the way you can stretch the shapes and composition of letters to express more than just the verbal meaning.

I recommend a solid formal background study, but in combination with other more artistic and creative skills. Don't hesitate to combine your own knowledge with calligraphy and try to get rid of prejudice. Follow your own instincts and don't be afraid to experiment and fail.

Bleach, gouache, sumi ink, and pastel crayons on Chagall paper; Mitchell nibs; ruling pen; 13¾ x 19¾in (350 x 500mm) (triptych)

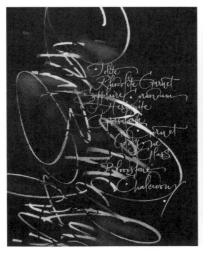
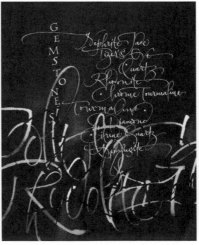
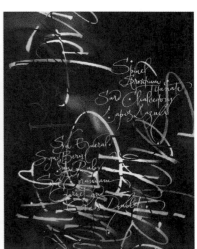

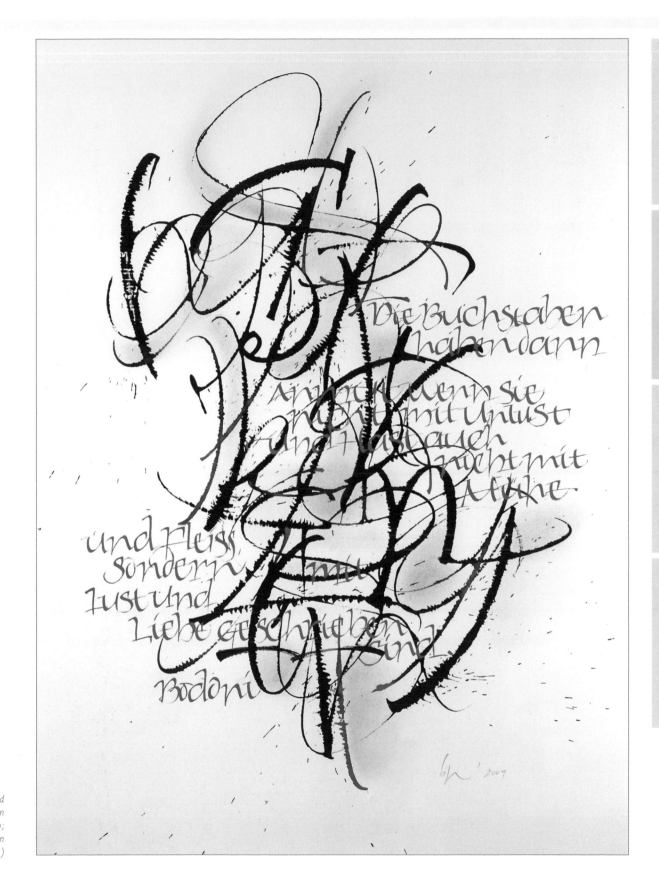

Gouache, sumi ink, and pastel crayons on Canson Edition paper; Mitchell nib; ruling pen; 15 x 21¾in (380 x 555mm)

GALLERY EXPRESSIVE

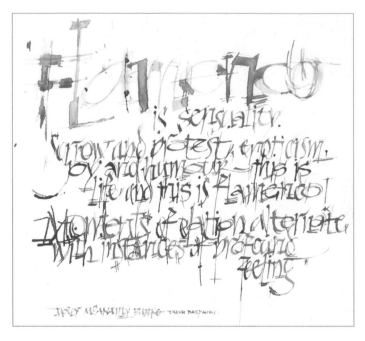

PETER EVANS (GESTURAL)
*Watercolor on paper; homemade pens and metal nibs;
10½ x 10¼in (270 x 260mm)*

**GAYE GODFREY-NICHOLLS
(GESTURAL)**
*Ink and pencil on Canson paper;
14¾ x 220½in (360 x 560mm)*

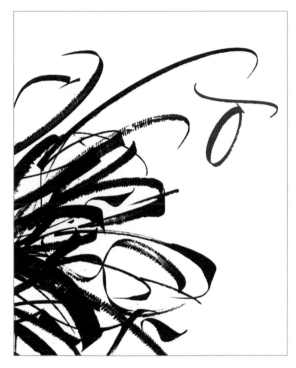

MARIA EUGENIA ROBALLOS (RULING PEN)
Sumi ink on sketch paper; Photoshop; ruling pen
7 x 10in (180 x 250mm)

Personal promotion piece.

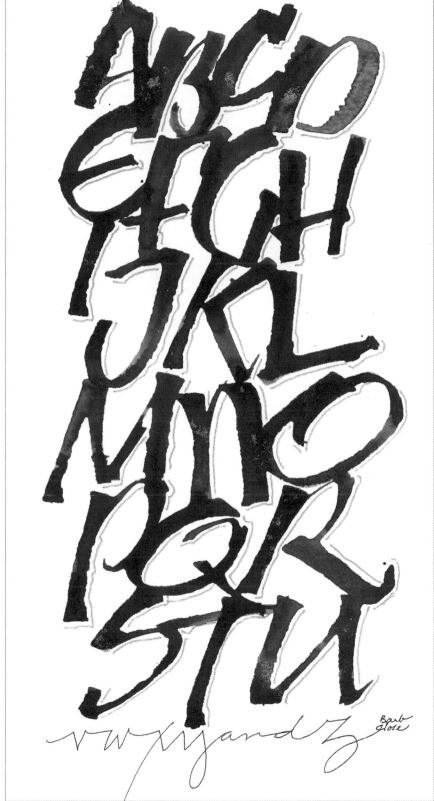

BARBARA CLOSE (RULING PEN)
Ecoline ink on paper; folded ruling pen;
8 x 15in (203 x 381mm)

GALLERY COMMERCIAL

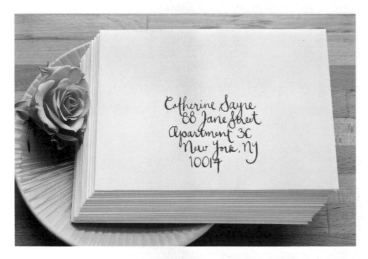

BRYN CHERNOFF (GESTURAL)
Sumi ink on paper; pointed nib

(Photography: Dan Eckstein)

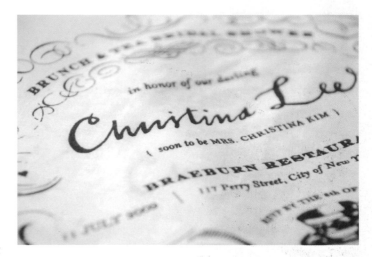

BRYN CHERNOFF (GESTURAL)
Black ink; tea napkins; pointed nib pen

The design of these tea napkins was a collaboration
between Paper Finger and Mimi Woo. (Photography: Mimi Woo)

Lord, make me an instrument of your peace

BRYN CHERNOFF (GESTURAL)
Black ink; pointed nib

Tattoo design created by Chernoff.
(Photography: Laynie Harris)

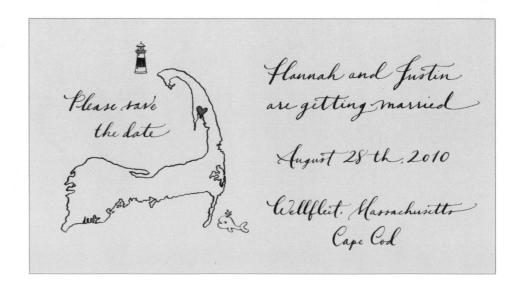

BRYN CHERNOFF (GESTURAL)
Dr. Ph. Martin's Matte Black Star Ink;
Strathmore Natural White Wove paper; pointed nib

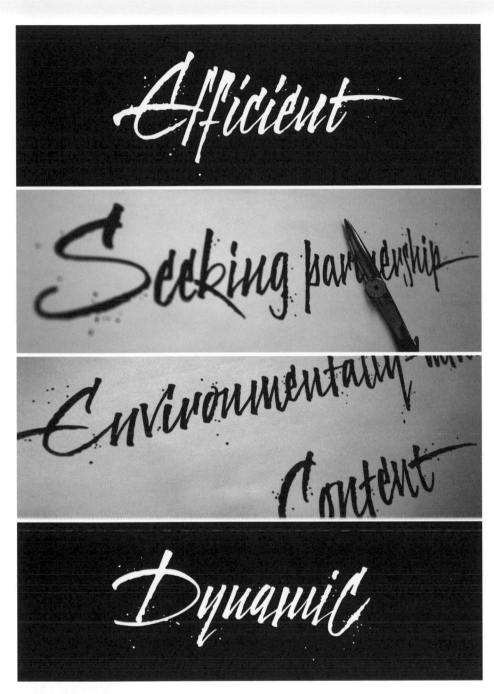

OLEG MACUJEV (RULING PEN)
Ink on paper

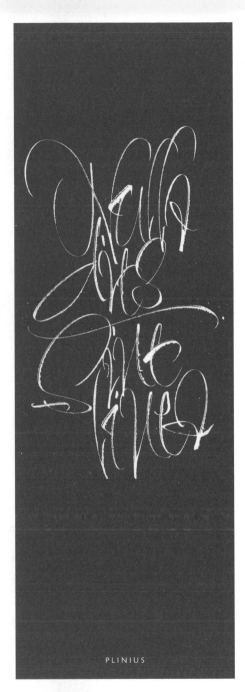

PLINIUS

JEAN LARCHER (RULING PEN)
Ink on paper

POINTED-PEN ALPHABETS

The pointed pen requires a completely different approach from the broad-edged pen. Many people find the use of pressure to create thick lines uncomfortable at first, and remembering the rhythm of light up, heavy down can take a while. The pointed pen does not have a reservoir to hold extra ink, so more dips or loads are necessary. It is possible to modify existing reservoirs to fit pointed pens; however, the most responsive pointed pens do not work well with reservoirs as they tend to squeeze the nib so the points misalign.

There is a vast range of pointed pens available. The best way to learn what nibs work best for you is to buy a selection and experiment systematically. I recommend the Gillott 404 and the Mitchell elbow nib to start with; they are a little stiffer, which makes learning to obtain thicks through pressure easier as there is less range of thickness possible. The Gillott 303 is a more flexible nib that easily allows a thicker downstroke, while the EF Principal is a very responsive nib that gives beautifully thin hairlines. If your hand is unsteady, a stiffer nib is preferable as small wobbles won't show up in your hairlines so much. As you become more experienced, you will find the more flexible nibs yield the most pleasing results. The same pen can be used for a range of letter sizes, although when working with very small sizes it is often advisable to use a finer and more responsive pointed nib. A smaller size of nib that requires a smaller pen holder can be used for very small writing.

In this chapter, we will examine two pointed-pen alphabets: the traditional and quite formal Copperplate, and the Contemporary Pointed Pen, which, as its name suggests, is a more modern alphabet. Both of these hands require the paper to be turned so the 55° slope lines (and thus pen alignment) are vertical. Many calligraphers prefer working on a flatter work surface—in fact, the ink will not flow properly if your board angle is too high.

NUMERALS AND PUNCTUATION

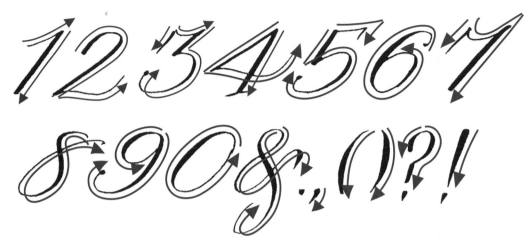

SUITABLE FOR COPPERPLATE x-height slightly shorter than majuscules • 55° letter slope •
Compressed character

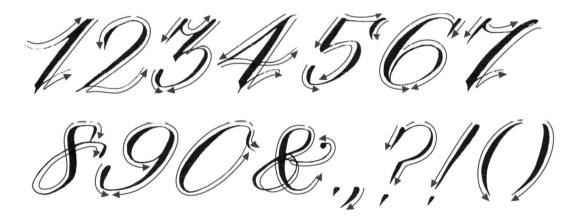

SUITABLE FOR CONTEMPORARY POINTED PEN x-height slightly shorter
than majuscules • 55° letter slope • Compressed character

COPPERPLATE

HISTORY

Copperplate evolved from the third and final phase of Italic development. Rather than the square-cut quill, scribes increasingly used the pointed metal pen for this Italic. This change led to a modification of technique to achieve thick and thin strokes; rather than holding the quill at a relatively constant angle, greater pressure was exerted on the downstrokes to form thick strokes. Styles became highly ornate, with flourishes often overwhelming the text. Copperplate was the pinnacle of baroque and rococo calligraphic styling.

Pen widths are irrelevant to pointed-pen alphabets, as they require pressure rather than pen angle to create thicks and thins. The size of ascenders, x-heights, and descenders are based not upon pen widths but determined by what size you want your letters to be. Height proportions of 3:2:3 are the most common; if you prefer longer ascenders and descenders, you could increase these to 4:2:4. The angle at which the pen is held is still critical for consistency with this hand. As the pen opens with pressure to create a thick line along whatever angle it is held, we will work with forward-sloping lines of 55° to align the downstrokes. You may find some variation of this angle listed in other books—some mention 53° or 54°, but there is little discernible difference.

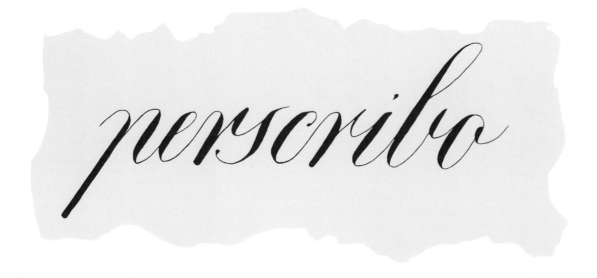

LETTER GROUPS: MAIN CHARACTERISTICS

The o shape is an isometric ellipse.

The letters of the n group have symmetrical arches that start low but branch two-thirds up the stem.

The underlying shape of the a group is the o shape.

Key points

- Pen angle: pointed nib held to align with 55° slope lines on the page

- x-height: usually shorter than ascenders and descenders

- Ascenders and descenders: usually long and looped

- Forms: compressed and sloping

- Arches: start low and emerge about two-thirds up the stem

- Rhythm: equidistant parallels

- O: based on a compressed, sloping isometric ellipse

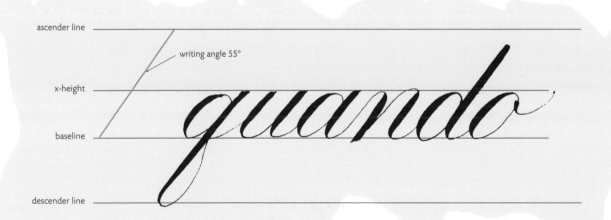

ascender line

writing angle 55°

x-height

baseline

descender line

EXERCISES

When you are learning Copperplate, begin with exercises designed to prepare you for the angles, strokes, and movement of the hand that are required. Complete about two lines of each exercise consistently before moving on to the next. Start with a Gillott 404 in an oblique pen holder or a Mitchell elbow nib in a straight holder.

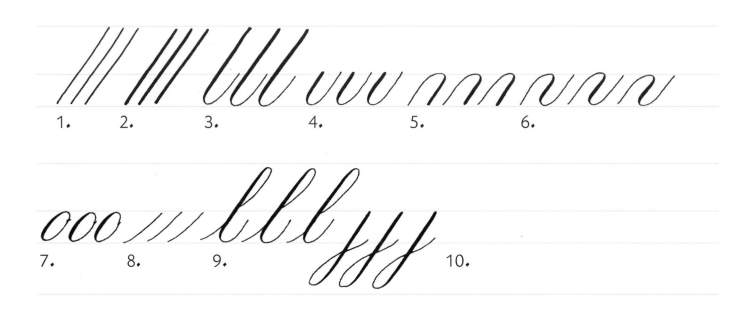

1. 2. 3. 4. 5. 6.

7. 8. 9. 10.

To begin, rule a set of guidelines. Use a ratio of 3:2:3 ascender: x-height: descender. Start with measurements of ⅜in (9mm) ascender, ¼in (6mm) x-height, and ⅜in (9mm) descender. Rule a series of 55° forward-sloping lines as well. After completing the exercises, begin working with the minuscule letter groups, using the same guidelines.

1. Establish the alignment of your pointed nib with your ruled 55° slope lines by turning your paper so the slope lines are vertical. Begin with light pressure; start your first strokes at the ascender line and finish at the baseline.

2. Make the same stroke with heavier pressure to achieve a thick downstroke. This is the key Copperplate stroke: heavy down, light up.

3. This is exercise 2 with an added curve to the right; ease the pressure off the nib before you start to curve.

4. Do a short version of exercise 3 by starting at the top of the x-height rather than the ascender line. The standard finishing stroke is exercise 3 with a shorter light upstroke—about halfway to the x-height line.

5. Turn exercise 4 upside down by starting with a light upstroke curving into a heavy downstroke. This is one of the standard starting strokes for arching letters such as n, m, p, v, and w. Start the light upstroke about halfway to the top of the x-height.

minimum onion

11.

million

6. Combine exercises 5 and 4 into one with a light up, heavy down, light up.

7. Starting on the right side about a quarter from the top, travel light up anticlockwise and do the o in one stroke, thickening as you go around to the left, and then light up to meet on the right. Imagine a sloping oval shape of white space inside your letter as you write.

8. Do the standard lead-in stroke with light pressure and a slight curve. This starts i, t, j, u, y, l, f, h, k, s, and e.

9. Start with the lead-in stroke from exercise 8, leave a small gap, then do a light upstroke with a curve and travel down with a heavy downstroke finishing with a light curving upstroke as you did with exercise 3. This is the standard looped ascender stroke.

10. Start the standard looped descender stroke with a heavy downstroke that loops to the left, stop when it meets the stem, then resume its journey up to the baseline.

11. Using just the strokes from the exercises, create words. Extend your finishing strokes to incorporate into the next letter—avoid stopping in the middle of a thin upstroke.

MINUSCULES

a b c d e f g h i j k l m n

o p q r s t u v w x y z

Minuscule alphabet with directional arrows showing the ductus.

Letterforms

As the o form in Copperplate is an isometric ellipse, the other letters in the o group—a, d, g, q, c, and e—and letters in other groups all conform to this shape, either fully or partially. Ascenders and descenders may be full loops, simplified plain lines, or a mixture.

Spacing

As one of the distinctive features of Copperplate is the joining of letters, make sure the finishing/starting extension strokes are smooth; avoid stopping and starting on a thin stroke, as this is difficult to conceal. This means that occasionally a very long sequence will be required; for instance, "tr" is done in one stroke from the top of the t to the bottom of

the r, while "ax" is done in one stroke from the right stem of the a to the bottom of the first stroke of the x (see the pangram example below). There are many permutations of letter combinations possible and only practice will allow you to anticipate and prepare for stroke extensions.

The rhythm of Copperplate is equidistant parallels. Maintaining this rhythm involves staying consistently on the 55° slope; this is a challenge, as most people tend to straighten their letters when concentrating on forms, with the result being a mixture of differently angled downstrokes. Use your ruled slope lines until you are very comfortable with keeping the slope consistent.

Use generous interlinear spacing with Copperplate, especially if you are working with 3:2:3 or higher proportions to avoid clashing ascenders and descenders.

trans zephrique globum scandant tua facta per axem jav wyk

Use this pangram phrase as a guide to spacing your words and letterforms.

i it j nn nnm nr p uu uy vv v w

COPPERPLATE i GROUP

Begin i with the lead-in stroke (exercise 8), a short heavy downstroke, then a light upstroke finishing halfway up the x-height (exercise 4). Start t with the lead-in stroke and begin your heavy downstroke a little higher than the i, but not as high as the ascender line. Finish the stroke as you did with i, then add the light crossbar right on the x-height line. Begin the j with the lead-in stroke, then exercise 10, the looped descender. Start n, m, and r with a light upstroke curving into a heavy downstroke (the short form of exercise 5), then add one arch for n and two for m. To finish the r, travel back up the stem and do a short u-shaped finish. Begin p as you did n, but continue down to three-quarters of the descenders' line. Finish as you would n. Start u and y with a lead-in stroke—finish u with exercise 4 and the finishing stroke, and finish y with the looped descender stroke (exercise 10). Begin v and w with a short form of exercise 6. To finish v, add a short u shape; for w, add another u-shaped arch then the same finish as the u.

o oa og oq od c e

COPPERPLATE o GROUP

Start o, a, q, g, and d with exercise 7. To finish o, add a small u-shape. To finish a, add the standard finishing stroke—the short exercise 4. To finish g, add the standard looped descender (exercise 10). For q, reverse the descender curve so it faces the opposite direction from the g. To finish d, add a descender by starting a quarter down from the ascender line and use the standard finish. Begin c with a dot, then travel anticlockwise following the o shape. Start e with the lead-in stroke, then add a small loop to the standard finish.

l bb lh lk ff s x z

COPPERPLATE l GROUP

Begin l, b, h, and k with the lead-in stroke, then the standard ascender stroke (exercise 9). Finish b with a short u-shape, and complete h with exercise 6. Finish k with a small bowl, tiny loop, heavy downstroke, then standard finish. Start f as you did h, but continue three-quarters down to the descender line and finish. Add a light curving upstroke for the crossbar that dips above then below the x-height. Start s with a more sloping lead-in stroke, then finish with a heavy downstroke that curves to the left and finishes with a dot. Begin x with an upside-down c that is overlapped by a right side up c. Start z as you did x, then make a small loop and a looped descender.

MAJUSCULES

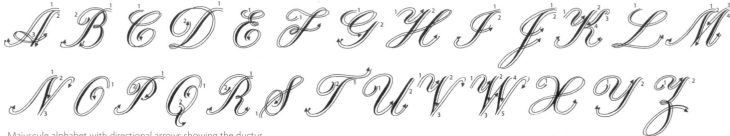

Majuscule alphabet with directional arrows showing the ductus.

Letterforms

Copperplate majuscules vary as much as Gothic majuscules (see p. 83); there are many variations of both historical and modern forms. Start with the simplest forms to understand the basic structure before you tackle the more elaborate and complicated forms. As with Gothic, avoid using all majuscules together—the result is not only difficult to read but visually jarring. The majuscules are undoubtedly a feature of the hand that most students find exciting, but they are generally more difficult to execute well due to archaic shapes and ductus. Some capitals are done in one stroke, which can be decoded by establishing where the thick lines are and knowing that they have to be downstrokes.

Spacing

With Copperplate, spacing majuscules is the same as for minuscules, as majuscules are always followed by minuscules. The finishing stroke is frequently overlapped by the next minuscule letter, thus giving the impression of a continuous stroke.

COPPERPLATE A GROUP Begin A, N, and M with a diagonal stroke that curves to the left at the base and finishes with a dot. To finish A, add a thick downstroke, hit the baseline, then curve to the left in a loop to form the crossbar. To finish N and M, add an almost identical thick downstroke but allow it to taper into a point at the baseline. To finish N, make a light upstroke that curves to the right.

To complete M, add a similar stroke without the curve, then the final thick downstroke with a finishing flick. Start V and W with a short version of exercise 6, then come into a thick downstroke that tapers to a point at the baseline. Finish V with the same stroke that finished N. To finish W, make another V shape.

S B S P S R S D L

COPPERPLATE B GROUP

Begin B, P, and R with the standard capital stem stroke—start with pressure at the top of the stroke, ease off as you curve at the baseline to the left, finishing with a dot. Continue with a clockwise curve. Finish B with a small loop just above the center and curve around to the left. Stop the bowl of P a little lower and finish with a dot. To finish R, make a small loop then curve to the right. Begin D as you did B but instead of finishing with a dot make a small loop at the baseline and stop. Make a large clockwise curve that cuts through the stem near the top and swings around to meet the small loop at the baseline. This is a tricky letter—the stem is positioned about two-thirds along the circular form. Start L with an anticlockwise loop, then come down through it with a thick downstroke and a small loop at the baseline and curve upward.

C X G E O O Q V U

COPPERPLATE C GROUP

Start C at the top and make an anticlockwise loop that continues down to form the thickened spine of the letter and finishes with a thickened loop. X is a one-stroke letter that begins with a dot and a clockwise curve like a reversed C. Continue through the middle and loop back around like a large minuscule e. Start G as you did C with the anticlockwise loop but curve up about two-thirds down, then make a thick downstroke that finishes in a dot. Start E in the same way, but on a smaller scale with a bottom loop that takes up the lower two-thirds of the height and finish as you did C. O and Q begin with an anticlockwise spiral—finish with a smaller spiral about a third from the top. To complete Q, add the final tail (a similar stroke to the first stroke of the minuscule x). Begin U with a clockwise spiral, make a thick downstroke, then a thin upstroke. Finish with a thick downstroke and curve to the right that terminates with a dot.

S T S I S J S Y Z H I K F S

COPPERPLATE T GROUP

Start T and I with the standard thick downstroke that tapers and ends with a dot. Finish T with a clockwise spiral that curves up, hits the top, and points upward. Finish I with an anticlockwise curve that cuts through the stem about halfway. Begin J with the standard descender stroke curving to the left, then add the same second stroke as the I. Start Y with a clockwise spiral and a short U-shape, then pull down into a thick downstroke ending with a dot. Begin Z with a smaller clockwise spiral and make a tiny Y shape, add a small loop, and finish with a large curve that points downward. H and K start with a tiny Y-shape. H continues, cuts through the stem, then loops around like a minuscule l. Stop K just above the baseline with a dot, then make a shape like a curly bracket with the point almost touching the stem. Begin F (another single-stroke letter) with a clockwise loop, swing around and come down into a thick downstroke before curving to the left, add an extra loop, then cut through the middle of the stem. Start S with a diagonal upstroke, loop around and swing into a thick downstroke finishing with a clockwise spiral.

VARIATIONS

Minuscules

abcdefghijklmnopqrstuvwxyz

This reference alphabet shows the Copperplate from the exemplar.

abcdefghijklmnopqrstuvwxyz

A plainer variation of the Copperplate minuscule.

abcddeffghijklmnopqrstuvwxyz

A more elaborate variation of the minuscule with flourishes, written with an EF Principal nib.

Majuscules

A B C D E F G H I J K L M
N O P Q R S T U V W X Y Z

This reference alphabet shows the Copperplate from the exemplar.

A B C D E F G H I J K L M N
O P Q 2 R S T U V W X Y Z

A plainer variation of the Copperplate majuscule.

A B C D E F G H I J K L M
N O P Q R S T U V W X Y Z

A more elaborate variation of the majuscule with flourishes, written with an EF Principal nib.

◆ PROFILE MARIA EUGENIA ROBALLOS

My work has been influenced by my graphic design background and my calligraphy studies at the Associazione Calligrafica Italiana (Italian Calligraphy Association). My style has a very strong European imprint because of the excellent teachers I had there. It has also been enriched by the daily work at my studio together with my business partner Betina Naab (see pp. 160–161).

Sometimes a color inspires me; at other times, there is a style or a particular theme I would like to explore. The visual aspect always prevails over the meaning of the written text. I sketch the image that takes shape in my head; it is usually quite different from the final piece. I don't always stick to this first inspiration; I enjoy being surprised by the result. On many occasions the final piece is a combination of sketches and casual compositions that appear during the creative process. When the visual aspect is the main component in the piece, the text isn't intended to be anything more than letterforms.

I have been experimenting with carpenters' pencils in my artwork. I look for subtle details by trying out different hardnesses. These are very clean, minimalistic pieces where the eye is drawn directly to the details of each mark. For my commercial calligraphic work, I have developed a personal style of Copperplate mixed with Italic, which results in a very fresh script without losing classical elegance.

In the beginning, I tried to use strictly what I had learned, even imitating the style of other calligraphers, without developing anything personal. Working with Betina Naab has helped me explore other paths and to search for my own style. Working with other high-level calligraphers enriches your personal work and helps you to grow as a professional calligrapher.

What excites me in calligraphy and lettering is the shapes. In experimental calligraphy as well as in lettering, the shapes and details of the strokes and the joining points, and the balance of the countershapes are what move me. Many times it is not the composition that seduces me, but each letter in particular.

I recommend a solid formal background for people just starting out in calligraphy; do not skip stages, and seek a personal style. Copying other calligraphers is useful, but only as an exercise. Don't get tempted by flourishes and the endless overlapping of strokes that can be seen in many calligraphy pieces. The shapes of the letters are what matters most; the rest will come with experience. Learning other art disciplines such as collage, painting, and bookbinding will also help you become a more complete calligrapher.

Collage, gouache, and paste paper on Canson Edition paper; pointed metal nib and woodtype; 16¾ x 16¾in (425 x 425mm)

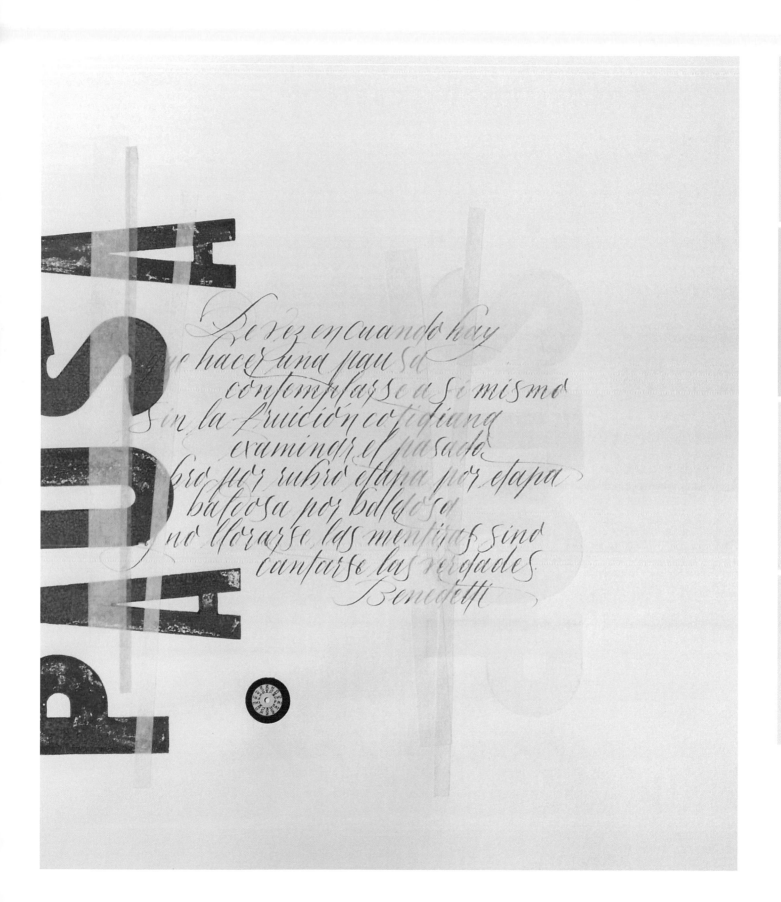

CONTEMPORARY POINTED PEN

HISTORY

The model used here is based on the work of Mike Kecseg, one of the foremost proponents of this hand. Mike has skillfully evolved the form into its own distinctive character, shaped by speed, confidence, and gesture, separate from the parent form of Copperplate but clearly related to it. I have added Italic aspects, such as the sharper arches and asymmetrical a-shape. The pointed pen has great potential for expressive or gestural writing, as it is extremely responsive to slight changes in pressure. This can be a disadvantage when beginning, but an advantage when you gain experience and wish for a more nuanced stroke. Thin Versals can take on a different character executed with a pointed pen—thick lines can be achieved with pressure rather than double strokes. The pointed pen and pointed brush have much in common, and mastering one skill set will make the other easier.

Set up your page as for Copperplate, with a flatter board than normal, 55° slope lines, and the paper turned so that those slope lines are vertical. Start with height proportions of 1.5:1:1.5. To minimize similarity to Copperplate, I have shortened the ascenders and descenders. It is the letter size you want that determines the heights for ruling guidelines. If you prefer classic Copperplate proportions, use 3:2:3; for longer ascenders and descenders, increase to 4:2:4. The same pen can be used for a range of letter sizes, but when working with very small sizes it is advisable to use a smaller or finer pointed nib.

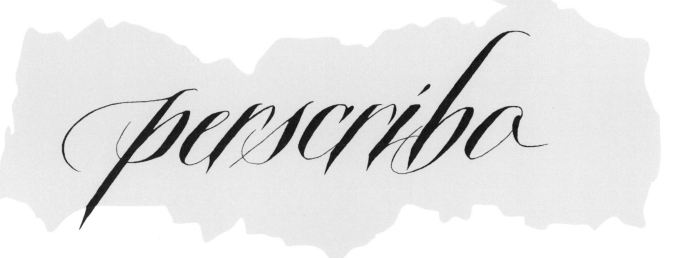

LETTER GROUPS: MAIN CHARACTERISTICS

The o shape is an
isometric ellipse.

The letters of the n group
have asymmetrical arches that
branch from low in the stem.

The underlying shape
of the a group is an Italic
rounded-off triangle.

Key points

- Pen angle: held to follow 55°
 slope lines on the page

- x-height: shorter than ascenders
 and descenders

- Ascenders and descenders: can
 be long and looped or shortened
 and plain

- Forms: compressed and sloping

- Arches: asymmetrical, branching
 from low in the stem

- Rhythm: equidistant parallels

- O: based on a compressed,
 sloping isometric ellipse

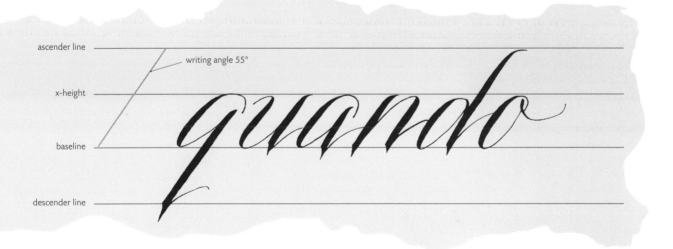

ascender line

writing angle 55°

x-height

baseline

descender line

EXERCISES

When you are learning this script, begin with exercises designed to prepare you for the angles, strokes, and movement of the hand that are required. Complete about two lines of each exercise consistently before moving on to the next. Start with a Gillott 303 in an oblique pen holder—I prefer a more flexible nib for this hand.

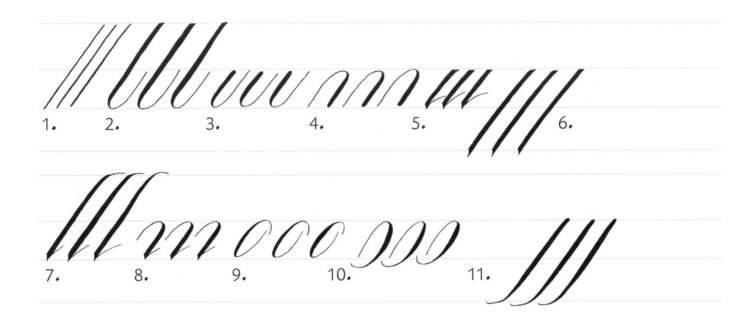

1. 2. 3. 4. 5. 6.

7. 8. 9. 10. 11.

To begin, rule a set of guidelines with a ratio of 1.5:1:1.5 ascender: x-height: descender. Start with measurements of ⅝in (15mm) ascender, ⅜in (10mm) x-height, and ⅝in (15mm) descender, and rule forward-sloping lines of 55° to align downstrokes.

1. Establish the alignment of your pointed nib with your ruled 55° slope lines by turning your paper so the slope lines are vertical. Begin with light pressure. Start your first strokes at the ascender line and finish at the baseline.

2. Start with heavy pressure at the ascender line with an added curve to the right—ease the pressure off the nib before you start to curve.

3. Do a short version of exercise 2 by starting at the top of the x-height rather than the ascender line. The standard finishing stroke is exercise 4 with a shorter light upstroke—about halfway to the x-height line.

4. The reverse of exercise 3, start at the baseline with a light upstroke, arch, and add pressure for the downstroke, finishing at the baseline.

12. *minimum*

13. *onion million*

5. This downstroke with a hairline flick is one of the most important in this hand and is present in the majority of letters. Start with pressure at the top of the stroke, ease off slightly, then add pressure at the base. Drag it into a point, then make a quick flick about a third up the x-height.

6. Repeat exercise 4, but extend down to the descender line and don't add the flick.

7. Come in from the right with a thin curve at the top of the ascender line and finish with the flick from exercise 5.

8. Similar to exercise 4, but start about halfway up the x-height and add the flick from exercise 5.

9. Start this about a third from the top of the x-height with a light upstroke, travel anticlockwise, add pressure on the downstroke, ease pressure off, and come back up on the inside of the starting point.

10. Similar to exercise 4, start at the baseline with a light upstroke, arch and add pressure for the downstroke, and curve back past the starting point.

11. Start this simple descender stroke with a thick downstroke and ease the pressure off as you curve to the left at the descender line.

12. Identical to exercise 11, add a hairline loop to the right, crossing the stem just under the baseline. This is the standard looped descender.

13. Create words from the strokes of the exercises.

MINUSCULES

Minuscule alphabet with directional arrows showing the ductus.

Letterforms

The o form in Contemporary Pointed Pen is an isometric ellipse, as with Copperplate, but the forms are looser and allow for adaptations of speed and gesture. The other letters in the o group—a, d, g, q, c, and e—all conform to this shape partially; they are somewhere between Italic and Copperplate. The main departure from Copperplate is the stem finishing stroke, in which a convex hairline upstroke is done at speed separately to the final stem.

In the exemplar above, a second version shows an alternative letter with a gentle curve that dips below the baseline (exercise 3). These letters can be combined with the first version, which has a sharp flick (exercise 5); it makes for an interesting contrast.

Spacing

The rhythm of Contemporary Pointed Pen is equidistant parallels, but as you grow more confident and free with the form you can change this to polyrhythms or irregular parallels that have a more asymmetric balance. Keep interlinear space large to start with, as it will increase legibility. For a denser texture, decrease interlinear space.

Use this pangram phrase as a guide to spacing your words and letterforms.

ii tt ir inn inmm ll lhh lbb lpp lk

CONTEMPORARY POINTED PEN i GROUP

Begin i with exercise 5 and add a dot. For the second version, use the gentle curve from exercise 3. Start t above the x-height, but finish as you did with i and add a hairline crossbar on the x-height line. Start r, n, and m with a heavy downstroke. Finish r with a partial clockwise arch; for n and m, add the arch from exercise 8. For m, add another arch before the final finishing stroke. For l, do exercise 7. For h, add to the l (without the finishing flick) the arch from exercise 8. Begin b as you did h, then add the curve from exercise 10. Start p with exercise 6, then add the curve from exercise 10. Begin k with exercise 7, then add a clockwise loop and kick the leg out.

oaa oqogg oddd ceo uvy

CONTEMPORARY POINTED PEN o GROUP

Start a, q, and g with exercise 9 shape (note that the finish is to the left of the start). To finish a, add a slightly shorter exercise 5; to finish q, a longer version (exercise 6); to finish g, add a simple descender (exercise 11) or a looped descender (exercise 12). Begin d with exercise 9 and finish with exercise 7, or exercise 2 at a more vertical angle or a hairline loop. Start c with a short tapering downstroke and finish with an anticlockwise curve following the shape of exercise 9. For e, start with a small anticlockwise loop, following the shape of exercise 9. Begin o with exercise 9 and add a small u-shaped loop to finish. Begin u and y with a thin upstroke and then exercise 3. Finish u with exercise 5 and y with the simple descender (exercise 11) or a looped descender (exercise 12).

jj ff w ww ix z s

CONTEMPORARY POINTED PEN j GROUP

Begin j with a simple descender (exercise 11) or a looped descender (exercise 12) and add a dot. Start f with a short tapering downstroke at the ascender line, then combine exercises 7 and 6 for a long ascender to descender stroke. Finish it with a hairline crossbar at the x-height. Begin v and w with exercise 8, but pull the hairline upstroke out from the stem before sweeping upward. Finish v by curving to the right; for w, add a stroke like a partial o and finish with a slight u-shaped loop. Start the almost vertical stroke that makes the body of x with a hairline arch up, heavy downstroke, and light upstroke. Finish it with a thin swinging downstroke that stops just short of the descender line. Begin z with a short tapering downstroke—with a clockwise curve, loop just before the baseline and finish with a looped descender (exercise 12). Start s with a long hairline lead-in stroke and finish with a heavy downstroke with a mini looped descender that emerges about halfway up the stem.

MAJUSCULES

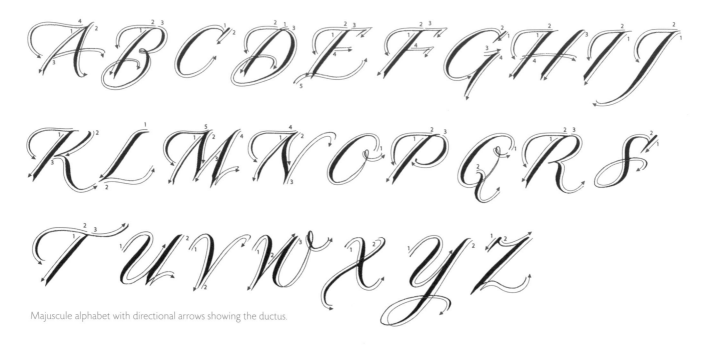

Majuscule alphabet with directional arrows showing the ductus.

Letterforms

In the same way that the minuscules have ventured away from the formality of Copperplate, so too the majuscules avoid typical Copperplate embellishments—I have kept closer to the Italic capitals. Keep them simple and use pressure to bring a slight emphasis to the flourishes as well as the terminations (as with the minuscule stem strokes). Keep the majuscules slightly shorter than the ascenders: if your x-height is (³⁄₈in) 10mm, make your majuscules ½in (13mm) tall (proportion close to 1:1.25).

Spacing

With Contemporary Pointed Pen, spacing majuscules is the same as for minuscules, as majuscules are generally followed by minuscules. The finishing stroke is frequently overlapped by the next minuscule letter, thus giving the impression of a continuous stroke.

CONTEMPORARY POINTED PEN C GROUP

Start C and G with a short tapering downstroke and finish with an anticlockwise curve following the shape of exercise 9—this is the same as the minuscule on a larger scale. To finish G, do a short horizontal, then add a thick tapering downstroke below the baseline. O and Q begin with a bigger version of exercise 9 and finish with a larger loop. To complete Q, add the final tail (a similar stroke to the first stroke of the minuscule x).

CONTEMPORARY POINTED PEN I GROUP

Begin all majuscules in this group with the standard capital stem stroke: start with pressure at the top of the stroke, ease off slightly, then add pressure at the base and taper to a point. Add a simple left-curving flourish that begins at the place you started the stem, which can stay thin or thicken slightly on the bowl. This makes the I shape. To finish T, add the right side of the crossbar with a hairline that sweeps up to the right. F and E continue with horizontal strokes that drop into a short, thin vertical serif. Finish E with a curving horizontal hairline.

Leave the flourish off L and finish with the curving horizontal hairline. H is completed by adding another downstroke and a hairline crossbar through the middle. Finish K with a diagonal that travels to the stem then kicks out below the baseline. P, B, and R continue with a bowl: finish P to the right of the stem; finish R with a kick like the K, and finish the B with a loop and another curve that comes back through the stem about a third up. Finish D with a large curve that cuts through the stem at the same place as the B.

CONTEMPORARY POINTED PEN A GROUP

Begin A, N, and M with a diagonal stroke that thickens slightly at the base. Add the same left-curving flourish that you did with the I. To finish A, add an almost vertical thick downstroke and curve to the right before adding the crossbar. To finish N and M, add an almost vertical thick downstroke that curves slightly to the left. To finish N, make a light upstroke that curves to the right. To complete M, add a similar stroke without the curve, then the final thick downstroke with a finishing flick. Start V and W with a curving upstroke that thickens as you come down and tapers to a point at the baseline. Finish V with the same stroke that finished N. To finish W, leave the curve out of the thin upstroke and then add a thick curving downstroke that is very similar to the majuscule O shape.

CONTEMPORARY POINTED PEN U GROUP

U and Y are essentially large versions of their minuscule counterparts, as is J. To finish J, add the standard flourish curving to the left. Begin S with a short tapering downstroke, add a curving downstroke, counter-curve, and swing up to cross through the center of the stem (the same loop at the looped descender stroke). X is a large version of minuscule x. Start Z with a short tapering downstroke, add a convex hairline curve to the right, a heavy diagonal downstroke, and finish with a curving horizontal hairline stroke that swings up, down, and up again.

VARIATIONS

Minuscules

abcdefghijklmnopqrstuvwxyz

This reference alphabet shows the hand from the exemplar.

abcdefghijklmnopqrstuvwxyz

A lively variation of the Contemporary Pointed Pen minuscule, this version requires more pressure on the downstrokes for thicker letters as well as more free movement and looped flourishes.

abcdefghijklmnopqrstuvwxyz

This is a hand that I have called Emiline. It is in some ways a short, wide version of Contemporary Pointed Pen with a touch of Akim Cursive (invented by Hans Joachim Burgert). It was also influenced by a font called Johann Sparkling, and an essence of imagined 19th-century diary bookhand.

Majuscules

A B C D E F G H I J K L M

N O P Q R S T U V W X Y Z

This reference alphabet shows the hand from the exemplar.

A B C D E F G H I J K L M

N O P Q R S T U V W X Y Z

A lively variation of the Contemporary Pointed Pen majuscule, this version requires more pressure on the downstrokes for thicker letters and an extension of hairlines flourishes that often pass through the stem of the letters in a generous curve.

The Emiline majuscules tend to be a looped version of Contemporary Pointed Pen majuscules; the minuscules are nicely counterpointed with a more ornate capital.

◆ PROFILE BAILEY AMON

As a professional calligrapher and business owner, my lettering tends to be most influenced by the client and what they are looking for. I draw from many resources when researching a project—historical manuscripts, antique lettering in advertising and packaging, signs, and vintage exemplars are some of my favorites. I am constantly on the lookout for any lettering that I can study and develop into my own style. My studies of historical broad-edge hands have trained me to break down scripts, stroke by stroke, and really see the letter shapes. This helps me immensely in my effort to reproduce the letters with my nib.

I love to be outdoors and be free to just see and observe my surroundings. It clears my head and creates my best work. Visual stimuli from online sources such as Pinterest and design blogs are very good for sparking new ideas. My business partner and I use this approach to create the content for our online magazine, *The Antiquarian Post*. It is one of the few places where I can experiment with different styles of lettering since it is not client-based.

I usually start my work by doing rough sketches with pencil or black Sumi ink on graph paper or smooth copy paper. I do this before diving into the full project so that I have an execution plan. For traditional fine-art pieces, the final piece is done slowly and perhaps multiple times depending on the project. However, I often work with black ink on white paper that is then scanned into the computer. Much of the editing and design happens in Adobe Illustrator.

Currently, I do a lot of pointed pen and drawn letter work for reproduction. I love seeing my lettering go beyond the page and get letter-pressed or made into a rubber stamp. One of my passions is to make calligraphy accessible and bring it to a wider audience. Most people think everything is computer-generated, so I love being able to share and educate them on the practice of calligraphy.

In the beginning, I was so passionate about calligraphy that I knew pretty quickly that I wanted to make it a big part of my life. Three months after my first class, I quit my day job and opened my calligraphy business. I've been lucky to have had many mentors and teachers help me get through the unique and potentially scary projects I've encountered. My first paying job was recording a family's birth and death history in a 100-year-old Bible. It took lots of deep breathing and constant spell-checking!

Practice is the key to achieving consistent letterforms. Addressing envelopes was great practice for me—constant repetition and many different letter combinations helped me learn endurance and spacing. It is very important to surround yourself with inspiring seasoned calligraphers who will mentor you in the learning process. My mentors helped me out of frustrating and nerve-racking situations that on my own might have made me feel discouraged.

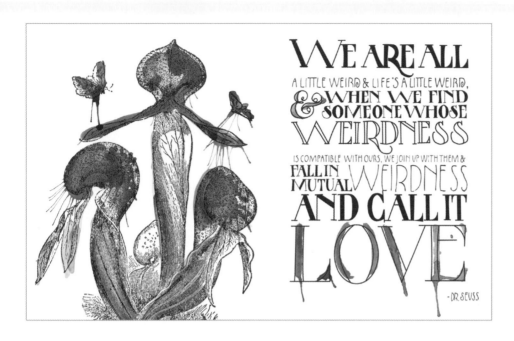

WE ARE ALL A LITTLE WEIRD & LIFE'S A LITTLE WEIRD, & WHEN WE FIND SOMEONE WHOSE WEIRDNESS IS COMPATIBLE WITH OURS, WE JOIN UP WITH THEM & FALL IN MUTUAL WEIRDNESS AND CALL IT LOVE

– DR. SEUSS

Digital collage; watercolor;
vintage etchings; Micron pen; paintbrush

This artwork was a collaboration between Bailey Amon and Emma James for *The Antiquarian Post*.

Collage of digitized calligraphy
and photography; pointed pen

An update of the traditional love letter using a loose, free Pointed Pen script. Text by John Steinbeck. (Photography by Robert Bredvad.)

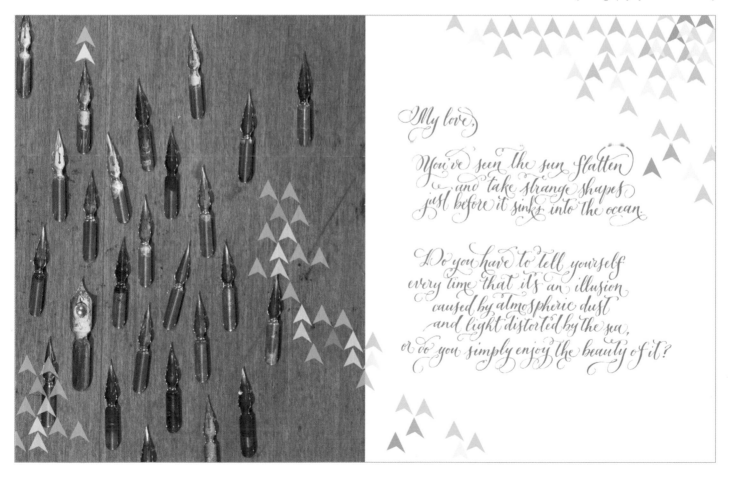

My love,

You've seen the sun flatten
and take strange shapes
just before it sinks into the ocean.

Do you have to tell yourself
every time that it's an illusion
caused by atmospheric dust
and light distorted by the sea,
or do you simply enjoy the beauty of it?

GALLERY EXPRESSIVE

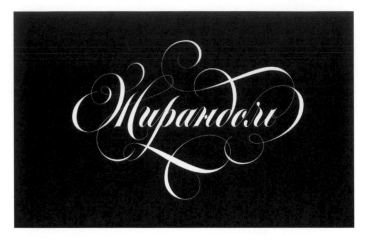

OLEG MACUJEV (COPPERPLATE)
Ink on paper

Macujev created the logos above and above right using a
copperplate nib to create elegant baroque-style calligraphy.

OLEG MACUJEV (COPPERPLATE)
Ink on paper

**MONICA LIMA
(COPPERPLATE)**
*Sumi Moon Palace black ink
on cream cardstock; Oblique
penholder with a Gillot 404
vintage nib*

**MONICA LIMA
(COPPERPLATE)**
*Sumi Moon Palace ink on
cardstock; flower accents
painted with gouache and
a fine camel-hair brush;
Oblique penholder and
a Nikko G nib*

**YANINA ARABENA
(CONTEMPORARY
POINTED PEN)**
Sumi ink on paper

**YANINA ARABENA
(CONTEMPORARY POINTED PEN)**
*The calligraphy piece shown left scanned,
vector-traced, and applied to a rubber stamp*

193

GALLERY COMMERCIAL

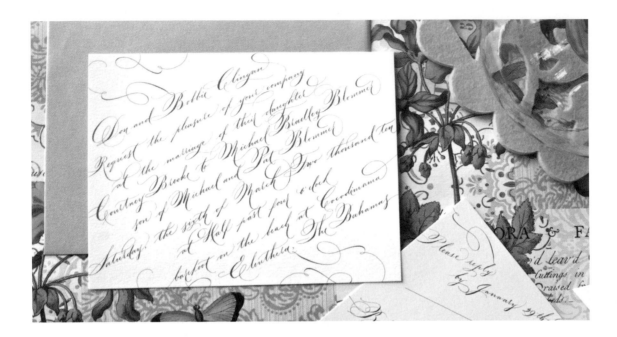

DANAE BLACKBURN-HERNANDEZ (COPPERPLATE)
Ink on card

BAILEY AMON (CONTEMPORARY POINTED PEN)
Sepia ink on bartlett pears; Pigma micron pen

This project was for a title page in the holiday 2011 issue of The Antiquarian Post. (Photography: Robert Bredvad)

JANA ORSOLIC (CONTEMPORARY POINTED PEN)
Created by hand and then digitized

THERESE SWIFT-HAHN
(COPPERPLATE)
Pointed pen and ink

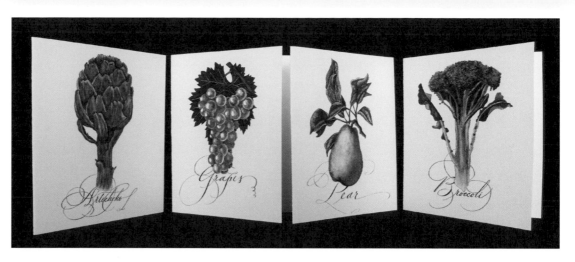

VITALINA AND VICTORIA LOPUKHINA OF
VISUALIZERS (CONTEMPORARY POINTED PEN)
Pointed pen; brush; ink

BRUSH ALPHABETS

In this chapter, we explore alphabets using the pointed and the flat brush. Both require quite different techniques and feel very different from the pointed or broad nib—although both pointed instruments rely on pressure for thick strokes, and both edged tools rely on pen/brush angle. It can take time to get used to the responsiveness and flexibility of a brush after working with metal nibs.

Brushes are available in a greater range of sizes than nibs, with the finest pointed brush generally being size 000 (or 3/0). Flats range from about 1/16in (1.5mm) to enormous 12in (30cm) brushes used for gesso and wallpaper glue application. There are many varieties of brushes, from the traditional and expensive sable through to synthetics such as taklon and golden nylon. Within those groupings you can find long brushes or short ones; experiment and discover which length suits you.

There are advantages to using brushes rather than nibs: With certain substrates—heavily textured paper, handmade paper, fabric, wood, stone, and shiny surfaces such as glass, stone, or plastic—ink or gouache in a broad pen would not remain, but acrylic and other media painted on with a brush will often successfully adhere.

I recommend working with gouache rather than ink; it is better for your brush and gives pleasing results. Working on a flat surface rather than a sloping one is also advisable; it allows for whole-body movement, particularly when working with large sizes. Flat brush grip can be similar to pen grip, although holding the flat brush more vertically allows for easier twisting and manipulation. The vertical hold associated with Oriental brush techniques is recommended when using the pointed brush, as it facilitates fine upstrokes. The main disadvantage is the instability of the hand, which does not rest on the substrate. Allow the wrist and little finger to rest on the substrate to create more stability. If greater height is required, place the other hand under the writing hand.

NUMERALS AND PUNCTUATION

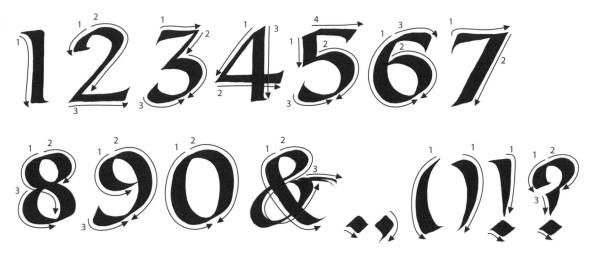

NUMERALS SUITABLE FOR FLAT BRUSH x-height slightly shorter
than majuscules • 0° letter slope • Compressed character

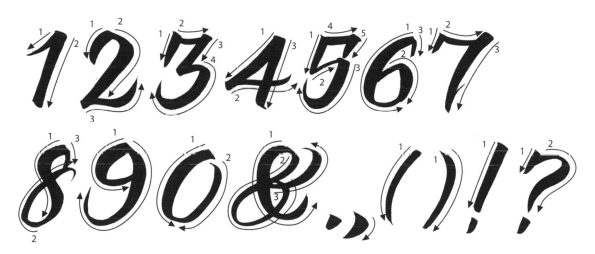

NUMERALS SUITABLE FOR POINTED BRUSH x-height slightly shorter
than majuscules • 30° letter slope • Compressed character

FLAT BRUSH

HISTORY

The flat or chisel brush is in many ways a good substitute for the broad nib. Most of the broad pen hands can easily be adapted for use with the flat brush. The one we examine here is an adaptation of Charles Pearce's Bold Roman, which is itself a modification of Foundational with brush manipulation. My version is nowhere near as meticulous as Charles's so it might be more accurately described as Free (Roamin') Roman!

The flat brush has a marvelous textural quality that imparts an extra dimension to broad pen scripts, allowing the stroke to break up with dry brush effects. Many calligraphers have successfully exploited this effect, as you will see in the Gallery (pp. 222–223).

The major difference between using a broad pen and a flat brush is the responsiveness of the brush to pressure and the ease with which you can twist the shaft of the brush. Although the flat brush uses the same pen angle principles as the broad pen, the brush is more sensitive to pressure, so precise and controlled movements are required. There are a number of pleasing effects that a flat brush can achieve that are not possible with other instruments, so experiment and discover the joys of manipulation and pressure. Given that manipulation is required for this hand, bear in mind that it is a more advanced or challenging hand, and it may take longer to achieve pleasing results.

LETTER GROUPS: MAIN CHARACTERISTICS

To understand the shape of the o, imagine a full circle inside a square.

The letters of the n group have symmetrical arches that branch from high in the stem.

The underlying shape of the a is the n shape.

Key points

- Brush position: varies from 0° to 90°, often 30° and 45°
- x-height: four brush widths
- Ascenders and descenders: two brush widths
- Forms: round
- Arches: symmetrical, branching from high in the stem
- Rhythm: undulating and round with equidistant parallels
- O: based on a circle

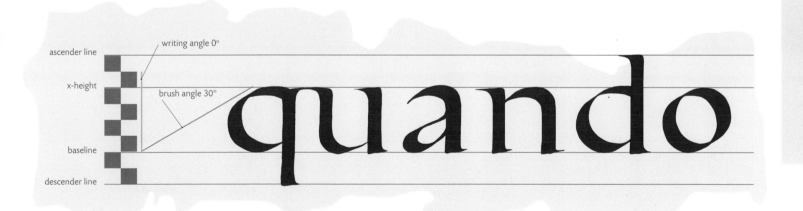

ascender line
writing angle 0°
x-height
brush angle 30°
baseline
descender line

quando

Flat brush minuscule letters within guidelines showing the x-height, ascender and descender heights, and writing angle.

EXERCISES

When you are learning Flat Brush script, begin with exercises designed to prepare you for the angles, strokes, and movement of the hand that are required.

Mix some gouache or watercolor to the consistency of light cream. Wet the brush thoroughly so the paint will adhere effectively. Take a small square of scrap card or matboard and paint the initial load from the brush onto the card, turning so both sides are used equally. This works both to reduce excess media and to shape the edge of the brush, which can easily lose its sharpness, resulting in inconsistent letters with thick hairlines. Alternatively, the brush can be pulled along the side of the paint container. Each time you load the brush, wipe off and shape—this will soon become an automatic action. Test the edge by drawing the brush along to form a square; it should have clear straight sides and sharp defined corners.

Work on a sloping or flat surface; try out both and see what works best for you. As with pointed brush, I prefer a flat surface that facilitates more whole-body movement. Use the vertical hold as described in the brush introduction. Start with the exercises. Complete about two lines of each exercise consistently before moving on to the next. After completing the exercises, begin working with the minuscule letter groups, using the same guidelines.

1. 2. 3. 4. 5. 6. 7.

8. 9. 10. 11. 12. 13. 14. 15.

minimum onion

16.

To begin, rule up guidelines with an x-height of four brush widths—1in (24mm)—and ascenders and descenders of two brush widths—½in (12mm); start with a flat brush of approximately ¼in (6mm). I like to use the Westart D22 or the flin Silver Crystal (6808S SQ wash) flat brush; they are synthetic and consistent.

1. The standard keystroke of this alphabet: at 0°, slide in at the x-height with a thin horizontal serif and extra pressure as you curve into a thick vertical downstroke. Finish the same way you started with extra pressure as you finish around the curve, and taper off along the edge of the brush. Fran Strom Sloan called this exercise the "knife-in, knife-out" stroke.

2. Repeat exercise 1, then add a curve, branching from the stem about a fifth from the top, changing the brush angle from 30° to 0° around the curve. Pull the stroke down and finish with the knife-out stroke.

3. Begin at 0° and knife in as you did in exercise 1, then, as you bring the brush down, lift the right side so the angle increases up to about 60° and finish at the baseline.

4. The reverse of exercise 3: Start at a higher angle of 60° for the downstroke, then flatten as you go toward the baseline. Finish with the knife-out stroke.

5. This exercise, common to a number of hands, is the classic crescent moon leaning backward. Start at 30° at the x-height, curve around, and finish just above the baseline.

6. The inverse of exercise 5: start at 30° just below the x-height, then curve around to the right, finishing on the baseline.

7. Put exercises 5 and 6 together to form an o.

8. The next five exercises form the manipulated serif strokes. Start at 30° just under the x-height, make a gentle arc to the right, twist the brush to almost 90° to finish about the same level as the start, and knife down to finish with a smooth straight serif.

9. The reverse of exercise 8: Begin at 90° just above the baseline, curve to the right, twisting the brush to about 30°, then tapering to a point about the same height as the start.

10. Very similar to exercise 8: start at 30°, but pull into a horizontal stroke along the x-height, before knifing down to finish with a smooth straight serif.

11. Very similar to exercise 9: begin at 90° just above the baseline, but pull into a horizontal stroke along the x-height, twisting the brush to about 30°, tapering to a point.

12. A combination of exercises 11 and 10: begin at 90° just above the baseline, but pull into a horizontal stroke along the x-height, twisting the brush to about 30°, before twisting back to 90° and knifing down to finish with a smooth straight serif.

13. Start at 0° and knife in, pulling into a diagonal from left to right, finishing at the baseline.

14. Start at 0° and knife in, this time pulling into a diagonal from right to left, twisting the brush to taper into a point.

15. Begin at 30° with a curve, then countercurve, finishing at the baseline.

16. Create letters and words using the strokes from the exercises.

MINUSCULES

abcdefghijklmn
opqrstuvwxyz

Minuscule alphabet with directional arrows showing the ductus.

Letterforms

If you have worked with the Foundational hand (see p. 44), this script will feel familiar. As is the case with numerous hands, this Flat Brush script has a standard keystroke that is used in many of the strokes that make up the letters: exercise 1. Once you master this stroke, your letters will become more consistent.

Spacing

The rhythm of this Flat Brush hand is regular undulating arcs with equidistant parallels. Careful spacing is very important to maintain this rhythm. Interlinear space needs to be at least eight pen widths from baseline to baseline to ensure that ascenders and descenders don't clash. However, as you progress, you may wish to change the texture of the writing block and decrease it for a denser texture or increase it for ease of legibility.

trans zephrique globum
scandant tua facta per
axem jav wyk

Use this pangram phrase as a guide to spacing your words and letterforms.

iljltſlſf

FLAT BRUSH i GROUP
Begin i with exercise 1, knife in at 0°, make a thick vertical downstroke, knife out, and add a dot. Start l at the top of the ascender line and proceed exactly as you did with i. Begin j with a simple descender tapering off at the descender line and add a dot. Start t halfway between the x-height and the ascender line, make a thick vertical downstroke, and finish with a curving arc, using pressure to slightly thicken the curve. Add a crossbar on the x-height line—this is exercise 10. Begin f at 30°, at the top of the ascender line on a curve, then pull a thick vertical downstroke, knifing out at the baseline. Add a gentle curving arc (exercise 8) at the top, then a crossbar on the x-height (exercise 10).

vvvwyɪxˉ7z

FLAT BRUSH v GROUP
Start v, w, and y with the diagonal from exercise 13; finish v with exercise 14. The second stroke of w has no serif, so pull a diagonal right to left at about 45°; this makes joining the last v easier. Finish y at 30° with a descender that swings to the left and tapers off to a point. Start x by knifing in at the x-height; use the same diagonal stroke and knife out at the baseline. Add the second stroke at 0°, pulling a diagonal from right to left, tapering in the center then thickening and knifing out at the baseline. For z, start with exercise 11, draw a thick diagonal from right to left, and finish with exercise 10.

ɪnmrlhɿɑʋɥylk

FLAT BRUSH n GROUP
Start n, m, and r with a knife-in, heavy downstroke, and knife out. To finish n and m, add the arch from exercise 2; for m, add another arch before the final finishing stroke, and finish r with a short version of exercise 8. Begin h as you did l and finish with the arch from exercise 2, knifing out along the baseline. Start the letter a with the arch from exercise 2, knifing out along the baseline. Finish with a stroke at 30° about a third of the way up the stem emerging out of the stem about halfway and loop around, rejoining the stem about a quarter of the way up. Begin u and y with exercise 1, but make a wide curve at the baseline (the inverse of exercise 2); finish u with exercise 1. Finish y with a tapering descender like a j. Start k with an l, add a diagonal starting at 0° then twisting to 30° to finish and kick the leg out, twisting to 0° to finish flat on the baseline.

cocecqdlbɿpʊggſss

FLAT BRUSH o GROUP
Hold the brush at 30° unless otherwise indicated. Start o, c, e, q, and d with the same stroke, the crescent-moon shape of exercise 5. Join the arc to finish the o with exercise 6 and add a flattened arc to finish c (exercise 8). Add a curving hook to finish e, a flattened arc for the top of q, and finish q with a simple descender, knifing out at the descender line. For d, add a flattened arc and a simple ascender, knifing out at the baseline. Begin b at the ascender line, knifing in, then make a heavy downstroke and swing into a curving arc, using pressure to slightly thicken the curve. Finish b with exercise 6. Start p with a long version of exercise 1, knifing out at the descender line, then add exercise 6. Start g like a short o, add the serif (a mini version of exercise 8) at 45°, and swing the descender down in a slightly flatter version of exercise 15. Finish g with a sweeping anticlockwise stroke at 30° and meet the previous stroke. Start s with exercise 15, add the top stroke (exercise 8), and finish with the bottom stroke (exercise 9).

MAJUSCULES

Majuscule alphabet with directional arrows showing the ductus. The majuscules used here are based on Roman majuscules (see pp. 38–39), but are much looser and more relaxed in order to match the minuscule.

Letterforms

As for the Flat Brush minuscules, if you have worked with the Foundational hand (see p. 44), this script will feel familiar. It has a standard keystroke that is used in many of the strokes that make up the letters: exercise 1. Once you master this, your letters will become more consistent.

Spacing

As with Roman, consider the volume of the counterspace as an indicator for the amount of space between majuscule letters. Use the internal space inside the H as the standard unit of volume for spacing majuscules together. As a rough guide, letters with straight stems are generally placed furthest apart (the basic H counterspace); a curve placed with a stem is closer, and curves together are placed closest.

IH⋀AWINNIT
LUⅣXⓎYⁱ7Z

FLAT BRUSH H GROUP

Start H at 0° with the standard keystroke, knifing in at the top and knifing out at the bottom and repeat. Finish with a horizontal stroke at about 10°. Starting at about 60°, do the first diagonal of A by veering to the left, flatten the brush to 0°, and knife out at the baseline. Balance it by starting at the same point and veering to the right with a thick diagonal twisting the brush to 0°, and finish with a horizontal stroke at 10°. Start V as you did with the minuscule, with a diagonal starting at 0°, twisting to 45°, then add the second stroke at 0°, twisting to taper to a point and meet the first stroke at the baseline. Begin N with a tall version of exercise 4, then pull a thick diagonal from left to right and finish by dropping down directly above the diagonal termination with exercise 3. Create T with the standard keystroke and cap with exercise 12. Start U as you did the minuscule b—knife-in, heavy downstroke and sweeping curve to the right, then overlap with another keystroke, a larger version of the minuscule. Start Y as you did V, then drop a short downstroke, knifing out at the baseline. Begin Z, another larger version of the minuscule, with exercise 11, add a diagonal from right to left, then finish with exercise 10.

LℙBIℙRILFELKⵚⵚ⌡

FLAT BRUSH B GROUP

Start B with the standard keystroke, then curve out to the right as you did with D. Add the top bowl then the bottom bowl, making it slightly larger than the top, overlapping at the baseline. Begin P and R with the standard keystroke, then add the top bowl. The bowl on R is slightly smaller than that of P—finish it with a diagonal from left to right that twists into a 0° brush angle at the baseline. Start F, E, L, and K with the standard keystroke. For F and E, add exercise 10 along the top, then another emerging halfway down the stem. Finish E and L with exercise 11. To finish K, start at 0°, pull a diagonal just above the center of the stem, then kick the leg out, twisting to 0° to finish flat on the baseline. Another larger version of the minuscule, begin S with exercise 15, then add the top stroke (exercise 8) and the bottom stroke (exercise 9). Start J by knifing in at 0°, drop a thick downstroke, and curve below the baseline.

OLCGQLD IⵏVMWW

FLAT BRUSH O GROUP

O, C, G, and Q begin with a bigger version of exercise 5. To complete O, add a larger version of exercise 6. Finish C and continue G with exercise 8, knifing in with a short vertical bar to complete G. To finish Q, add the final tail, allowing it to taper to the right. Begin D knifing in with a heavy downstroke, then continue with a large curve to the right. Finish D with a horizontal stroke that turns into exercise 6, and overlap the previous stroke at the baseline.

FLAT BRUSH M GROUP

Begin M with a tall version of exercise 4, then pull a thick diagonal from left to right, finishing at a point on the baseline. Add the opposing diagonal right to left then the final downstroke at a slight backward angle, knifing out at the baseline. Create W by simply doing a larger version of the minuscule—essentially adding two Vs together.

VARIATIONS

Minuscules

abcdefghijklmn
opqrstuvwxyz

This reference alphabet shows the Flat Brush minuscule from the exemplar.

abcdefghijklm
nopqrstuvwxyz

This minuscule is a version of Flat Brush Gothic, showing the effects of the dry-brush technique. This is a nod to Luca Barcellona and John Stevens, who both make outstanding brush Gothic forms.

abcdefghijklm
nopqrstuvwxyz

This minuscule is inspired by Eliza Holliday's Eliza Vertical script, using a fairly flat brush angle, a tall compressed form, and some dry-brush effects.

Majuscules

ABCDEFGHIJKLMN
OPQRSTUVXYZ

This reference alphabet shows the Flat Brush from the exemplar.

This majuscule is a version of Flat Brush Gothic, showing the effects of the dry-brush technique.

This majuscule is inspired by Eliza Holliday's Eliza Vertical script; it features a fairly flat brush angle and a tall compressed form with some dry-brush effects.

◆ PROFILE RACHAEL YALLOP

20th- and 21st-century German calligraphers are my biggest influences, primarily Werner Schneider and Hans-Joachim Burgert. My work is also inspired by abstract shapes and designs, particularly those found in nature, and by tools and the marks that they make. I find living in a peaceful and beautiful country environment very conducive to producing creative work.

I rarely do rough sketches; I see the whole piece in my head and then I start. Obviously the first rendition may not be the finished one, but each attempt starts by being "the one." I also leave a piece overnight if I cannot see what is required to finish it. The next morning, I creep up on it unawares before it has a chance to rearrange itself; the solution then jumps out at me.

My hand-skills have developed in calligraphy enormously, and consequently my work has improved over the years. This has also helped me try new things that I might not have had the confidence to do before. The development of hand-skills is down to practice—the pursuit of calligraphy in a serious manner is a lifetime's work.

Gouache, charcoal, and conté on paper; flat brush, round brush, ruling pen, and eraser; 14 x 18¾in (355 x 475mm)

In my experience, there are two things essential for successful calligraphy: concentration and analysis. Through my own development and through teaching, I have realized that the ability to concentrate intensely and for long periods of time is vital. Also the ability to analyze one's work in minute detail, see what is wrong with it, and then make corrections. You need to be willing to take risks with your work, to push things, to be free-thinking, and you need a strong imagination if you want to develop free creative styles. You also need a very steady and controlled hand!

What excites me in calligraphy and lettering has to be line. I adore it! The shape made by a beautiful line perfectly placed, the many textures, and in particular the tension between one line and another—the electricity is almost palpable.

At the moment I'm enjoying doing large gestural pieces with extreme contrast between line characteristics; for example, texture and weight. I see myself moving toward drawing. Not drawing as an entity in itself, but using drawing skills and materials to create letters or to enhance them.

Gouache, charcoal, and conté on paper; flat brush, round brush, ruling pen, and eraser; 21 x 27in (535 x 700mm)

Gouache, pastel, and conté on paper; flat brush, eraser; 21 x 26in (540 x 660mm)

POINTED BRUSH

HISTORY

The pointed brush requires a different approach from the broad-edged pen: A slight change in pressure will fatten up a hairline, and render an adequate shape lumpy and inept. However, the pointed brush is a wonderfully responsive tool and is worth the struggle to master. The most popular hands to adapt are Italic and Copperplate, which take on a distinctive quality when executed with this tool. Any hand can be modified, but some are more difficult: Gothic presents challenges, as curves detract from the rhythm and straight lines of this hand.

Pointed brush has an immediate personal quality that is recognized by its prevalence in advertising, graphic design, and packaging. We will examine a hand based on Eliza Schulte Holliday and Marilyn Reaves' Pointed Brush script, as well as looking at abstract gestural marks. Many calligraphers use the pointed brush for sweeping gestural marks rather than as a substitute for a metal nib, for precise lettering.

The pointed brush is held in a similar position to the broad nib, but the downstroke is angled the opposite way. Samples of this script can look effortless and spontaneous, but care must be taken with hairlines: These are the biggest challenge, as too much pressure in the upstroke will thicken the stroke. Stopping at the base of the stroke and changing your hold on the brush to use the tip in a more vertical fashion is a good way to start.

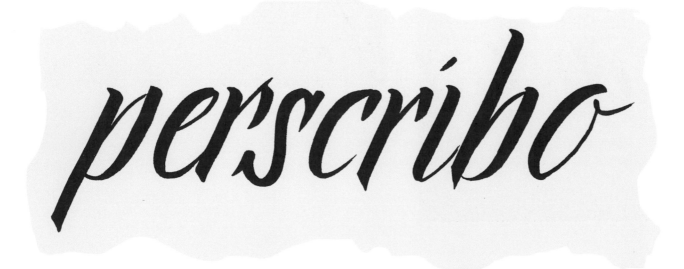

The o shape is a compressed ellipse.

The letters of the n group have asymmetrical arches that branch from low in the stem.

The underlying shape of the a group is the same as the o.

Key points

- Brush position: mainly held sideways
- Writing angle: downstrokes about 30° from the vertical (or 60° from the writing line)
- x-height: shorter than ascenders and descenders
- Ascenders and descenders: extended and usually simple
- Forms: compressed and sloping
- Arches: asymmetrical, branching from low in the stem
- Rhythm: equidistant parallels
- O and A: based on a compressed ellipse

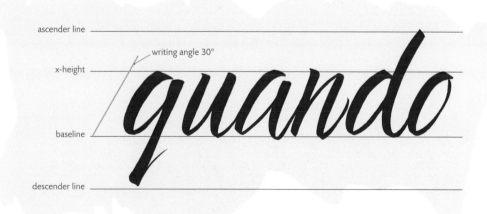

Pointed Brush minuscule letters within guidelines showing the x-height, ascender and descender heights, and writing angle.

EXERCISES

When you are learning Pointed Brush script, begin with exercises designed to prepare you for the angles, strokes, and movement of the hand that are required.

Use a small- to medium-size pointed brush—I like the Silver Ultra Mini (Designer RD 2431S) size 6, which is made in Japan. A waterbrush (a synthetic taklon brush fitted to a hollow barrel that can be filled with media) is an excellent alternative, and often gives better results than a traditional brush. The waterbrush can also be dipped into media.

Mix some gouache or watercolor to the consistency of light cream. Wet the brush thoroughly so the paint will adhere effectively. Take a small square of scrap card or matboard and paint the initial load from the brush onto the card, rolling the brush so the tip stays tapering to a point. This reduces excess media and shapes the tip, which can easily lose its sharpness, resulting in inconsistent letters with thick hairlines. Each time you load the brush, roll off on the card; this will soon become an automatic action.

You can work on a sloping or a flat surface. Try out both and see which you prefer. I find a flat surface works better for me; I can also stand up if I want to get more body movement. Start with the exercises. Complete about two lines of each exercise consistently before moving on to the next. After completing the exercises, begin working with the minuscule letter groups, using the same guidelines.

To begin, rule a set of guidelines with an x-height of ¾in (20mm), and ascenders and descenders of ⅜in (10mm). As with Copperplate and Contemporary Pointed Pen, pen or brush widths are not relevant to these proportions, as pressure is the factor that affects stroke thickness.

1. Holding the brush sideways, pull an angled downstroke from the x-height to the baseline.

2. Repeat exercise 1, stop, then in a more vertical position, add a fine curving upstroke with the tip of the brush.

3. Repeat exercise 1, stop, then in a more vertical position, add a fine arching upstroke with the tip of the brush, branching about halfway to a third from the top of the stem.

4. Holding the pen sideways, start an angled downstroke with a slight curve at the start and finish. Stop at the baseline, then, in a more vertical position, add a fine upstroke with the tip of the brush.

5. Extend exercise 4 so the fine upstroke finishes near the start of the letter.

6. In a vertical position, add a fine upstroke with the tip of the brush following the same path as the second stroke of exercise 3.

7. Extend exercise 6 with a heavy downstroke that curves back to meet the start of the letter.

8. Holding the brush sideways, pull an angled downstroke from the x-height, curving to the left to finish at the bottom of the descender line. This forms the standard descender stroke.

9. Holding the brush with the point facing left, make a small horizontal entry stroke, then pull a heavy downstroke to the right, tapering off to a point at the baseline.

10. Holding the brush sideways, pull an angled downstroke form the x-height, tapering down to a point at the baseline.

11. Form letters and words from the strokes of the exercises.

213

MINUSCULES

a b c d e f g h i j k l m
n o p q r s t u v w x y z

Minuscule alphabet with directional arrows showing the ductus.

Letterforms

The o form in Pointed Brush is a compressed ellipse, quite similar to Contemporary Pointed Pen (see p. 184). The forms are even looser due to the nature of the pointed brush, and allow for adaptations of speed and gesture. The other letters in the o group—a, d, g, q, c, and e all conform to this shape partially—are somewhere between Italic and Copperplate. The stem-finishing stroke is a curving or a convex hairline upstroke, and is made separately to the final stem.

Spacing

The rhythm of Pointed Brush is equidistant parallels, but as you grow more confident and free with the form you can change this to polyrhythms—irregular parallels that have a more asymmetric balance. The third variation (see p. 218) shows this kind of rhythm. Keep interlinear space large to start with, as it will increase legibility. Decrease interlinear space for a denser texture.

trans zephrique globum scandant tua facta per axem jav wyk

Use this pangram phrase as a guide to spacing your words and letterforms.

nilljtsfff

POINTED BRUSH i GROUP

Begin i with exercise 2 and add a dot. Start l at the top of the ascender line and proceed exactly as you did with i, adding the finishing stroke separately. Begin j with a simple descender (exercise 8) and add a dot. Start t above the x-height, but finish as you did with i and add a hairline crossbar on the x-height line. Begin f at the top of the ascender line on a curve, then pull an angled downstroke to the bottom of the descender line. Add a short tapered serif at the top, then a hairline crossbar on the x-height.

vvwyvx zz ssss

POINTED BRUSH v GROUP

Start v, w, and y with the angled downstroke from exercise 9. To finish v, add exercise 10; to finish w, add another v; to finish y, extend exercise 10 to the descender line. Begin x with exercise 9 but curve to the right and taper off. Finish with a cross-stroke similar to exercise 10, but taper and swing at the baseline. Make a z by holding the pen sideways and pull a short tapering horizontal stroke across the x-height. Pull a heavy, more angled, downstroke across to the left, then finish another short tapering horizontal stroke on the baseline. Start the first s with a fine hairline upstroke at a stroke angle of about 45°, then finish with a heavy downstroke that curves to the left and tapers to a point. Begin the second s with a curve and countercurve, then flick upward. Add the short tapering downstroke to finish.

iirnnmir lh lb jp lk

POINTED BRUSH n GROUP

Start n, m, and r with a heavy downstroke. To finish n and m, add the arch from exercise 3 then exercise 2; for m, add another arch before the final finishing stroke, and finish r with a short tapering downstroke. Begin h, b, and k with a tall version of exercise 1; to finish h, add the arch from the n. To finish b, add exercise 7, and to finish k, add a clockwise loop and kick the leg out. Start p with a long version of exercise 1 finishing at the descender line, then add exercise 7.

ccaqgdiuywcceo

POINTED BRUSH a GROUP

Start a, q, g, and d with the exercise 5 shape (note that the finish does not quite touch the start). To finish a, add exercise 2; to finish q, extend the heavy downstroke to the descender line. To finish g, add a simple descender (exercise 8). Finish d with an angled heavy downstroke like an l. Begin u, y, and the curved w with exercise 2. Finish u with another exercise 2 and y with the simple descender of exercise 8. Finish w with a tapering downstroke that joins the upstroke. Start c and e with exercise 4; to finish c, add a short tapering downstroke. For e, finish with a short curving downstroke that meets the stem at the halfway point. The o is exercise 5.

MAJUSCULES

ABCDEFGHIJK
LMNOPQRSTU
VWXYZ

Majuscule alphabet with directional arrows showing the ductus.

Letterforms

Many of the strokes that are required for the majuscules are simply proportionately larger versions of the minuscules, with extra pressure to thicken the strokes.

Spacing

When using Pointed Brush majuscules together, spacing can often be tighter than, for example, Roman. The example I have shown here is done at speed; packing letters closely often works effectively with this kind of approach.

COCCGOQID

POINTED BRUSH O GROUP O and Q begin with a bigger version of exercise 5. To complete Q, add the final tail, allowing it to taper to the right. Start C and G with a larger version of exercise 4. Finish C with a short tapering downstroke—this is the same as the minuscule on a larger scale. To finish G, do a short horizontal stroke, then add a thick tapering downstroke below the baseline. Begin D with a heavy angled downstroke, then finish with a large curve that cuts through the stem at the baseline.

216

IH/∧∆W∆W∆WINN IT

LU/X``Y`yy`7Z

POINTED BRUSH H GROUP

Begin H with a heavy angled downstroke, add another downstroke, then a hairline crossbar through the middle. Start A with a lighter, diagonal downstroke, add an opposing heavy diagonal downstroke from the starting point, then add the thinner horizontal crossbar. V is another majuscule that is a larger version of the minuscule, so begin with a tall version of exercise 9, then add exercise 10. Start N with a light angled downstroke, then pull a diagonal heavy downstroke to the right, curving slightly to the left. To finish N, add the same stroke that you began with, overlapping the second stroke at the baseline. Begin T with a heavy angled downstroke and finish with a tapering horizontal stroke at the top. X is a large version of minuscule x, so begin with exercise 9 and taper to the right. Finish with a diagonal cross-stroke that crosses through the center of the first. The first y starts like a short v, then drops into a short heavy downstroke. The alternative versions of Y begin with a small u; the first curves and tapers to the left, the second is a simple heavy angled downstroke. Start Z, a large version of the minuscule, with a short tapering horizontal, add a heavy diagonal downstroke, and finish with another short tapering horizontal at the baseline.

IPRBTFELKSSIJ

POINTED BRUSH B GROUP

Start P, B, and R with a heavy angled downstroke, then continue with a bowl. Finish P to the right of the stem, finish R with a kick, and finish B with a loop and another curve that comes back through the stem at the baseline. Begin F and E with a heavy angled downstroke, then continue with tapering horizontal strokes, two for F and three for E. Begin L and K with a heavy angled downstroke and finish L with a tapering horizontal stroke at the baseline. Finish K with a diagonal that travels to the stem then kicks out at the baseline. Begin S with a curving downstroke, countercurve, and taper off, finishing with a short tapering downstroke, the same as the minuscule. The simplest majuscule of all is the I—a tall version of exercise 1. Create the J as you did the minuscule, with exercise 8 and a little more pressure to thicken it up.

I∧NM∆V∧W

POINTED BRUSH M GROUP

Begin M with a light angled downstroke, add a heavy diagonal downstroke, then an opposing light diagonal downstroke that meets the second at the baseline; finish with a heavy downstroke at the same angle as the first stroke. Create W (another majuscule that is a larger version of the minuscule) by overlapping two Vs.

VARIATIONS

Minuscules

abcdefghijklm
nopqrstuvwxyz

This reference alphabet shows the Pointed Brush from the exemplar.

abcdefghijklmn
opqrstuvwxyz

This variation of the Pointed Brush minuscule is written with more pressure on the downstrokes and at a faster speed than the exemplar version, with flicked finishing strokes instead of curves.

abcdefghijklm
nopqrstuvwxyz

This variation of the Pointed Brush minuscule is also written at a faster speed; it has more variation of stroke angle, thickness height, and alignment, which results in a more dynamic feel.

Majuscules

ABCDEFGHIJKLM
NOPQRSTUVWXYZ

This reference alphabet shows the Pointed Brush from the exemplar.

ABCDEFGHIJKLM
NOPQRSTUVWXYZ

This variation of the Pointed Brush majuscule is written at a faster speed than the exemplar version, with more pressure (and therefore a heavier feel); it has flicked finishing strokes instead of curves.

ABCDEFGHIJKLM
NOPQRSTUVWXYZ

This variation of the Pointed Brush majuscule is also written at a faster speed; it has more variation of stroke angle, thickness, height, and alignment, imparting a more dynamic feel.

◆ PROFILE SUE ALLCOCK

My biggest influence has been joining the Calligraphers' Guild of Western Australia in Perth: a constant source of teaching good lettering, providing regular workshops, with a good library, exciting projects, exhibitions, wonderful friendships, and sharing. I am constantly influenced by the beauty and talent of other artists and calligraphers around the world.

So many things inspire my calligraphy: colors, shapes, movement, contrast, the subject matter, good design, books, the joy of being able to see work of others on websites, and the wonderful calligraphy teachers I have had. I am inspired by my faith, the beauty of landscapes and nature, the joy of life, and of course words.

I seem to work backward when approaching a piece. I am definitely not a good planner. I usually do various backgrounds for the sheer enjoyment of it, and then often a subject for the lettering will suggest itself and I go ahead with it. This sometimes results in failure, but sometimes gives me a nice surprise! I really enjoy working this way and I like to keep myself open to all possibilities. The area I most enjoy working in at the moment is with brushes. I enjoy working on various backgrounds, using watercolors, gouache, inks, and bleach, spraying techniques with various sizes of spray bottles, using brushes and nibs, also different tools. It is usually experimental work done with speed and energy.

Since beginning calligraphy in 1989, I have found myself drawn to contemporary calligraphy, especially brush calligraphy. I love experimental, abstract, and gestural marks, resulting in my work being very loose and varied.

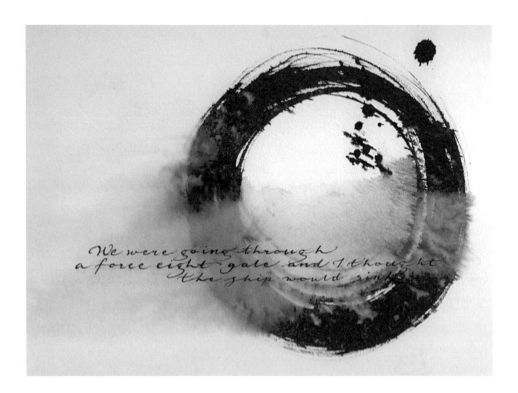

Watercolor and gouache on watercolor paper; damaged brush and copperplate nib; 7½ x 9¾in (190 x 250mm)

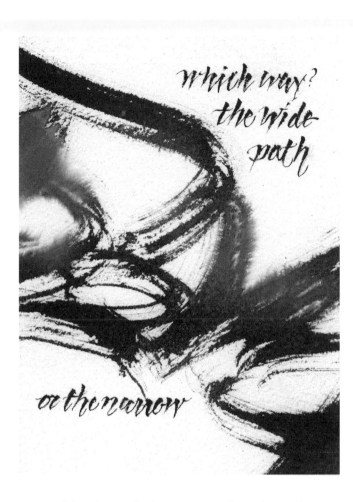

Quink ink and bleach, gouache on Black Canson paper and watercolor paper; damaged brush; 5 x 7in (130 x 180mm)

Dr. Ph. Martin's pen ink and gouache on black Canson paper; damaged brush, 5½ x 11¾in (140 x 300mm)

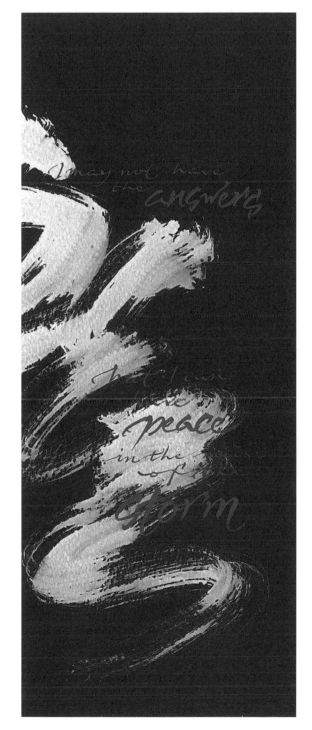

Some of the things I find exciting in calligraphy and lettering are negative shapes; black marks on white background, especially works done in red, black on white, or white on black; Arabic calligraphy with its wonderful distinctive shapes; strong contrast; pushing the envelope; pen manipulation; new alphabets; using a large brush and making a lively quick mark on white paper, Japanese style. I see myself moving toward more experimental and abstract work, but I never want to lose the ability to do fine lettering.

My advice to those starting out in calligraphy would be to join a guild or established calligraphy group, find an inspiring teacher whose work you admire, then seriously study and learn the scripts. Practice, practice, practice, constantly learn, and research the various works available through books and websites.

GALLERY EXPRESSIVE

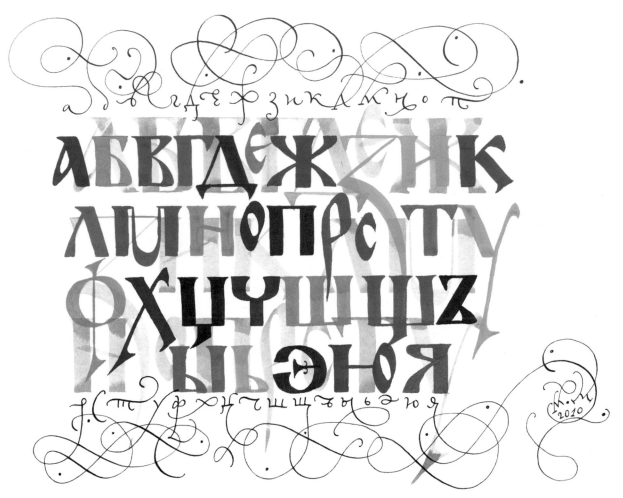

MARINA MARJINA (FLAT BRUSH)

Flat brush and pointed pen

The idea with this piece was to connect in one composition two Russian historical styles of the Ustav and Skoropis.

**GAYE GODFREY-NICHOLLS
(POINTED BRUSH)**

*Pointed brush and Brause nib on paper;
5¾ x 8¼in (148 x 210mm)*

MARINA MARJINA
(FLAT BRUSH)
*Ink and gouache
on craft paper*

Two Russian writing
styles overlapped.

GALLERY COMMERCIAL

OLEG MACUJEV (POINTED BRUSH)
Faber-Castell PITT brush pen and ink

ANNA BOND (POINTED BRUSH)
Pointed brush; gouache

ANNA BOND (POINTED BRUSH)
Pointed brush; gouache

**FRANCESCA BIASETTON
(FLAT AND POINTED BRUSH)**
Flat and pointed brushes; acrylic; fabric; wood

Biasetton created this calligraphy for fashion designer Martino Midali. It is her variation on Italic and Copperplate.

NATASHA MILESHINA (POINTED BRUSH)
Pointed brush; Indian ink; watercolor paper

BARBARA CALLOW (POINTED BRUSH)
Pointed brush; gouache

BACKGROUNDS AND COLORS

Making backgrounds is an exciting aspect of calligraphy, although some calligraphers prefer to work with a more neutral background that allows the lettering to be the principal design element. Watercolor paper is popular because it is an amenable surface for writing on, but other media, such as acrylic and Plaka, can also be used effectively. We will look at handmade paper, papyrus, marbled paper, embossing, and a resist technique using masking fluid.

In many historical manuscripts, color is restricted to illuminated letters, illustrations, and decorative capitals, with the main body of text rendered in black or brown ink. Today we have the luxury of using a dizzying array of colors in any way we desire. Gouache, the media of choice for using color in the pen or brush, allows us to write in a pale color over a dark background. The simple technique of changing colors each time you load your pen is easy, effective, and striking.

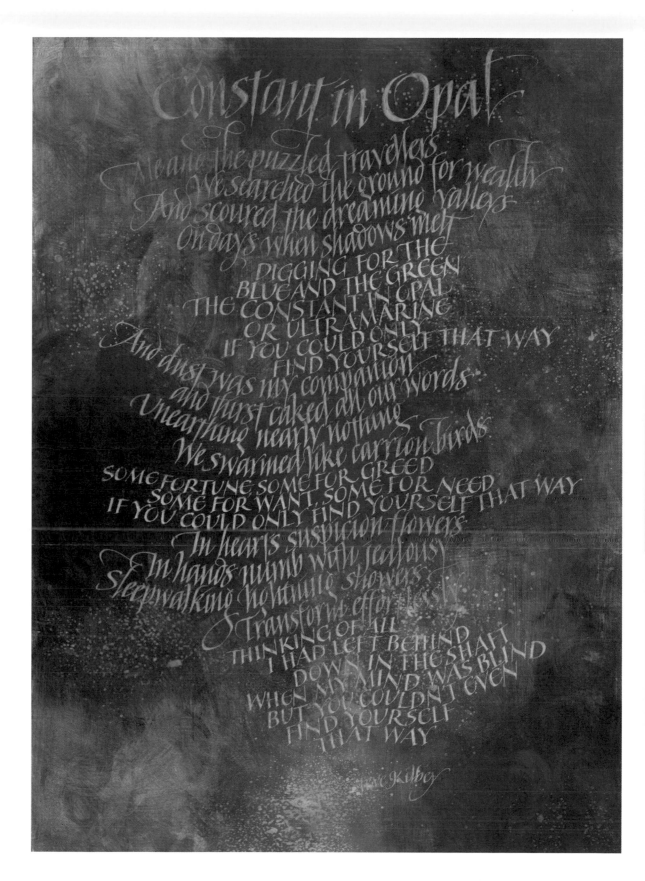

Constant in Opal

We are the puzzled travellers
We searched the ground for wealth
And scoured the dreaming valleys
On days when shadows melt
DIGGING FOR THE
BLUE AND THE GREEN
THE CONSTANT IN OPAL
OR ULTRAMARINE
IF YOU COULD ONLY
FIND YOURSELF THAT WAY
And dust was my companion
and thirst caked all our words
Unearthing nearly nothing
We swarmed like carrion birds
SOME FORTUNE, SOME FOR GREED
SOME FOR WANT, SOME FOR NEED
IF YOU COULD ONLY FIND YOURSELF THAT WAY
In hearts suspicion flowers
In hands numb with jealousy
Sleepwalking hellmute showers
& Transform effortlessly
THINKING OF ALL
I HAD LEFT BEHIND
DOWN IN THE SHAFT
WHEN MY MIND WAS BLIND
BUT YOU COULDN'T EVEN
FIND YOURSELF
THAT WAY

Steve Kilbey

GAYE GODFREY-NICHOLLS
Gouache and Plaka on museum board; Brause nibs; 17¾ x 23½in (450 x 600mm)

Lively, compressed Italic completed for a solo exhibition.

PAPER FOR BACKGROUNDS

Although watercolor paper is the substrate of choice for most calligraphers, a vast array of beautiful handmade and commercial papers is also available. The only way to know if they are suitable for the pen is to test them out. It is beyond the scope of this book to examine papermaking and marbling, but I recommend further investigation. I have attended numerous papermaking and marbling workshops, including a traditional Japanese washi workshop where participants had to macerate plant fibers by hand with a wooden mallet for several days! Happily, a blender takes the labor out of papermaking for most of us.

Handmade paper

Making paper by hand is very satisfying. The process itself is enjoyable; recycling paper and plant material is environmentally friendly, and using paper that you made yourself is very rewarding.

The principal consideration of handmade paper for calligraphy is whether or not it bleeds. Test out a small section with ink (this medium usually bleeds the most), gouache (usually bleeds less than ink), or felt marker (usually bleeds least). If the paper does bleed but you still want to use it, it will require sizing; this means applying a solution to the paper that prevents bleeding. If you are making the paper yourself you can add various substances to the pulp before sheetforming, including methyl cellulose, cornstarch, gelatine (or the plant-based equivalent, agar agar), or kudzu, a plant-based powder available in health-food stores.

If you are using readymade paper, there are various surface treatments that you can apply. The substances listed above can be made into a solution and painted on. Another effective sizing material is diluted PVA glue. Various dilutions will work (for example, 1 part PVA to 20 or fewer parts water), but ideally do not go much heavier on the PVA as it will change the appearance of the paper, making it shiny. Experimenting and labeling the results will give you an appropriate dilution for your paper. The standard solution of spraying with fixative and giving a light dusting of sandarac is always advised.

Also note that problems with bleeding can often be bypassed by using a brush.

Paper made by Gretchen Forrest; pure flax fiber combined with recycled pulp to form a gradation.

Paper made by Gretchen Forrest; pure plant fiber combined to create an abstract landscape.

Paper made by Gaye Godfrey-Nicholls; marbled traditionally using alum, carrageenan, and gouache.

Papyrus

Papyrus was the material used by ancient Egyptian scribes; the Greek word *papyros* is the source of the word "paper." Papyrus use dates back to around 4000 BCE. Producing a sheet of papyrus today is quite straightforward, very low-tech, and requires only the plant (the wetland sedge *Cyperus papyrus*), a knife to cut it into strips, a tray, water, a wooden mallet, a press, some cotton sheets, felt sheets, and time and patience.

The stalks are triangular and once the outer green skin is removed, it is easy to cut the pith into long strips; these are pounded to break down the cellulose. The strips are soaked in water for about three days until the pith becomes clear; they are then cut down to the size of the finished sheets. The strips are laid on the cotton and overlapped with a row of vertical and horizontal strips. The sheets are placed between boards padded with felt, stacked up with others, and placed in a press in the sun to dry out. The wet felt is removed and replaced with dry felt every eight hours or so until the papyri are dry, which takes three or four days. The plant produces its own form of glue, which laminates the strips to each other.

Other plants, including carrot, rhubarb, and onion, can be used in the same way. Papyrus is surprisingly good to write on, despite the ridges on the surface, and takes ink and gouache well. The only issue I had was ensuring that the nib didn't catch on the fibers and drag the gouache across the letter. The papyrus plant can also be used as a fiber in papermaking, and makes a beautiful crisp sheet with a sheen.

Marbled paper

Marbling paper is another trap for the unwary calligrapher, who may be drawn into the hypnotic world of marbling and distracted from their calligraphy! Marbling dates back about 2,000 years; it was first developed in China and was developed in the 15th century in Persia, Ottoman Turkey, and India.

A tray of a viscous size made from carrageenan powder (various other substances can be used) has gouache or watercolor paint dropped onto the surface, where it sits and can be formed into patterns using combs. A sheet of paper or fabric can be laid upon it to pick up the pattern. Ox Gall is a surfactant usually added to the paint to ensure spreading, while the substrate needs to be treated with a mordant (usually an alum solution) so the color stays on the substrate. Traditionally, marbled papers were used as endpapers in books or decorative pieces in their own right. There are many patterns requiring different tools, the most familiar being the combed, swirling variety.

PASTE PAPER: STEP BY STEP

MATERIALS

Paper (watercolor paper or Canson) · Rubber brush · Broad pens · Pop sticks · Balsa wood · Household sponge (clean) or foam brush · Plastic sheet to protect your work surface

Paste mix recipe ½ cup cold water · ½ cup corn, rice, or wheat flour · 2 cups cold water · Acrylic paint

Optional Matte medium (improves the surface for pen work) · 1 tsp glycerine (makes the mixture slicker) · 2 tsps PVA glue (to prevent cracking)

Paste paper makes an excellent background for calligraphy. It was used in the 16th century as a decorative paper, principally for endpapers in books. It creates an interesting background for ink or gouache, and can also act as a size, making previously difficult papers more receptive for the pen. A sgraffito technique can be used to remove some of the surface to create patterns or letters. This involves scraping the surface of the substrate to remove media—tools such as pens with no media, pop sticks, bits of cardboard, woodgraining tools, and combs can be used to scratch the paste away from the surface.

Paste paper is simple to make, requiring a paste made from corn, rice, or wheat starch. The starch is made into a custard-like consistency to which color in the form of water-based pigment such as acrylic is added. Gouache, ink, or watercolor can also be used, but, as larger amounts are required, acrylic is more economical. Watercolor paper or Canson is recommended; the substrate needs to be thick enough to bear wet media and surface agitation. Colored paper can make interesting effects; try mixing up your papers and doing the same colored paste on different papers.

STEP 1

In a saucepan, mix ½ cup water to ½ cup flour and whisk until blended. Gradually add 2 cups water, stirring well.

STEP 2

Cook on a medium heat, stirring constantly, until the mixture is thick like a custard.

STEP 3

Remove from heat and allow to cool. Strain the cooled mixture through old pantyhose or blend in a blender.

STEP 4

Add matte medium, glycerine, and PVA glue for an improved surface for calligraphy.

STEP 5

Divide it between 3 to 4 containers and add different colored acrylic paints. Metallic powders can also be added. (Leftovers can be stored in a plastic container with a lid in the fridge.)

STEP 6

Place a plastic sheet and piece of glass over your working area—this keeps your paper flat when you work with the paste. Place a sheet of paper on top and spread some colored paste on it. Use a household sponge (A) to spread the colors around, and tools such as plastic knives (B), paintbrushes (C), and corks (D) to make patterns or letters.

STEP 6: A

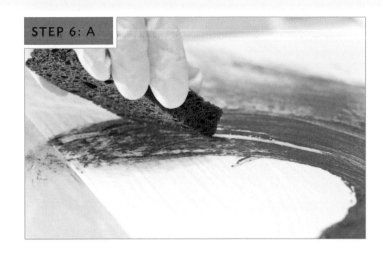

STEP 6: B

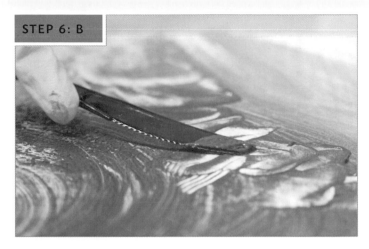

STEP 6: C

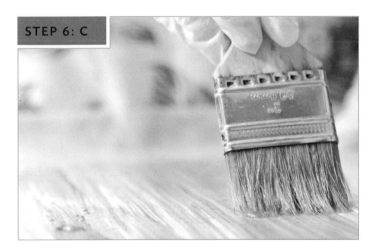

STEP 6: D

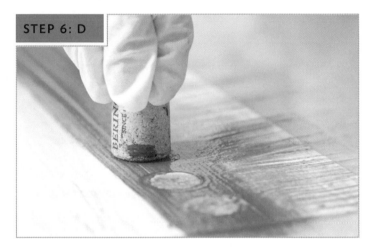

A selection of dried paste papers ready for calligraphy.

EMBOSSING AND RESIST

Embossing is a simple but effective technique that shows the subtle effect of cast shadows on the surface of a substrate. It requires only a substrate (usually paper), a burnisher, and a stencil. Resist is a technique where a substance is applied to a substrate, painted over, then removed to reveal the paper underneath. Layers of resist can be applied over the top of previous ones, but the impact and definition is decreased with each layer.

Embossing

Use a reasonably thick paper (roughly 200gsm) as it needs substance to hold the shape—watercolor or Canson paper works well. Solid colors work best, as variations of color or pattern on the page detract from the effect. There is a wide range of burnishers available; the one I prefer for embossing has a flattened end and a slight bend. You can cut your own stencil from card or acetate, or use a precut commercial stencil. If you are using lettering, remember that the stencil must be in reverse to emboss, otherwise your lettering will read backward.

Place your paper right side down on your stencil and gently press the burnisher around the edges to establish the boundaries of the stencil. Tape the stencil to the paper with removable masking tape to stop it from moving (movement is the nemesis of embossing!). It can be difficult to see the position of the stencil under your paper; a lightbox is helpful at this point. Once you know where the edges are, you can apply a little more pressure. Work slowly into the corners, coaxing the paper right into the edges with the burnisher. Acute angles and corners are important with embossing; they provide strong definition for the light to catch. When you have finished, turn the paper over, remove the tape and there you are—three dimensions. Don't be tempted to color in or around your embossing—it renders the embossing invisible and pointless. Another lesson I learned is not to emboss anything that will be in a closed book or it will get pressed out!

A commercially made metal stencil showing squares of varying sizes is ideal for embossing.

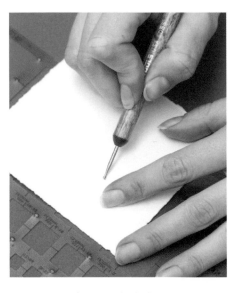

With the paper facing good side down, the scribe gently presses the burnishing tool into the corners of the chosen shape.

The finished embossing turned right way up—the embossed part is raised up from the rest of the paper.

Resist

The most effective resist medium is masking fluid, as it can be used in a pen to create sharp letterforms. The dried fluid forms a gum that can be removed from the substrate with a soft eraser when dry. Remove the gum from the pen when dried—it should be easy to pull off. Masking fluid can damage good brushes, so I avoid using it in a brush. There are masking fluid pens available that allow a thin stream of fluid through a monoline end. Oil or wax crayons can also be used as a form of resist, although crayons, even when sharpened into a broad edge, tend to get blunt quickly. Unlike masking fluid, the crayons remain on the surface. Another method of resist involves using low-tack adhesive film, such as masking or frisket film. Lay the film on to the substrate, carefully cut out letters or shapes, remove the excess, and then paint over. When dry, remove the remaining film.

The word "kimono" is written in masking fluid with a pointed pen and allowed to dry.

A watercolor wash is applied over the dried masking fluid, completely covering the area.

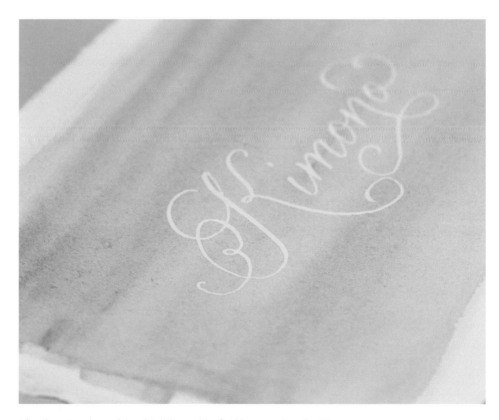

After the watercolor wash has dried, the masking fluid is removed gently with a finger or an eraser, revealing the white surface of the paper underneath.

LAYOUT AND COMPOSITION

This chapter examines the challenges experienced by every calligrapher when facing a blank page. We explore standard approaches to layout, as well as a process for determining the most suitable arrangement of text, graphic elements, color, and design. We analyze finished pieces that show successful and eclectic approaches to layout; consider these and imagine whether changing placement, size, or color would affect the finished works.

DAVID MCGRAIL
Sumi ink; Brause nibs; 12 x 17¾in (300 x 450mm)

Even though David has only one line of six words in this piece, it is complete and needs nothing further. David illustrates the power of restraint with his active use of white space. The energetic Italic has a sense of movement, emphasized by the tapering ascenders, which have a quality of wind-blown grass. The positioning of the text in the lower third allows breathing space for the simple, elegant flourish on the N. This line of script establishes a horizon with the restrained flourish floating in the sky but anchored by the square. The counterpoint of the date and bottom flourish balances the composition.

GEMMA BLACK

*Gouache, Bleedproof White, and ink with pen
and brush; 23.75K gold leaf laid on gum
ammoniacum; 4¾ x 4¾in (120 x 120mm)*

Gemma successfully modernizes the medieval
format of the illuminated letter using a
nontraditional palette of pink balanced with green.
Three shades of each hue overlaid with white
follows the customary approach to illumination.
The cascading foliate motifs suggest the canopy of
a weeping tree, and the piece is completed with
carefully placed sections of gilding.

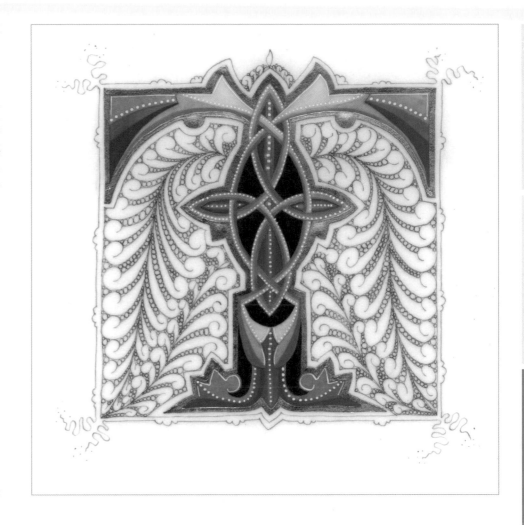

JOKE BOUDENS

*Detail from concertina book;
5½ x 29½in (140 x 750mm) (open)*

Joke's work is a masterpiece of design—each element
has a clear and well-considered relationship with its
neighbor as well as an overall balance. White space
is used actively around each section of text.

BASIC LAYOUT

Calligraphy is not limited to ink on a rectangle of paper. As you will see in this book, there is an abundance of creative possibilities for media and substrate choice. Letters can be sandblasted onto glass, carved into or out of stone, wood, metal, bone, or plastic; sculpted from polystyrene or clay; cut from metal; drawn in the sand; written on the skin or in the sky, or created by photographing light curved into letterforms. However, the rectangle of paper is a good place to start!

When you have practiced your letterforms sufficiently, you will want to work on a finished piece. It can be daunting to see the work of skilled calligraphers and to try to deconstruct how they approach layout and design, so we will start with the basics.

Many calligraphers make thumbnail sketches of possible layouts in order to visualize a piece and make initial design choices. These are little, quick drawings, often in pencil, that indicate placement of text and position of graphic features.

Cut and paste

Cut and paste is one of the first techniques that will aid your understanding of layout. Similar to cut and paste on the computer, this process involves writing out your text, cutting it out, and arranging it as a template for your finished piece. It is then glued or taped in place, and traced or measured and marked out for your finished work. This technique allows you to look at various options before choosing one. Unless you design and install your own calligraphic font, you will have to prepare the old-fashioned way with cut and paste. Work at this stage is referred to as a rough; most pieces with a large amount of text require at least one rough. Spontaneous, creative work is often unplanned, with each element placed as a response to those already present. It is helpful to decide whether the piece will be planned or spontaneous—this will depend on the purpose of the work.

felix qui potuit rerum cognoscere causas happy is he who is able to understand the causes of things

Write out your quote without considering layout.

Using a lightbox

One aspect of successful layout management is developing the ability to keep your writing and spacing consistent from your rough to your finished piece. Even the most seasoned, experienced calligrapher may find that the identical line on their finished work is somehow shorter than their rough. This is usually due to feeling more relaxed on the rough but (literally) tightening up for the finished piece. Sometimes it's the other way around, and the writing will be slightly longer. A lightbox is very useful in this case and ensures accuracy of spacing. Another solution is just keep practicing!

Text alignment

Layout options presented in calligraphy or design books usually involve ways of aligning blocks of text in hands of a similar size and texture. These are based on print formats that are available at the push of a button on a computer: flush left, centered, flush right, or justified. Many calligraphers prefer to work with an asymmetrical approach. Frequently, calligraphers work with less text, perhaps only one line or word that is not addressable with block alignment. Design and spacing of your words and placement of your text on the page are equally critical and can mean the difference between a successful piece and a merely adequate one.

felix qui
potuit rerum
cognoscere
causas

happy is he
who is able to
understand
the causes of
things

Cut up the page and arrange it in various ways until you are satisfied with the arrangement. Measure your lines to ensure even spacing, then paste it down with a glue stick.

felix qui
potuit rerum
cognoscere
causas

happy is he
who is able to
understand
the causes of
things

Using a lightbox, or taping your work to a window, write your final version over the top of the cut and paste. For a finished piece, I would decrease the interlinear space of the Latin and write the English with a nib a size or two smaller so the two panels are more balanced. I would also decrease the gap between the two panels.

HEADING

Flush left.

HEADING

Centered.

HEADING

Flush right.

HEADING

Asymmetrical.

STARTING A CALLIGRAPHIC PIECE

The standard layout approaches are: justified, flush left, flush right, centered, and asymmetrical. However, many pieces do not conform to these simple categories. Our task in this section is to analyze what works, why it works, and what doesn't.

The ability to choose the most appropriate approach is a skill in itself. Knowing immediately what to do with a piece is rare. Sometimes we are able to work intuitively, organically, and quickly, but at other times it just doesn't come together. We need to understand design principles to help us.

As calligraphers, we are often interpreters of other people's (or our own) words; our objective is usually to render clearly our understanding and interpretation of the text (although with more abstract or painterly approaches, the contents of the text may be subordinate or irrelevant). The process of lettering is interactive, and the choice of media and substrate influence the arrangement of the text. The choice of background decoration, image integration, or interaction between different hands and sizes requires a thoughtful, well-considered approach that experimentation will allow to develop. Try not to overcomplicate things; in most cases keeping it simple is appropriate.

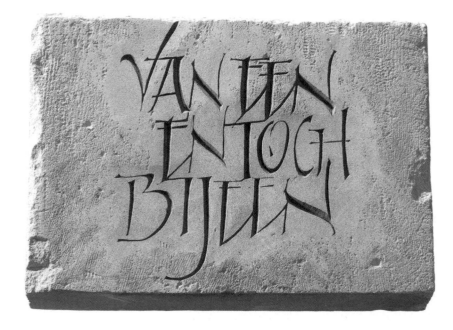

(Left)

HELEEN DE HAAS
Calligraphy by Heleen de Haas, lettercarving by Jos Brabants

This stonecarving was one of two renditions of the same Tom Lanoye quote, part of the WORL(D)s exhibition, organized by Maud Bekaert, a collaborative project between Belgium and South Africa where all money raised from the auction of these stones was donated to AIDS projects in South Africa.

(Right)

MALIK ANAS AL-RAJAB
Digital artwork; 8 x 12in (200 x 300mm)

Malik displays his understanding of design with bold gestural strokes dividing the panel. The double and triple strokes create a tension that is somehow resolved with their convergence and traveling off the page. The intertwining of the gold branch stroke forges an intimate link with the triple line stroke, and the sharp vertices of the crescent moon echo the tapering stroke ends. Somehow, within this most abstract of works, Malik has imbued warmth and a sense of narrative—as if we feel the bird yearning for the moon.

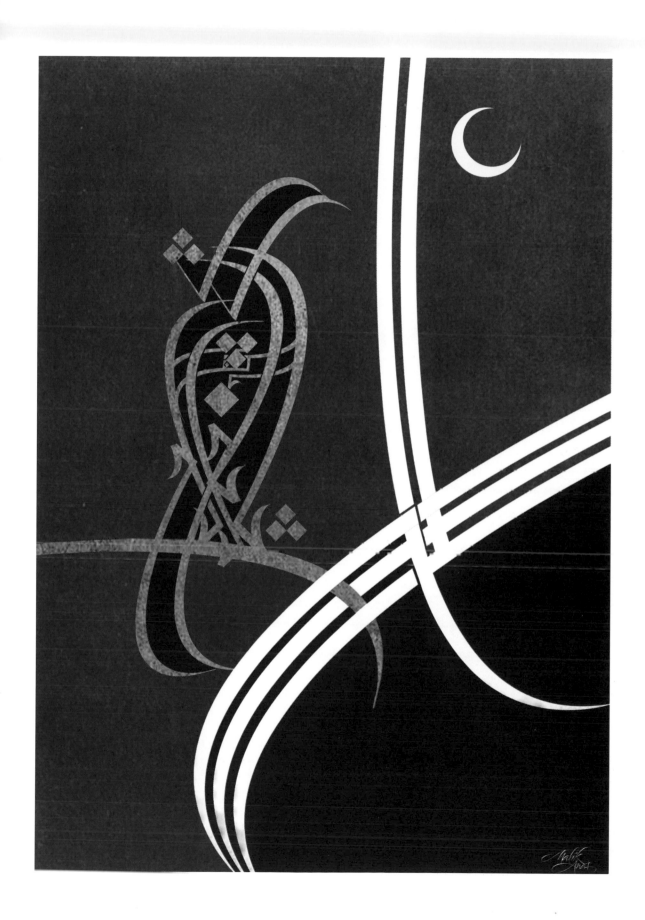

The process

Take a moment to review the text of your project. Read it through and try to visualize the essence of the quote. Without trying to impose a calligraphic approach, what are the key words of the text; what is the atmosphere; what do you associate most strongly with the piece—what emotions, colors, or images? Jot down your impressions. Choose five to ten adjectives to describe what you want to express with your piece. At this stage, I often try to decide on a color scheme: perhaps a single hue, or more of a mood, such as cool, warm, dark, light, or neutral.

What quality of script would best suit the piece? This can be obvious in some cases, or difficult. You may deliberately choose a hand that doesn't seem appropriate, or colors you don't like in order to challenge yourself. It is a personal choice and will be influenced by factors including your own aesthetic and preferences. Warm up by writing out the first line in different styles and compare their appearances. Does one style look more appropriate than another?

What format is most suitable? Standard paper (light, dark, with background)? A concertina book? A three-dimensional object? What size? What proportion? What media will you use?

Clearly the choices are wide. Allow the purpose of the piece to influence these decisions. Do you want to spend money getting it custom-framed? If not, use a frame you already have or buy a standard frame and choose a size and paper to fit. These are decisions that can be made before starting on thumbnails or roughs. Quickly draw up some thumbnails of potential layouts. Start with four, the first ones that occur to you. Have you chosen keywords or a dominant element? Start with that, in pencil. Sheila Waters starts her roughs in pencil rather than ink. Play around with larger versions of your thumbnails to sketch in some elements of dominance and contrast.

Ideally, you will create your piece from scratch. If you are an experimenter, you may have spent time preparing backgrounds with various colors and techniques that are first-stage-ready; these may be appropriate to use. Choose carefully if you use an already created background, or sheet of colored paper—it should always be chosen for relevance, not convenience. In her book *The Foundations of Calligraphy*, Sheila Waters states, "I try to heed Edward Johnston's advice for solving a problem—learning from what it needs instead of imposing a pet notion upon it."

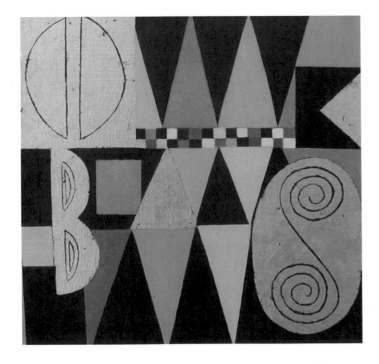

JULIA BAXTER

Acrylic paints and gold leaf on canvas; brushes;
10 x 10in (254 x 254mm)

A homage to the remarkable artist Gustav Klimt, Julia's piece dynamically divides the space of the work into bold geometric shapes. She comments, "Being very inspired by the works of Gustav Klimt, I focused on parts of his pattern designs while seeing some letterforms within." Julia contrasts the acute angles of the triangles against the simple linear curves of the letters inscribed into gold. Other gold triangles link the letters and balance the design. The other major contrast is the tone—dark triangles against mid/light tones. The lynchpin of the piece is the checkerboard panel that functions as a bridge and acts as a color test strip, further unifying the design. It also links the gold segments.

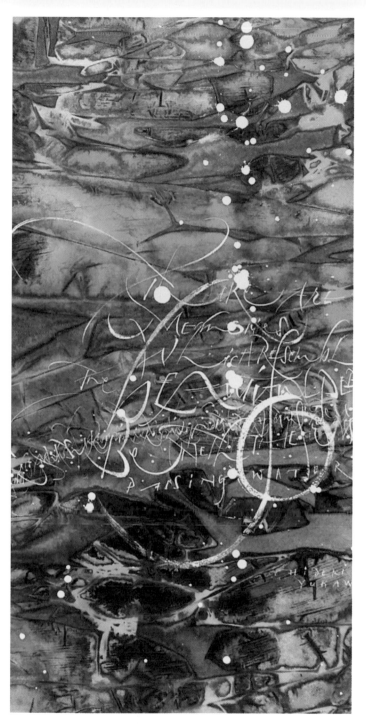

YUKIMI ANNAND
Gouache and acrylic ink on Arches text wove paper; pointed brush; 18 x 10in (460 x 255mm)

Critical thinking

Critical thinking is a valuable tool for calligraphers, and we should be aware of our strengths and areas for improvement. If we are constantly drawn to, for example, swirling backgrounds of blue and green with layers of italic writing, with keywords in large sizes, nesting and usually asymmetrical (that's me!), it is helpful to avoid these in order to extend out of our creative comfort zones.

We need to be critical of our skills in each hand and whether this skill can support ambitious layouts and decoration. Always work within your means; any additional treatments should enhance your calligraphy. Sometimes we see pieces of calligraphy that have great images or ideas that are let down by the quality of the lettering. We need to ensure that we have the technical details sorted—pen angle, shape, slope, origin of arch, consistency, spacing of letters, lines, and margins. Until we are aware of what is satisfactory and what needs improvement, we are disadvantaged.

Anyone who has studied drawing will recognize the advice to learn how to see. Drawing is about observing accurately and transcribing what you see, rather than drawing what you think is there. To improve our calligraphy, we need to know what shape we are aiming for, and hold that image in our mind's eye. Great calligraphy does not need a gimmick; it needs a sensitive and considered analysis of what is required, and a confident, flowing, and appropriate application of our skills.

Be aware of trends and directions in calligraphy. There are distinct styles that are immediately identifiable in broad categories. Calligraphers who have been through Roehampton are heavily influenced by Ann Camp's rigorously accurate approach. Layouts are usually minimal; hands are often Cnut charter, Roman, and Versals, color is restrained, with an emphasis on technical accuracy, spacing, and margins. British calligraphers tend to follow the Johnstonian tradition and use more formal layouts and traditional materials. American calligraphers are often more flamboyant, more readily incorporating techniques such as paste paper, mixed media, ruling pen, pointed pen variations, and brush work. Australian, New Zealand, South African, South American, and European calligraphers (particularly German, Belgian, French, and Italian) have their own inimitable vibrant and eclectic styles, and, of course, individual calligraphers are often immediately recognizable. Keep abreast by reading *Letter Arts Review*; we can learn a lot from familiarizing ourselves with the work of our peers.

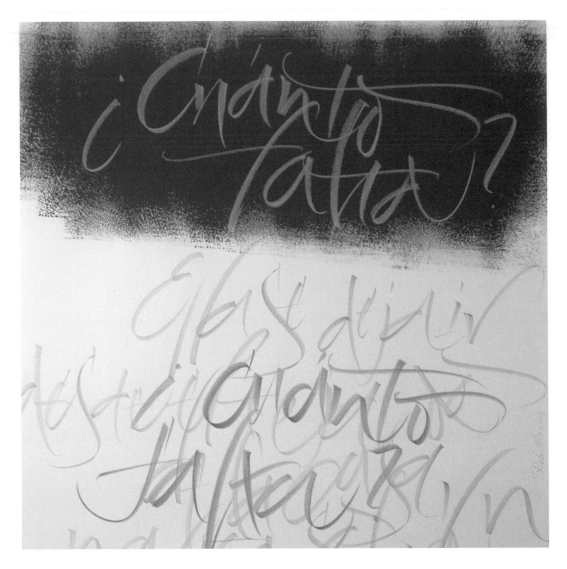

MARIA EUGENIA ROBALLOS
*Gouache and carpenter's pencil
on Shoeller paper; 13½ x 13½in
(345 x 345mm)*

The hallmarks of a successful piece

Another question it is helpful to ask is, "What do I want to achieve with this piece?" This will vary according to the individual and particulars of the piece, but generally most of us want to achieve the following with our work: that it has fulfilled its function well; satisfaction with our lettering (90% is sufficient—don't get caught up in wanting it to be perfect); that it has a unique, well-considered presentation and harmony within the design, regardless of style, legibility, or intentional discord; that it generates an emotional response that is what we hoped for at its conception, and a sense of completion (i.e., that there is no more we can do to enhance it).

Inspiration

Many calligraphers say that they are not creative and have no inspiration for design and layout beyond the most basic. To expand your own repertoire of design, look around. Look at your choice of furnishings, paint on walls, arrangements of ornaments. Understand and develop your own personal aesthetic by looking at books on design, architecture, art, and particularly calligraphy. Look at the work of your favorite artists and identify which elements appeal to you. Make copies of appealing designs and include them in your journal. Use your journal frequently—it is a very useful tool. Add to it weekly; daily if you can. Refer to it in times of need—a successful journal should spark many ideas from a single flick through. I like to write out words that best express the essence of something I want to capture and I keep them in

my journal. Imagine all the pieces you enjoy seeing in books and magazines and how you'd love to have time to experiment with those ideas. Analyze the qualities of the designs and figure out why they work. This is the beginning of critical thinking applied to calligraphy.

The best designs are not arbitrary but often meticulously planned, even the most spontaneous-looking ones. These works are often the products of experience, repeated practice, and being in the right state of flow. Study your favorite calligraphers and learn their approaches—what can you take on board? Ideally, we are not copying someone else's layout or idea, but drawing inspiration from it and tailoring it to fit our needs.

There is never a single or perfect solution to a layout. My teacher Peter Evans has been working on one text for many years, and has more than 50 interpretations of the work.

Numerous calligraphers have made the link between calligraphy and music, both as a metaphor and as a direct way of understanding rhythm. Consider interpretation of a text as you might a piece of music. It is an interesting exercise to visualize what hands might go with different types of music. Thomas Ingmire used music in one of his workshops to see how music changes our writing tendencies; the effects were quite noticeable. Try it yourself and find your ideal creating soundtrack.

Principles of design

The following principles of design are those suggested in Sheila Waters' *The Foundations of Calligraphy*.

- Unity can be achieved by using proximity, grouping, and repetition.

- Balance can be symmetrical, asymmetrical, nesting.

- Contrast size (of script, of blocks of text), shape (simple, complex), position (placement on page), direction or text flow (up, down, diagonal), number (of elements), intervals/spaces and density/texture.

- Emphasis or dominance is hierarchy using contrast.

- Proportion in this context means considering the spatial relationships of design elements. It involves understanding and active use of negative space—the space between letters, words, lines, blocks of text, margins, and the placement on page.

- Movement concerns where the eye travels on the page—in the Western tradition, from left to right and from up to down.

Other considerations

- Script choice—what hand do you think has the right feel for the piece?

- Palette—what is your first emotional color association with the text?

- Interpreting the text—using contrast and dominance, you have the opportunity to emphasize the most important words or phrases.

- Writing over decorative backgrounds—watercolor washes, plain, graded, acrylic, Plaka, pastel, spray, use of masking or resist, a single layer with writing or multiple layers of wash, multiple layers of writing.

- Illustrations—these may be your own work—drawing, painting, printmaking, or using techniques such as stamps, embossing, or transferred images.

- Collage—layers of paper, torn or cut, inclusion of other materials, such as fabric, ephemera, or embellishments.

ILLUMINATION

In this chapter, we investigate illumination. This is a term applied to decorated initials, words, panels, or pages that feature gilding with gold or metal leaf. In many medieval manuscripts, gilding required a base or size of gesso, which was applied to the substrate, allowed to dry, reactivated with the breath, and gold leaf attached. This technique is referred to as raised gilding, as the gesso can be built up off the page, with the gold leaf able to be burnished to a high, glassy sheen. The gesso recipe remains unchanged from medieval times and is available from specialist suppliers, although the results can be disappointing if the climate is not optimal. It should be noted that gilding gesso is a different substance to painting gesso.

Modern sizes for gilding are usually easier to apply than their traditional counterparts, and deliver more satisfactory results, although the glorious sheen possible from gesso cannot be achieved with them. A range of alternative gilding sizes can be found, including gum ammoniacum, another traditional size used for flat gilding, as well as acrylic bases, proprietary gilding mixes, PVA glue, and even oil crayons. A diluted PVA solution (equal parts of each) yields very pleasing results for letters and small areas, as well as large blocks of gilding, which can be written over with pen or brush.

The most important component of gilding is the gold leaf. This is available as loose gold leaf or transfer gold. Loose gold is packaged in small square books, sandwiched between thin sheets for protection. It is difficult to handle, as it is very light and the merest breath can blow it into the air. Loose gold is available in a range of colors including red gold, green gold, yellow gold, and white gold. There are other metallic leaves available including silver (which will tarnish), copper, aluminum, and palladium.

Transfer gold is attached to the backing sheet and is applied face down onto the size and burnished onto the surface. There are many varieties of transfer gold; as well as the colors listed previously, there is a range of Dutch metal or Schlag gold, which also comes in patterns of variegated shades.

Powdered gold is also available in numerous forms. Shell gold is presented in a small pan and is activated by water. Other powdered forms—bronze powders, mica powders, or acrylic pigments such as Pearl Ex—are mixed with a binder such as gum arabic and distilled water. These forms can be used in the pen or brush, although they are slightly duller.

Although not strictly gilding, gold gouache is an effective way of getting gold on your page. If gold powder, gum arabic, and water are added to the gouache, it produces a solid, opaque and shiny gold that is able to flow through the pen. It requires constant stirring with a mixing brush, as the metallic particles settle quickly. Newer products such as Dr. Ph. Martin's iridescent metallics can also give pleasing results, but they need to be cleaned off the pen immediately upon finishing or it will clog up.

THERESE SWIFT-HAHN
This illuminated letter was created in a gothicized Italic using gouache and gold leaf.

AN ILLUMINATED LETTER: STEP BY STEP

MATERIALS

Black-and-white photocopy of the illuminated letter • Saunders or Arches hot-pressed watercolor paper • No. 2 (HB) pencil • Tracing paper • Removable tape • Eraser • Waterproof ink • Waterproof fineliner such as Pigma Micron or Copic • Gouache: ultramarine blue, vermilion or flame red, oxide of chromium (green) • Bleedproof White • Mixing brushes • Fine-pointed brushes: 00 or 000 • Palette or mixing dishes • Pointed pen • Water • Small rolled-up tube of paper, about 4in (10cm) long • Glassine or waxed paper • Gold size or base: gloss medium, tannin sealer, PVA diluted half with water, duo adhesive, or other gilding mix • Gold leaf (use transfer gold if you are gilding for the first time • Burnisher • Gum arabic and dropper • Broad nibs • Ink or gouache for calligraphy

For your first foray into illumination and gilding, copy an original illuminated letter. Not only will this give you an understanding of the methods of illumination, it will also give you an insight into letter design. The letter we use here is an adaptation of an illuminated letter from the *Wharncliffe Hours*, a French book of hours written around 1480 CE. This outstanding manuscript is examined in detail in *The Felton Illuminated Manuscripts* by Margaret M. Manion. The process described here can be used for any letter, including your own design.

You can leave it as an illuminated letter or add text to present it as a manuscript. This additional stage is explained in steps 5–7; skip these steps if you just want to do the letter. I would advise you to complete any calligraphy before commencing with illumination, in case you make a mistake.

STEP 1

Make a black-and-white photocopy of the letter you want to use. Make the letter 2-4in (5-10cm) to allow plenty of space for gilding and painting. Place your tracing paper over the copy and, using a sharp HB pencil, trace over your photocopied letter, including foliate filigree.

STEP 2

Turn the tracing paper over and cover the traced lines with crosshatching or quick scrubbed lines in pencil.

STEP 3

Tape the tracing paper to the substrate and place registration marks (a small + in each corner) in pencil on both the tracing and the substrate to avoid misalignment should the papers move. If you want to use calligraphy as well as the illuminated letter, position your letter in the top left-hand corner so you have room for your writing.

STEP 4

Trace the letter and design onto the substrate with the no. 2 (HB) pencil. When the design is transferred, remove the tracing paper.

STEP 5

If you don't want to add calligraphy to your letter, skip to Step 8. If you want to add calligraphy to your illuminated letter, rule up your page correctly according to the hand you want to use. As the example chosen is a 15th-century Gothic letter, Gothic is an obvious choice; however, experiment with whichever traditional style you feel confident in.

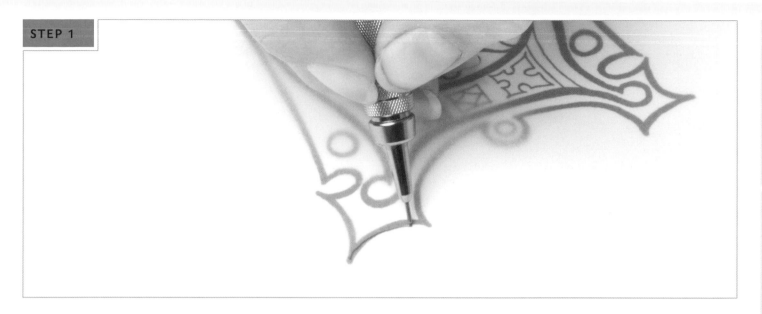

STEP 1

STEP 2

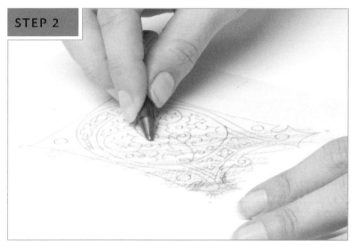

STEP 4

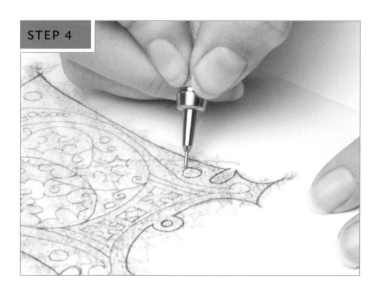

STEP 5

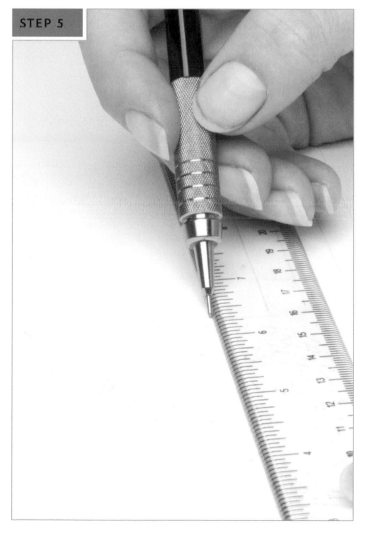

STEP 6

Use your ⅛in (3mm) pen to start the first two or three lines (which can be one of the three colors used in the letter), then a ¹⁄₁₆in (1.5mm) pen (with black or sepia ink/gouache) to continue. This is a device often used in manuscripts known as hierarchy of script.

STEP 7

Once your writing is dry, carefully erase the pencil lines and cover the inked section with a piece of paper taped onto it to protect it from smudges.

STEP 8

Load a pointed pen with a black waterproof ink or use a waterproof fineliner to draw over the pencil tracing on the substrate.

STEP 9

When the ink is dry, take a pencil and label the sections of the design that will be gilded with a g. For this letter, it is the background that is gilded rather than the letter itself.

STEP 10

Using your chosen gold size or base prepared as per instructions, paint the size in these areas. It is a good idea to use a piece of the same substrate as a test swatch to get used to the texture of the gold size and check the drying time. Ensure the size is not still wet before you continue.

STEP 11

When the size is dry (it will be slightly tacky to touch with your finger), place the small paper tube in your mouth and blow on the surface of the size—this will activate it.

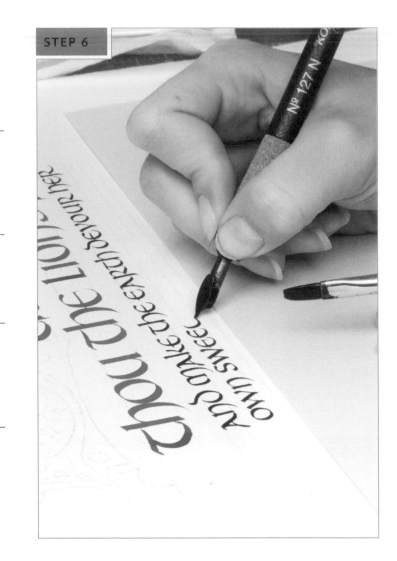

STEP 6

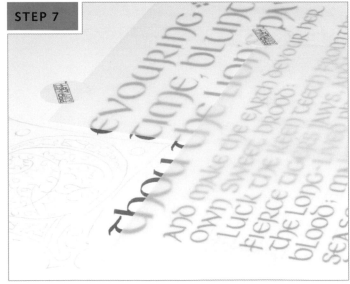

STEP 7

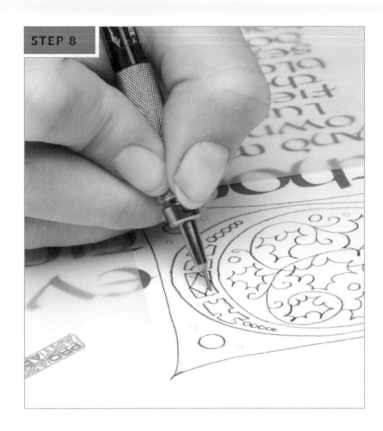

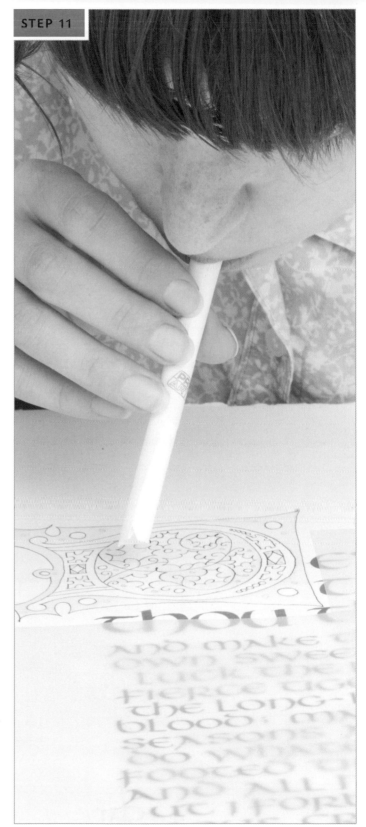

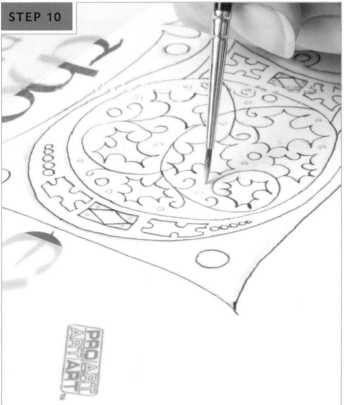

DESIGN AND DECORATION

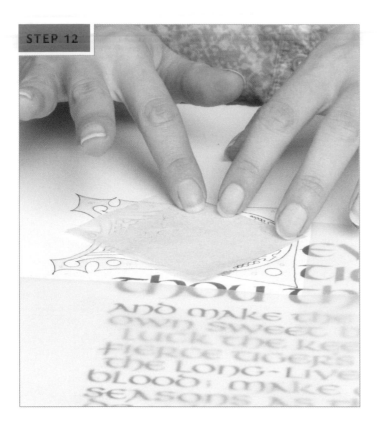

STEP 12

Cut a piece of transfer leaf to the correct size, and holding it only by the backing paper edge or with tweezers, quickly place it upon the size and press down on it with your finger. It should stick to the size—if there are any patches that haven't taken, try the process again. Gold tends to stick onto gold, so it can be built up successfully even if it went on patchily.

STEP 13

Once the gold is on, place a piece of glassine or waxed paper over the top of the gilded section, take your burnisher, and gently burnish (rub) over the surface.

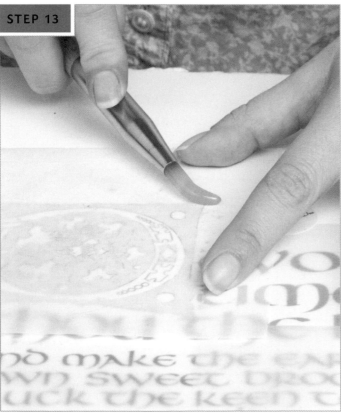

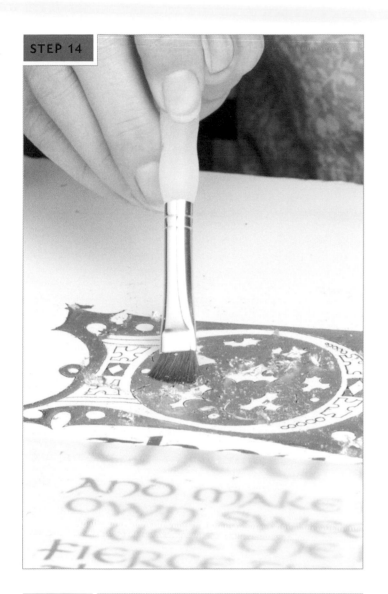

STEP 14

With a soft brush, lightly brush away any excess gold. The gilding aspect of your illuminated letter is now complete.

STEP 15

If the gold has covered up your black outline, go over it again.

STEP 16

In a mixing dish or palette, mix a small amount of ultramarine blue gouache with distilled water and a drop of gum arabic. This is the full-strength blue. Mix a little of this in another dish with some Bleedproof White to make a pale version. Do the same with the red and green gouaches so that you have a dark and light version of each. Mix up some Bleedproof White for the final layer of detail.

STEP 17

Taking a fine brush, paint inside the black lines of the letter with the light blue gouache so that the letter is filled. Allow this to dry.

STEP 18

Using the example as a reference, as your tracing is now covered up by the blue gouache, lightly mark in pencil the position of the internal letter decorations, which include cross shapes, diamonds, and circles.

STEP 19

With your dark blue gouache, paint around those shapes, leaving the light blue shapes clear. Allow to dry.

STEP 20

Paint the curving vine stems with the dark green mix, then alternate the ivy leaves with red and green. Paint the four circles in each corner and the berries in the dark red.

STEP 21

Taking the pale red, add highlights to the red leaves, berries, and circles. Do the same with the green.

STEP 22

Ensure the black lines are all still visible. If they are covered by the paint, touch them up again.

STEP 23

With white gouache in a fine brush, add the final layer of highlights to the letter, the stems, leaves, berries, and circles. Your illuminated letter is complete.

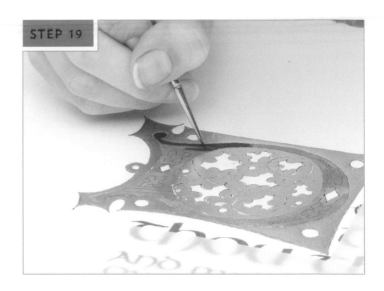

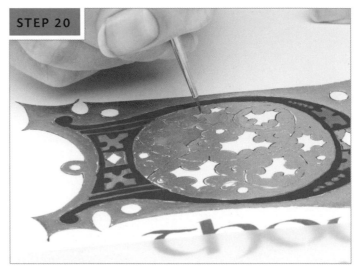

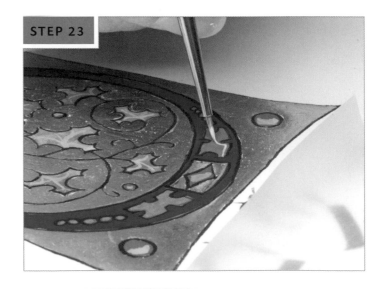

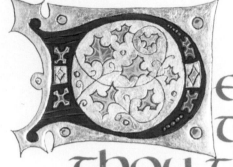

DEVOURING ❖
TIME, BLUNT
THOU THE LION'S PAW,
AND MAKE THE EARTH DEVOUR HER
OWN SWEET BROOD;
PLUCK THE KEEN TEETH FROM THE
FIERCE TIGER'S JAWS, AND BURN
THE LONG-LIVED PHOENIX IN HER
BLOOD; MAKE GLAD AND SORRY
SEASONS AS THOU FLEET'ST, AND
DO WHATE'ER THOU WILT, SWIFT-
FOOTED TIME, TO THE WIDE WORLD
AND ALL HER FADING SWEETS;
BUT I FORBID THEE ONE MOST HEI-
NOUS CRIME: O! CARVE NOT WITH
THY HOURS MY LOVE'S FAIR BROW,
NOR DRAW NO LINES THERE WITH
THINE ANTIQUE PEN; HIM IN THY
COURSE UNTAINTED DO ALLOW
FOR BEAUTY'S PATTERN TO SUCCEED-
ING MEN.
YET, DO THY WORST OLD TIME:
DESPITE THY WRONG, MY LOVE
SHALL IN MY VERSE EVER LIVE YOUNG.

- SHAKESPEARE -
SONNET XIX

◆ PROFILE CHERRELL AVERY

My study of literature, philosophy, and the classics, and my background in art, have all contributed to my fascination with visual language. Artists and sculptors such as Blake, Morris, Degancy, Klee, Schwitters, Paolozzi, and Van Doesburg have been major influences. In the calligraphy world, I have learned a great deal from Irene Wellington, Ewan Clayton, Ann Hechle, Margaret Daubney, Gottfried Pott, and Thomas Ingmire.

I am inspired to create through my personal responses to text, images, and life's experiences. I often begin with words—prose, poems, and lyrics that resonate—and explore a range of visual stimuli to develop my immediate ideas. When working on a piece, I try to engage with the meaning of my chosen text as I create, seeking to forge a link between the words I describe and the viewer. Although I begin with a seed of a design, I try to work openly and flexibly, exploring new materials, adapting scripts, and changing direction if I feel it necessary.

I experiment with gold and metal leaf, color, and texture—a combination I find extremely versatile and expressive. My calligraphy has become more experimental over the years, but remains rooted in my formal training. I enjoy developing my own expressive alphabets using a variety of writing tools, and exploring new materials and structures in a less conventional way.

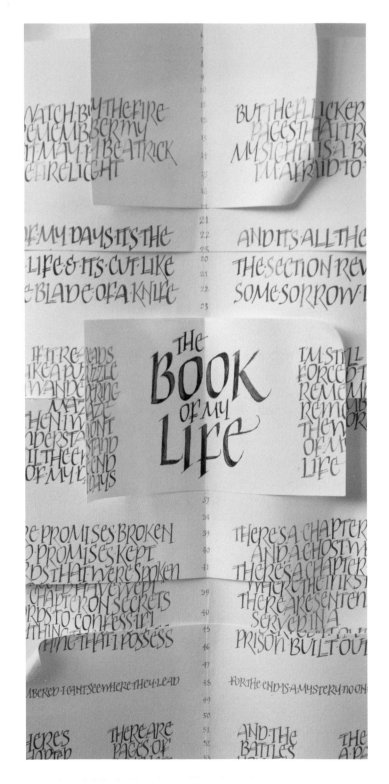

Gouache and bronze powder on manipulated and glued Roma paper; metal nib; 15¾ x 22¹⁄₁₆in (400 x 560mm)

Lyrics by kind permission of Sting.

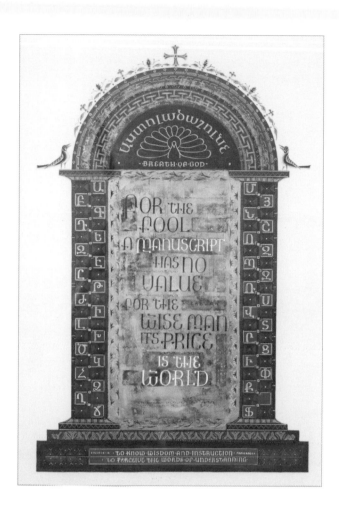

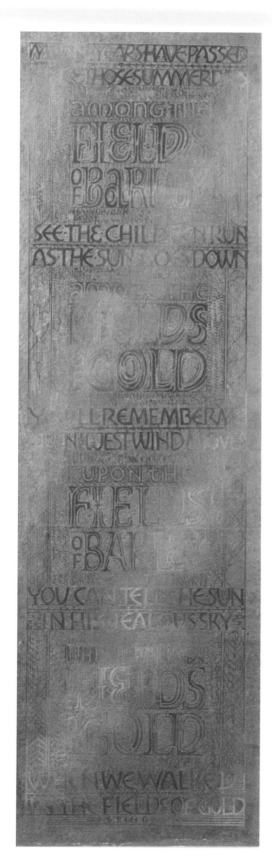

Oil pastel ground with layers of 24K transfer gold leaf; letters incised with pointed nib; 4$\frac{15}{16}$ x 14$\frac{3}{16}$in (125 x 360mm)

Lyrics by kind permission of Sting.

Gold leaf and waterproof inks on stretched vellum; brush and metal nib; 14$\frac{1}{8}$ x 18$\frac{15}{16}$in (360 x 480mm)

As a tutor on the calligraphy and design foundation degree course based at Kensington Palace, London, I am excited to see students from all over the world study the subject with enthusiasm and creativity. It is great to witness, at college and at calligraphy exhibitions and events, that calligraphy is thriving and is beginning to be appreciated by wider audiences, not just as a craft of the past, but as a relevant skilled art form today.

If you are just starting out with calligraphy—persevere! Becoming skillful and creative at calligraphy is like learning to play a musical instrument. It takes patience, time, and plenty of practice to progress, but once the fundamentals have been mastered, the possibilities are endless and are very rewarding.

GALLERY ILLUMINATION

◆◆◆

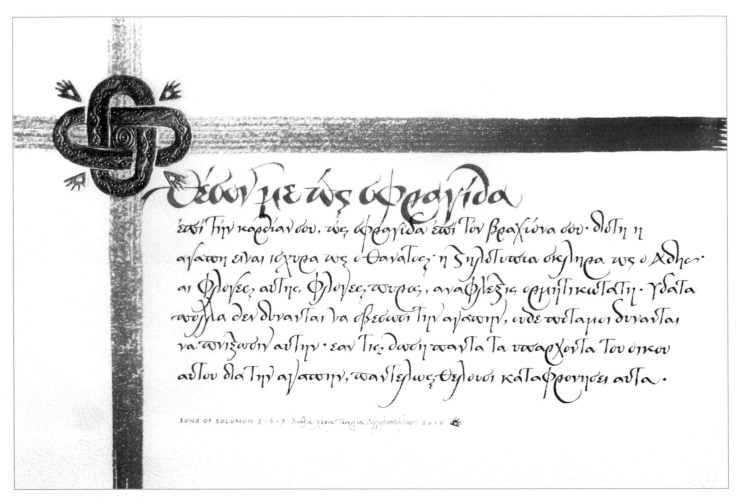

GEORGIA ANGELOPOULOS
Sumi ink, gouache, acrylic gold size; 23K gold
leaf on Saunders Waterford CP watercolor paper;
8 x 11in (203 x 279mm)

BARBARA YALE-READ
Gouache on vellum, stretched on canvas stretcher; illuminated
with traditional gilding; Versals, Italic, built-up Roman,
condensed Roman in the center; handpainted and illustrated
decoration; 22 x 22in (559 x 559mm)

Four texts are combined: Robert Frost, Nothing Gold Can Stay;
Dylan Thomas, The Force that Through the Green Fuse Drives the
Flower; Thomas à Kempis, Sic Transit Gloria Mundi; Ecclesiastes

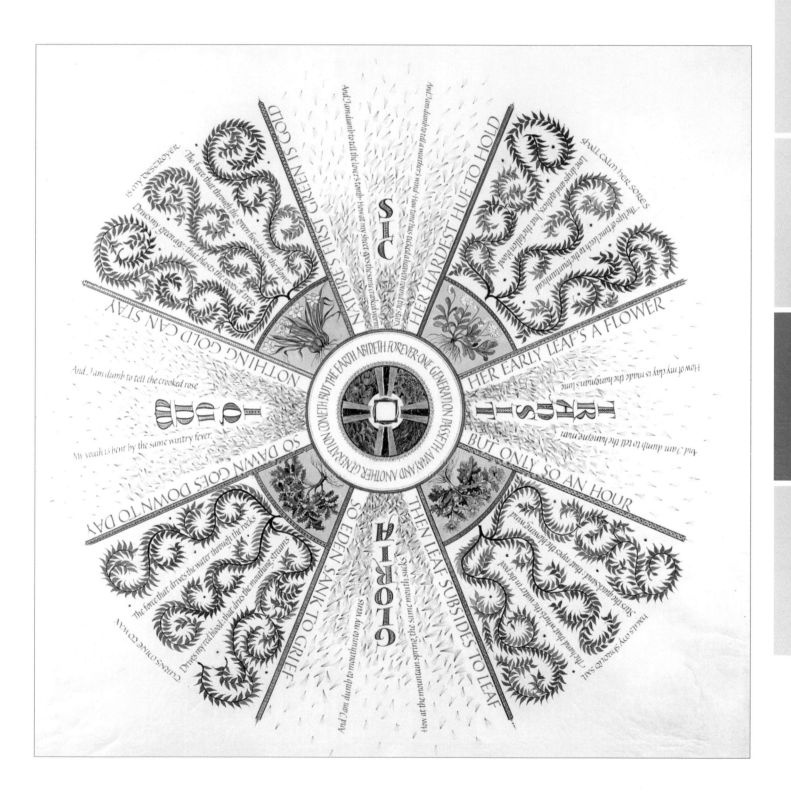

DIGITAL CALLIGRAPHY

4

DIGITIZING HAND-DRAWN LETTERING

Going digital provides limitless possibilities when it comes to layout, design, effects, and colors. The most valuable thing to do when launching into digital calligraphy is to play and explore. This chapter introduces you to what is possible, along with some demonstrations to get you started.

First we look at what equipment is necessary, and some theory. Then we explore one of the two broad categories of working digitally: digitizing a hand-drawn image (writing digitally using software is explored in the next chapter). I use Illustrator and Photoshop, both from Adobe Creative Suite 5 (CS5), on a PC, to illustrate the concepts. Although some features are specific to this software, the basic concepts apply to all similar programs.

I have assumed some knowledge of computer graphics programs, as this is too large a topic to be explained fully here. I have included several useful keyboard shortcuts, as they make a great difference to workflow efficiency.

Digital calligraphy cannot make up for a lack of skill or planning; nor can it replace the organic, living nature of the handwritten word. However, if you consider working digitally to be another tool in your calligraphic armory instead of a replacement, you will be amazed by the possibilities.

BEFORE YOU BEGIN

Here is a very short rundown of the equipment and software information that may be useful before you go digital.

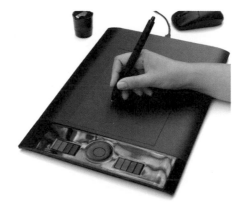

Hardware

Your basic hardware needs are:

- Computer, keyboard, mouse, and monitor (minimum requirements will be determined by the software).

- Pressure-sensitive tablet and stylus pen. The Wacom brand is considered the industry standard.

- Digital SLR camera and/or flat-bed scanner.

Software: pixels vs. vectors

Your basic software needs are:

- Photo-editing software (pixel-based). Pixel-based images are those constructed of pixels and are resolution-dependent. The higher the resolution, the greater the number of pixels per unit area that make up the image, and so the greater the file size. As you zoom in on the image, it eventually starts to pixellate; that is, it starts to look jagged and blurred as it separates into distinct units of information. Examples of such programs are Adobe Photoshop and Corel Painter.

- Drawing software (vector-based). Vector-based images, such as computer fonts, are created using digital lines, shapes, and curves based on mathematical equations. They are resolution-independent; as you zoom in the file stays clear and sharp, and it is recalculated as it is resized. Examples of vector-based programs are Adobe Illustrator, Inkscape, and CorelDRAW.

WORKING WITH DIGITIZED HAND-DRAWN LETTERING

It is important that both the original artwork and the digitization of that work be of high quality, as touching up poor originals digitally can take a lot of time. Make sure your calligraphy is crisp, with good contrast. A good starting resolution for scanning is 600dpi. It is best to start large, as you can always reduce the size if necessary.

A huge advantage to digitizing your work is the ability to layer. Layering adds a whole new dimension to your art. It can be invaluable when it comes to working out how best to arrange the elements of your piece on the page.

We will use Adobe Photoshop CS5 to illustrate this. We will also briefly look at digital brushes, although these are explored more fully later (see p. 269). We will be working with a number of palettes or panels within these programs. To open a palette, go to the Windows menu and select the one you require. They can be dragged around the workspace or minimized to suit your needs.

Using layers in Photoshop

The easiest way to explain the concept of layers is to imagine several sheets of transparency film (acetate) stacked on top of each other, each with different information. You can adjust each layer individually without affecting the others. Before trying to work with layers, it pays to get to know the layers palette.

Naming each layer is recommended.

You can right-click the layer name to change its properties.

The eye symbol to the left allows you to turn the view of the layer on or off.

Each layer can be dragged above or below others, making it easy to change the arrangement of individual elements.

Opacity can be changed by selecting the layer and changing the percentage in the top right corner of the palette.

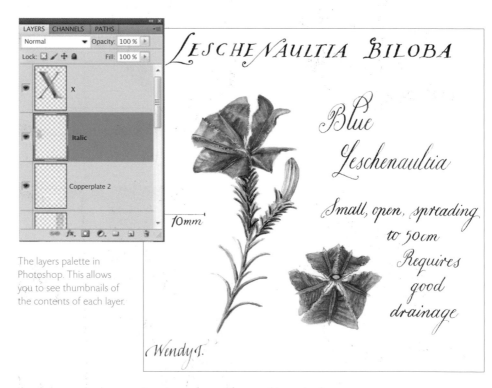

The layers palette in Photoshop. This allows you to see thumbnails of the contents of each layer.

Layering can be used for something as simple as adding calligraphy to an illustration or background.

Brushes in Photoshop

Digital brushes are symbols or pre-created pieces of artwork that either stretch or repeat along a stroke. They can be as simple as a dot, to create a simple line, or as complicated as any motif you can create. Because they create pixel-based marks, brushes in Photoshop are less user-friendly for calligraphy than in Illustrator as, like laying paint onto paper, they are harder to adjust or correct. We look at vector-based software later (see p. 263), but give a brief overview here as they can be very powerful for illustration.

PRESETS
Photoshop has a plethora of preset brushes that can be used to good effect.

ALTERING THE PRESETS
It is possible to change the characteristics of each of the default brushes by playing with the settings in the presets dialog box in the brushes palette.

Some of the variables include:

Shape dynamics

Scatter (of the brush elements, e.g. bubbles)

Texture

Dual brush

Color dynamics

Other dynamics

Experimentation is the best way to find out what these options do. Be aware that some—shape dynamics, for example—depend on pressure sensitivity, and therefore require a pressure-sensitive tablet.

Photoshop has a huge array of choices in its brush palette.

This bubble brush is an example of taking a motif and creating an effective and fun brush for illustration.

USING PHOTOSHOP LAYERS: STEP BY STEP

In this example, we will put together a number of individual calligraphic elements to create a complex yet cohesive image. We will work with a variety of palettes or panels, all of which can be found in the Windows menu. It is also necessary to have some idea of the tools we will be using, so familiarize yourself with the toolbox before starting.

STEP 1

Scan as JPEGs each of the elements to be included in the piece.

STEP 2

Open each piece in Photoshop. (If it is a bit soft or fuzzy, the image can be sharpened using Filter > Sharpen > Unsharp Mask.)

STEP 3

Create a new document (Ctrl + N) with the dimensions h30cm x w21cm and resolution 300ppi. (Make sure the Layers palette is open. Window > Layers or the F7 key.)

STEP 4

The background layer is colored by selecting it (Ctrl + A) then clicking Edit > Fill and choosing a color from the Use dropdown menu, then OK. To add texture, choose Filter > Texture > Texturizer.

STEP 5

Copy each element in step 2 by selecting the image (Ctrl + A) and pasting each one into the new document (Ctrl + V). As you paste them into the same document, Photoshop assigns each element a separate layer. To avoid confusion, rename the layers by right-clicking on the existing name, selecting Layer Properties, then changing the name. Now you can move, resize, recolor, or change any individual element independent of the rest of the piece to play with the design and layout of the image. NB: Make sure you select the correct layer before you make changes to it.

STEP 6

Click on the background color of each element using the "magic wand" selection tool, then delete. The magic wand selects all pixels of a similar color—the higher the tolerance set, the greater the range of colors allowed in the selection. This erases the background, making it transparent and leaving just the text or the motif.

STEP 7

Adjust the dimensions and angles of the elements via Edit > Transform > Scale function or Ctrl + T. (Clicking and dragging one of the handles on the bounding box adjusts the size or changes the angle by rotating. Holding the Shift key down simultaneously maintains its proportions. Use the move tool to click and drag objects around.)

STEP 8

To change the color of any particular area, first select it using one of the selection tools (marquee, lasso, or magic wand), then go to the Image menu, Adjustments > Hue/Saturation. In this window, try varying the image both with and without the Colorize check box ticked while dragging the three sliders around until you achieve the desired result. Click OK. Sometimes to select your text or motif it is easier to select the transparent background using the magic wand, then choose Inverse (Ctrl + Shift + I), which selects the text or motif. Once again, make sure you are in the correct layer.

STEP 9

In the example I copied the Copperplate element twice and gave it a different treatment with size and coloration. I also used the floral motif twice. Right-click on the layer name and choose Duplicate Layer.

STEP 10

Create a reverse or negative of the X by selecting it and using Image > Adjustments > Invert.

STEP 11

When you are happy with the image, save it as the default type PSD (Photoshop document). This will retain the layer information found only in Photoshop and will therefore be a relatively large file size, but it can be reworked later if desired. You can also save the document as numerous other file types depending on what you would like to do with it. The most common forms are TIFF and JPEG. For a good explanation of this, see George Thompson's *Calligraphy with Photoshop*.

STEP 1

STEP 4

STEP 5

STEP 6

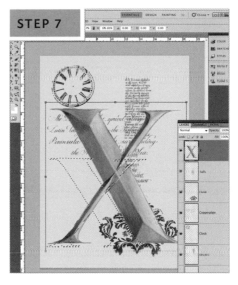

STEP 7

STEP 8

STEP 9

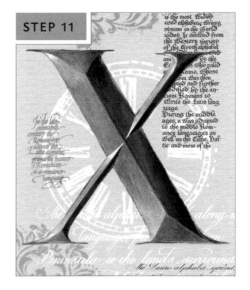

STEP 11

CREATING DIGITAL LETTERING

In this chapter, we explore creating editable, digitized lettering using Adobe Illustrator CS5. There are two methods of creating editable digital lettering. The first is to vectorize a pixel-based image; the second is to write digitally directly into the computer using the brush tool. Vectorizing a pixel-based image can be useful for simple shapes such as logos, but it is not always practicable for calligraphy. It can vary in accuracy, as when using Illustrator's automatic Live Trace function, or can be laborious, as when using the pen tool. Therefore, we focus here on the second method: writing using digital brushes.

A B C

Carpe Diem *Carpe Diem* *Carpe Diem*

Using a basic Italic brush of 45°, 0% Roundness, and 15pt diameter is fine for formal unadorned Italic (A); however, if flourishes are desired it is not as flexible (B), so adding pressure sensitivity and variation to the diameter setting allows for more expressive lettering (C).

DIGITAL BRUSHES

Using the brush tool with a stylus pen and tablet is the fastest and most enjoyable way of creating digital lettering. Even having a good deal of experience of pen and ink, it takes time to become familiar with using a stylus and tablet, as the surface and instrument are very different. The inflexible nature of digital calligraphic brushes means they don't allow for the manipulation that a good flexible nib can provide. However, the ease and ability to adjust what you have done or to quickly and cleanly erase mistakes soon makes up for this. Of course, if you are willing to go to the extra expense, this can be overcome by using the Wacom 6D art pen with the appropriate tablet. Writing digitally poses another challenge. There is a disconnect between the writing surface (tablet) and the image (monitor) that takes some getting used to. For a jump in cost, there are tablets available, such as the Wacom Cintiq, that are also the monitor, so the user writes directly on the screen. Before we begin, we need to familiarize ourselves with Illustrator's toolbox.

Illustrator's toolbox showing some of the tools that are used in this section.

The brush palette showing the artistic brush library.

The stages of creating a new brush.

Using brushes to create lettering

Illustrator comes with a range of preset brushes and brush libraries; these include a calligraphic brush library. When you open the brush palette (Windows > Brush), you will see the default ones; you can open other libraries by clicking on the Brush Libraries icon in the bottom left of the palette. Several categories of brushes can be selected from each, containing subcategories. For instance, the Artistic category holds the artistic paintbrush library.

Most programs with brushes allow variation on the presets as well as the creation of new brushes. In Illustrator, the new brush icon at the bottom of the palette allows you to create your own brush tip to simulate a calligraphic nib.

For example, an Italic brush would have the parameters Angle: 45°, Roundness: 0%, and the Diameter (or nib width) of your choice. It is best to experiment with the various settings. It is possible to combine the above settings with a pressure-dependent setting for extra flexibility. It requires greater control but allows for a much freer, expressive result with finer hairlines and finessed flourishing.

ADJUSTING SERIFS AND FLOURISHES: STEP BY STEP

Using the brush tool, it is possible to draw paths that are made up of editable points. This forms the skeleton of the letter, which we can use to adjust the position of the stroke. Most programs do not allow us to manipulate the thickness of the stroke, but converting that path from a skeleton to an outline allows us, for instance, to adjust serifs and flourishes. More excitingly, it allows us to create interesting fills within the calligraphic stroke and have the stroke outlined.

STEP 1

Open a new document. Select the brush tool, then choose a brush from the brush palette.

STEP 2

Click and drag to draw a letter. If it doesn't work too well, click Ctrl + Z to undo and repeat until you are happy with the result.

STEP 3

Select the letter(s) using the selection tool. Go to Object > Path > Outline Stroke.

STEP 4

Adjust the outline by manipulating the points on the outline with the direct selection tool as seen in the image below to create the serif and taper the ligature.

The next steps are only necessary if there are overlapping path lines, as in the second "C" of the image left.

STEP 5

Go to Object > Path > Offset Path.

Converting from a path to an outlined stroke.

STEP 6

Set offset at 0.001 > OK. This reduces a lot of the internal complexity of each letter's outline.

STEP 7

Remove the original lettering from the new underlying offset path by clicking and deleting. You will see when this is selected that the path has no overlapping lines. To do this it may be easier to first go into isolation mode by double-clicking on the letter. To exit isolation mode, double-click off the letter.

Using the Direct Selection tool to edit a path.

Illustrator effects

Once you have your letter outlined, it is time to have some fun. Both Illustrator and Photoshop come with a range of filters that can be applied to an image or a selected part of an image to create interesting effects. The best way to explain this is through demonstration. Going on from our manipulated letter C, organiwe can look in the Effects menu, select the letter, and apply some of the effects.

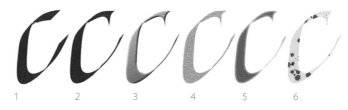

Using filters in Illustrator. 1 Original letterform. 2 Modified letterform.
3 Effect > Sketch > Bas Relief. 4 Effect > Sketch > Note Paper. 5 Effect > Distort
> Diffuse Glow after changing fill color. 6 Using the Paint Inside function in CS5.

Layers in Illustrator

Although we focus more on brushes here, the layering concept is so integral to the process that we must revisit it in Illustrator. Whereas layers in Photoshop act like transparency sheets with images printed on them, in Illustrator the layers are more like transparent shelves with objects arranged on each shelf as totally independent entities. All the information about each object is listed in the layers palette. Unlike Photoshop, you do not necessarily need to have the correct layer selected to edit an object—you can just click on the object to move into its layer. This can become confusing when the image has many objects and layers, so try the following features to minimize potential frustration:

- locking down layers—in order to avoid confusion and to prevent unwittingly changing what you have done in a layer, it is safest to lock it while you are not working in it.

- Isolation mode—if you double-click on an object, you will find the document will become pale except for the object you double-clicked on. You are now in isolation mode and can work on the object without the other parts of the document getting in the way or being affected. Double-click again to exit this mode.

- Layer visibility—as with Photoshop, it is possible to turn the visibility of layers on and off.

Use the clipping mask function to fill a path with an image.

Other layer palette features

Transparency—changing the transparency of a layer can create beautiful layering effects.

Twirling—refers to clicking on the arrowhead to the left of any object within the layers panel to reveal information about that layer or object.

Meatballing—refers to clicking the round circle to the right of any object within the layers panel in order to select the object. This can be helpful with highly complex images.

Rearranging layers—as in Photoshop, it is possible to click and drag layers within the layers palette to rearrange their order, thus changing the order of objects on the artboard.

Useful features of the layers palette in Illustrator.

PUTTING IT ALL TOGETHER: STEP BY STEP

STEP 1

Start a new document (Ctrl + N) with the dimensions w21cm x h50cm. This is your artboard. It is possible to use the area outside the artboard to store objects for use later if necessary. Just drag them off your artboard for later use. Create a rectangle by choosing the rectangle tool and clicking and dragging it to the dimensions h51cm x w4cm. With the rectangle selected, click on the Draw Inside icon toward the bottom right of the toolbox.

STEP 2

Click off the object to deselect it (it will still have the dotted corners of the Draw Inside icon), then select the brush icon. If you choose a brush with the item selected it will apply that brush to the object path—in this case, the rectangular outline. Open the brushes palette and click on the Brush Libraries menu at the bottom left of the palette. Choose Artistic > Artistic Watercolor. Choose any brush you like and open the color palette; with the stroke selected, choose a color from the spectrum bar or use the sliders to create a color you like.

STEP 3

Paint over the area of the rectangle. You will see that your strokes are bounded by the rectangle's dimensions. Do not worry if the color is darker than you would like; you can use the opacity slider in the object options toolbar at the top of the window.

STEP 4

Create a second rectangle with the dimensions h4cm x w 21.5cm. Position the rectangles by clicking and dragging them on the page. You can adjust the size and shape of any object by clicking on it with the selection tool (black arrow) to bring up the bounding box then clicking and dragging the handles on the bounding box. Pressing shift simultaneously will keep the object proportions.

STEP 5

In the layers palette, double-click the name of the layer and rename it "Rectangles," then click OK. Lock the layer by clicking on the box to the right of the visibility icon (eye) for that layer in the layers palette. You can click this again to unlock the layer if you want to work on it later. You can also turn off the visibility of the layer if it is disruptive.

STEP 6

Start a new layer by clicking on the new layers icon at the bottom of the palette. Rename the layer; this time call it "Flourishes."

STEP 7

Choose "Calligraphic Brush 1" from the preset brushes and, using the brush tool, make some sweeping calligraphic, flourished strokes of various sizes and shapes. Position them as desired on the page.

STEP 8

Select a stroke and apply color and gradients to it using the color or swatches and gradient panels. Gradient colors can be adjusted by double-clicking and/or moving the sliders along the bottom and top edges of the gradient slider square. By clicking on the edge you can add more sliders for a more complex gradient. Explore this panel for other options.

STEP 9

Layer a textural effect over the gradient by going to the Effect menu > Texture > Grain. Try other effects for yourself.

STEP 10

When done, lock down the layer as in step 5 and create a new layer as in step 6. Using the brush tool, choose the calligraphic brush and write an alphabet. You can write anywhere, on or off the artboard, and then place the letters where you want them on the page. See the box for creating guidelines to help you write.

STEP 11

If the letter is made up of more than one stroke, it is helpful to select both strokes by using the selection tool to click and drag over them then group them (Ctrl + G). They are now attached until you ungroup them (Ctrl + Shift G).

STEP 3

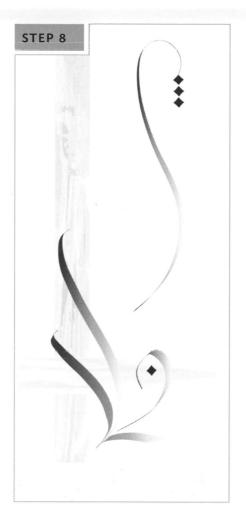

STEP 8

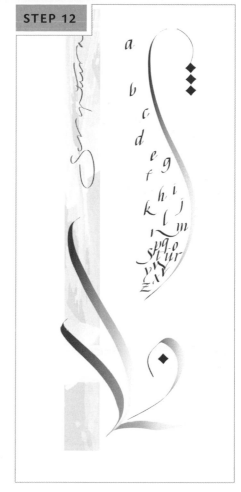

STEP 12

STEP 12

Use the 2pt Oval brush to write the word "Scriptura." Group the letters as described in step II. Change their size and orientation using the handles on the bounding box. NB: Rotate an object by hovering the selection tool around the corners of the object until the rotate cursor comes up (a small curve with arrows at both ends), then click and drag until you get to a 90° orientation. Click and drag it into place over the vertical rectangle.

STEP 13

When the work is complete, save the image as an Illustrator document with the layers still intact. To save the image as a JPEG or TIFF file, choose Export from the File menu.

Creating guidelines

You may want digital guidelines to aid your writing. Click and drag from one of the rulers and drag one or more guidelines onto your artboard. You may want to create a separate layer for the guidelines. If the rulers are not present around the work area, click Ctrl + R to bring them up.

◆ PROFILE MALIK ANAS AL-RAJAB

My passion for classical calligraphy started many years before discovering the contemporary aspect of calligraphy. The works of contemporary calligraphers and artists such as Nja Mahdaoui, Brody Neuenschwander, and Denis Brown opened a new door to me, presenting calligraphy with richness and elegance in a way that adds to the complexity of calligraphy.

Medieval manuscripts are always an inspiration. The layout and spirit of these manuscripts are the elements that I try to convey in my work. Also I have become interested in architecture as a source of inspiration, in terms of structure and space.

When I begin a piece, I start out by sketching the structural elements of the work; this is done with a reed pen and ink, or using Illustrator with a digital pen. Once I am satisfied with the structure and layout, I start working with textures and colors to get the right feeling and depth to the work. These two stages are intertwined and take as much time as necessary until I am satisfied with the result.

Any work that incorporates design and/or calligraphy has always been my field of interest and enjoyment. The *Oriental Pages Collection*, which I started in 2007, is my field of experimentation; and I add to the collection whenever I finish a new piece.

It is quite surprising to notice the evolution from when I first began calligraphy, but I guess that practicing and

Digital artwork; 17¾ x 12½in
(450 x 320mm)

Digital artwork; 17½ x 13½in (448 x 345mm)

Digital artwork; 9 x 12 in (225 x 320mm)

experimenting contributes immensely to anyone's evolution in any field, especially in art. I have learned that time and experimenting does not come cheap! You invest time and effort to reach a certain goal, and your passion for the goal is your fuel to stay on course.

The human quest to leave a mark, to make these elegant symbols to convey thoughts, ideas, and art is simply magical to me. This is why I can appreciate a foreign calligraphic piece without knowing the meaning of the text, and that is why my artworks do not rely on text but rather on symbols and feelings. This is to enable as wide an audience as

possible to have their own interpretation for the abstract work as a whole, without relating this reaction to a limited meaning of the text.

Passion, practicing, and experimenting can go a long way; never stop experimenting. Start by learning the basics and then develop your visual library as much as you can to make the best of the different styles and approaches in order to evolve your inner taste for calligraphy.

GALLERY COMMERCIAL

MOSHIK NADAV
Adobe Illustrator

ADAM ROMUALD KLODECKI
Corel Painter software

RUTGER PAULUSSE
Pencil on paper; Adobe Illustrator

FRANCISCO GIGENA
Pencil on paper; Adobe Illustrator

JULIA BAXTER
Black gouache on watercolor paper; scanned and manipulated on a computer for reproduction; 12 x 6in (305 x 152mm)

This logo design was commissioned by a band that plays medieval music.

ADAM ROMUALD KLODECKI
Molotov graffiti marker; 3D software

RESOURCES

Courses

Learning calligraphy by yourself from a book or video can be a great starting point, but you may find the process easier and quicker if you attend a class or subscribe to a course with personalized tutoring. Look for calligraphy at your local community college or adult education center. Some institutions offer seven- or eight-week courses with the option of continuing.

CORRESPONDENCE OR ONLINE

Organizations such as The Calligraphy and Lettering Arts Society (CLAS) and the Society of Scribes and Illuminators (SSI) offer correspondence courses and training programs. CLAS offers four levels of CLAS graded qualifications: the Certificate of Calligraphy, and the National Diploma of Calligraphy at Foundation, Intermediate, and Advanced levels.
www.clas.co.uk/calligraphy-courses.html

SSI took on the Roehampton University course (established in 1987) in 2009; the full course of 24 lessons is divided into four units of six lessons.
www.calligraphyonline.org/Pages/ccc.html

Satakunta University of Applied Sciences (SAMK) in Finland offers three courses in Professional Specialization Studies in calligraphy that may be attended in person, via correspondence, or online.
193.166.40.20/calligraphy

Denis Brown has a website, calligraphy.tv, through which you can subscribe and receive prerecorded video tutorials, DVDs, and quality prints.
www.calligraphy.tv

Scribblers, a UK calligraphy supplier, offers correspondence courses with Gaynor Goffe, former head of the Roehampton University calligraphy course.
www.scribblers.co.uk

The International Association of Master Penmen, Engrossers and Teachers of Handwriting (IAMPETH) offers material that can be printed and used for personal lessons.
www.iampeth.com/lessons_flourishing.php

An online resource to check out is www.lynda.com. For a small monthly fee it is possible to access an enormous amount of informative video tutorials and get to know the capabilities of various software programs before buying them.
www.lynda.com

FULL-TIME COURSES WITH QUALIFICATIONS

Sunderland University has a Foundation Degree in Calligraphy with Design (UCAS Code W150); this is a two-year full-time course based in London, which runs from September to June with three terms of ten weeks.
www.sunderland.ac.uk/course/1016/foundation_degree_in_calligraphy_with_design

RMIT, Melbourne Australia offers a four-unit (15 weeks each) Certificate of Calligraphy.
www.shortcourses.rmit.edu.au

Guilds and societies

Most major cities have a guild, society, or association that offers monthly meetings, workshops, projects, and a newsletter or magazine to update you of events and to show members' work; occasionally a group will bring an international calligrapher in to conduct workshops. CLAS and SSI (mentioned above) also offer lay memberships for anyone interested; this entitles you to the publications and to attend workshops.

For a comprehensive list of groups, see www.cynscribe.com, a meta site that has not only guilds and societies but everything related to calligraphy.

Cyberscribes is an internet calligraphy discussion group:
www.calligraph.com/cyberscribes/

Setting up a calligraphy business

If you decide that calligraphy is more than a hobby, the next step may be setting up your own business. Make sure that you are competent in Italic and Foundational at the very least. Jobs such as wedding stationery fill-ins (names on invitations, envelopes, placecards, and table plans), certificate fill-ins, corporate invitations, and poems are the bread and butter of most calligraphers, with more extensive commissions such as family trees, formal presentations, and awards coming less frequently. To avoid complications, it is advisable to register your business name (so noone else uses it), unless you trade under your own name, in which case you are known as a sole trader. The internet has made it easy to do your own marketing; get a webpage professionally designed or set one up yourself using Frontpage (an easy, fill-in-blanks software program) or Dreamweaver (a better option to customize your design). Along with standard information such as contact details and a description of the services offered, provide samples of invitations and certificates, as well as a gallery of finished artwork that is representative of your approach.

Suppliers

If your local art supplier does not stock a reasonable range of calligraphic equipment, try online suppliers. John Neal books (www.johnnealbooks.com) and Paper and Ink Arts (www.paperinkarts.com/) in the US have phone and fax options for ordering as well as internet. In the UK are Scribblers (www.scribblers.co.uk) and in Australia, Will's Quills (www.willsquills.com.au). Cynscribe (www.cynscribe.com) has an extensive list of suppliers throughout the world.

Conferences and symposia

The US offers some exciting programs every year with various calligraphy conferences. Organizers bring a considerable number of internationally recognized calligraphers together to present workshops over a five- to seven-day period.

Satakunta University of Applied Sciences (SAMK) in Finland hosts an annual symposium in June every year with international tutors.
193.166.40.20/calligraphy

The Calligraphy Society of Victoria in Australia hosts its annual summer school over five days (usually at the beginning of July) with international tutors.
calligraphysocietyvictoria.org.au/

ONGOING WORKSHOPS
Camp Cheerio conducts twice-yearly workshop retreats with international calligraphers.
www.calligraphycentre.com/che.o.html

Ghost Ranch Education and Retreat Center in Abiquiu, New Mexico, conducts calligraphy, lettering, and mixed-media workshops.
www.ghostranch.org/catalog?page=shop.browse&category_id=60

Publications

Letter Arts Review is the premier magazine dedicated to calligraphy and letter arts. *Bound and Lettered* is dedicated to letter, book, and paper arts. Both are available for subscription from John Neal Books (www.johnnealbooks.com). Somerset Studio features mixed media, paper crafting, art stamping, and letter arts (www.somersetstudio.com).

Galleries and museums with collections

Although calligraphy is generally not accepted to be on a par with contemporary art practices, there is an increasing interest, particularly with artists such as Denis Brown, Luca Barcellona, Massimo Pollelo, Nuno de Matos (Matox), and Julien Breton (Kalaam) exhibiting successfully in contemporary art galleries and creating calligraphically based performance art.

Many public art galleries and educational institution libraries have manuscripts in their collections. The following list contains significant permanent exhibitions of calligraphy in galleries, museums, and libraries.

The modern calligraphic collection of the national art library at Victoria and Albert Museum, Cromwell Road, London, SW7 2RL, England
www.vam.ac.uk/collections/prints_books/modern_ calligraphy/index.html

Ditchling Museum, Church Lane, Ditchling, East Sussex, BN6 8TB, England
www.ditchling-museum.com/index.html

Chester Beatty Library, Dublin Castle, Dublin 2, Ireland
www.cbl.ie/

Book of Kells, Old Library, Trinity College, Dublin 2, Ireland

Contemporary Museum of Calligraphy, 1 Sokolnichesky Val, Pavilion 7, Moscow, Russia
www.calligraphy_museum.com

Karpeles Manuscript Library Museums (includes 9 museums in USA), USA
www.rain.org/˜karpeles/

Harrison Collection of Calligraphy at San Francisco Public Library, 100 Larkin Street, San Francisco, CA 94102, USA
sfpl.org

The Getty Center, 1200 Getty Center Drive, Los Angeles, CA 90049, USA
www.getty.edu/visit/

The Catich Collection, St Ambrose University, 518 West Locust Street, Davenport, IA 52803, USA
catich@sau.edu

Klingspor Museum, Herrnstrasse 80 (Sudflugel des Busing Palais), 63061, Offenbach am Main, Germany
www.klingspor-museum.de/UeberdasMuseum.html

Schrift und Helmat Museum Bart/Haus, Museumstrasse 16, 4643 Pettenbach, Austria
www.schriftmuseum.at/

MlM Musee des Lettres et Manuscrits, 222 Boulevard Saint Germain, 75007, Paris, France
www.museedeslettres.fr

SSM Sabanci University Sakip Sabanci Museum, Sakip Sabanci Cad. No. 42, Emirgan 34467, Istanbul, Turkey
www.muze.sabanciuniv.edu

Islamic Arts Museum Malaysia IAMM, Jalan Lembah Perdana, 50480, Kuala Lumpur, Malaysia
www.iamm.org.my/

BIBLIOGRAPHY

J.J.G. Alexander, *The Decorated Letter*

J.J.G. Alexander, *Medieval Illuminators and Their Methods of Work*

Janet Backhouse, *The Illuminated Manuscript*

George Bickham, *The Universal Penman*

Michelle P. Brown, *A Guide to Western Historical Scripts from Antiquity to 1600*

Ann Camp, *Pen Lettering*

Edward Catich, *The Origin of the Serif*

Annie Cicale, *The Lively Art of Lettering*

Gerald Cinnamon, *Rudolf Koch, Letterer, Type Designer, Teacher*

Marc Drogin, *Medieval Calligraphy, Its History and Technique*

Alan Furber, *Layout and Design for Calligraphers*

Gaynor Goffe, *Calligraphy Made Easy*

Gaynor Goffe and Anna Ravenscroft, *Calligraphy School*

David Harris, *Art and Craft of Calligraphy*

David Harris, *The Calligrapher's Bible*

Donald Jackson, *The Story of Writing*

Tom Kemp, *Formal Brush Writing*

Stan Knight, *Historical Scripts*

Stan Knight and John Woodcock, *A Book of Formal Scripts*

Yves Leterme, *Thoughtful Gestures*

Patricia Lovett, *Calligraphy and Illumination*

E.A. Lupfer, *Ornate Pictorial Calligraphy*

Claude Mediavilla, *Calligraphy*

Janet Mehigan and Mary Noble, *Beginner's Guide to Calligraphy*

Janet Mehigan and Mary Noble, *The Calligrapher's Companion*

Janet Mehigan and Mary Noble, *Encyclopedia of Calligraphy*

Margaret Morgan, *The Bible of Illuminated Letters*

Margaret Morgan, *Illumination and Decoration for Calligraphy*

Margaret Morgan, *The Illuminator's Bible*

Timothy Noad, *The Art of Illumination*

Timothy Noad and Patricia Seligman, *The Illuminated Alphabet*

Mary Noble, *Calligraphy Techniques*

Gerrit Noordjit, *The Stroke*

Charles Pearce, *Anatomy of Letters*

Charles Pearce, *The Little Manual of Calligraphy*

Eliza Schulte Holliday and Marilyn Reaves, *Brush Lettering*

Fran Strom Sloan, *Pointed Brush Lettering*

Fran Strom Sloan, *Pointed Brush Writing Manual*

George Thompson, *Calligraphy with Photoshop*

Gordon Turner, *The Technique of Copperplate Calligraphy*

Sheila Waters, *Foundations of Calligraphy*

Eleanor Winters, *Mastering Copperplate*

Pascal Zoghbi and Don Stone Karl, *Arabic Calligraphy*

Letter Arts Review Vol 13 no 1, 1996 (article on Koch by Tom Greensfelder) "The Zanerian Manual"

GLOSSARY

ampersand the symbol for and (from "and per se and")

arch the curved stroke springing from the stem

ascender part of the letter that extends above the x-height: b, d, f, h, k, l

ascender line where an ascender extends to on a guideline or ruled page

baseline or horizontal line is the line on which the letters sit

Blackletter usually refers broadly to Gothic scripts, where the thickness of a letter creates a dark texture on the page

bookhand scripts used in books before the advent of printing

bowl a part of a letter with an enclosed curve

cadel an elaborate decorative capital used with Gothic scripts constructed with interlacing strokes

Cancellaresca corsiva or chancery cursive—original Italian name for Italic

clubbed an ascender that has been thickened for emphasis

compound letters drawn in multiple strokes rather than in a single stroke

counterspace (also called white or negative space) is the space inside a letter

crossbar the horizontal stroke on a letter

cursive usually a faster script with fewer pen lifts than a formal script

debossing is the opposite of embossing, where the image is pushed away from the paper

descender part of the letter that extends below the x-height: g, j, p, q, y

descender line where a descender extends to on a guideline or ruled page

diamond a single stroke mark made by a broad-edged pen when held at 30° or 45° pen angle

dot the mark above the i and j

downstroke a stroke commencing at the top of the x-height or ascender height and finishing at the bottom of the x-height or the descener height. Often the main strokes, downstrokes are usually the thickest part of a letter

ductus the order, number, and direction of strokes to create a finished letter

embossing where a burnishing tool is used with a thick template to create a raised effect; it involves pushing the paper into the template with the tool

entasis where a letter comes in slightly at the middle, or has a "waist"

equidistant parallels an even rhythm or monorhythm of equally spaced downstrokes

exemplar an example or model of a hand used a starting point for exploring a script

flourish a decorative extension to a letter—usually an ascender or descender, but also a majuscule or termination

formal a hand with an established ductus of multiple strokes; usually refers to a traditional or historical hand

Gestural a modern cursive, usually informal, hand with considerable variation of forms

gilding the process of laying gold leaf on a work

gold leaf a finely beaten sheet of metal leaf used for gilding—may be gold or imitation, or other metals

gouache an opaque pigment-based medium

guidelines lines ruled up specifically for a hand and pen size that are placed underneath thin paper to indicate x-height, ascender height, and so on

gum arabic a finely ground tree resin used to bind pigments to a substrate

gum sandarac a finely ground tree resin that can be lightly dusted onto the surface of greasy or unsuitable substrates to reduce bleeding of applied media

hackle a thorn-shaped decoration usually applied to Gothic majuscules

hairline the thinnest mark a pen can make, also called a thin

historiated initial a decorative enlarged initial that illustrates part of a text

hot pressed paper that has been put through hot rollers to give it a smooth surface

illumination use of gold in a work

ink a liquid substance used for writing and painting, can be waterproof or nonwaterproof, usually dye-based

interletter space the space between letters

interlinear space the space between each baseline

interword space the space between words

keystroke a standard stroke that occurs frequently within any given hand

layout the way letters and/or images are arranged on a page
letter groups letters arranged in groups according to similarity of stroke, construction, or proportion
ligature joining letters in one stroke or with an overlapped stroke
loop where a curve crosses itself

majuscule capital or upper-case character
manipulation twisting the pen in mid-stroke to achieve differing thicknesses of line
manuscript usually refers to a manuscript book containing historical calligraphy
minuscule small or lower-case character
monoline letters of a uniform width, with no thicks and thins

nib a metal pen point that fits into a pen holder that is dipped into or loaded with media to write
nib width the width of the mark made by the nib

pangram a phrase containing all the letters of the alphabet
pen angle the angle at which the blade or edge of the pen is held (not the pen holder) measured from the horizontal line. The thick and thin lines that characterize a calligraphic script are achieved by using and maintaining the correct pen angle, which determines the thickness or heaviness of the letter and the placement of the thick and thin strokes
pen width the width of the mark made by the pen when held at 90° to the writing line (sideways). It is used to determine measurements for the x-height, ascenders, and descenders
polyrhythm a pattern or cadence of writing that varies, e.g., uneven parallels
provenance the original source of a manuscript

quill a writing tool made from a feather, usually a primary flight feather from a goose or turkey

reservoir a small metal fitting that allows a nib or pen to hold extra media
rhythm the pattern made by the stems—usually monorhythm of equidistant parallels or polyrhythm of uneven parallels

sans serif alphabets those alphabets with no serifs
serifs the short starting and finishing strokes of a letter
stem the main vertical stroke of a letter
stroke mark made by the pen, part of a letter
substrate the writing surface or material

thick a heavy downstroke
thin a fine stroke or hairline
upstroke a fine thin line; usually refers to pointed pen hairlines

watercolor a pigment-based medium mixed with water that can be used as a background for work or used in a pen
weight refers to the relative thickness or heaviness of a letter
writing angle the angle at which the letters slope (not to be confused with the pen angle) measured from the vertical line

x-height the height of the body of the letter without extensions: a, c, e, m,n, o, r, s, t, v, w, x, z; it is measured upward from the baseline, and is also called body height or minim

CONTRIBUTORS

Hilary Adams, hilary@signature-ink.co.za
Capetown, South Africa

Sue Allcock, toosooroo@hotmail.com
Bridgetown, Western Australia

Bailey Amon, bailey@amondesignstudio.com
Austin, Texas, USA

Malik Anas al-Rajab, www.malikanas.com
Baghdad, Iraq

Georgia Angelopolous, cangelopoulos@shaw.ca
Vancouver, Canada

Yukimi Annand, yukimia@mac.com
California, USA

Yanina Arabena, yaniarabena@gmail.com
Argentina

Cherrell Avery, lettersonpages@talktalk.net
England

Julia Baxter, www.calligraphystudio.org
Sandwich, England

Francesca Biasetton, info@ biasetton.com
Italy

Gemma Black, gblack@pcug.org.au
Tasmania, Australia

Danae Blackburn-Hernandez, edanaeart@gmail.com
New Mexico, USA

Anna Bond, info@riflepaperco.com
Florida, USA

Joke Boudens, joke.boudens@gmail.com
Bruges, Belgium

Barbara Callow, barbaracallow@sbcglobal.net
California, USA

Bryn Chernoff, bryn@paperfinger.com
New York, USA

Barbara Close, barbara@bcdezigns.com
USA

Peter Evans, pev92491@bigpond.net.au
Perth, Western Australia

Francisco Gigena, frangigena@gmail.com
Argentina

Heleen de Haas, heleen@calligraphy.za.net
South Africa

Adam Romuald Klodecki, theosone@gmail.com
Poland

Jean Larcher, jean@larchercalligraphy.com
France

Monica Lima, monica@abitofink.com
Florida, USA

Manny Ling, www.mannyling.com
Sunderland, England

Vitalina and Victoria Lopukhina, —
Ukraine

Oleg Macujev, info@omtype.com
Russia

Marina Marjina, m.marjina@gmail.com
Russia

David McGrail, qdesign@Indigo.ie
Dublin, Ireland

Natasha Mileshina, Natasha.Mileshina@gmail.com
New Jersey, USA

Betina Naab, info@roballosnaab.com.ar
Buenos Aires, Argentina

Moshik Nadav, moshik@moshik.net
Israel

Jana Orsolic, ask@janaorsolic.com
Serbia

Rutger Paulusse, rutger@gwer.nl
The Netherlands

María Eugenia Roballos, info@roballosnaab.com.ar
Buenos Aires, Argentina

Therese Swift-Hahn, bellascrittura@verizon.net
New Jersey, USA

Wendy Tweedie, richandwend@iinet.net.au
Perth, Western Australia

Sophie Verbeek, sophie.verbeek@wanadoo.fr
France

Marian Watson, kurrajong1929@gmail.com
Perth, Western Australia

Barbara Yale-Read, yalereadb@appstate.edu
USA

Rachel Yallop, www.rachelyallop.co.uk
England

INDEX

Acknowledgments

This book is a result of community effort. Special thanks must go to Wendy Tweedie for her energy, enthusiasm, writing and illustrating the entire digital section, artwork, photography, software mastery, and shortcuts, inventing a brush to make arrows for the exemplars, and doing all the arrows: she shall henceforth be known as the Queen of Arrows. To Sue Allcock, not only for her feature and artwork, but numerous lunches, lots of legwork, proofreading, contacting contributors, typing, and constant support and encouragement. You two have gone above and beyond the call of duty—*grazie molte miei cari amici.*

A huge thank you to Bailey Amon and Robert Bredvad for their great work organizing and photographing: the materials section; samples and hitherto unknown design techniques; and the illumination sequence done entirely from my written instructions. All of this while Bailey was organizing and having her own wedding! I appreciate the effort, Bailey—thanks so much.

Grateful thanks to Gemma Black for her enthusiasm and wholehearted support from the get-go, illumination sequence, and notes; Cindy Lane for photography, advice, and support; Sue Hopkins for her work, motivational cards, and food packages; Trish Krauss for researching galleries and collections; my team of supporters from the Calligraphers' Guild of WA; my Atwell House students; my husband Craig for his love, support, patience, sacrifice (giving up the chance to play computer games while I hogged the computer), and IT wizardry, and my daughter Isobelle for understanding that I had to work all the time.

A huge thank you to all the contributors for your wonderful pieces—this book has given me the opportunity to discover and connect with so many inspirational artists.

About the author

Gaye Godfrey-Nicholls is a professional calligrapher and calligraphy teacher. She studied under Peter Evans and graduated from Edith Cowan University in Perth with an Associate Diploma of Arts, Major in Calligraphy and Fine Lettering. She picked up her first calligraphy pen in 1984 and has never looked back. To counteract the effect of many hours of writing in the usual posture, she also leads group fitness (Bodypump) classes. She lives in Perth, Western Australia, with her husband and daughter and a variety of furred quadrupeds.

www.inklings.com.au